REMEMBERING GREENVILLE

PHOTOGRAPHS FROM THE COXE COLLECTION

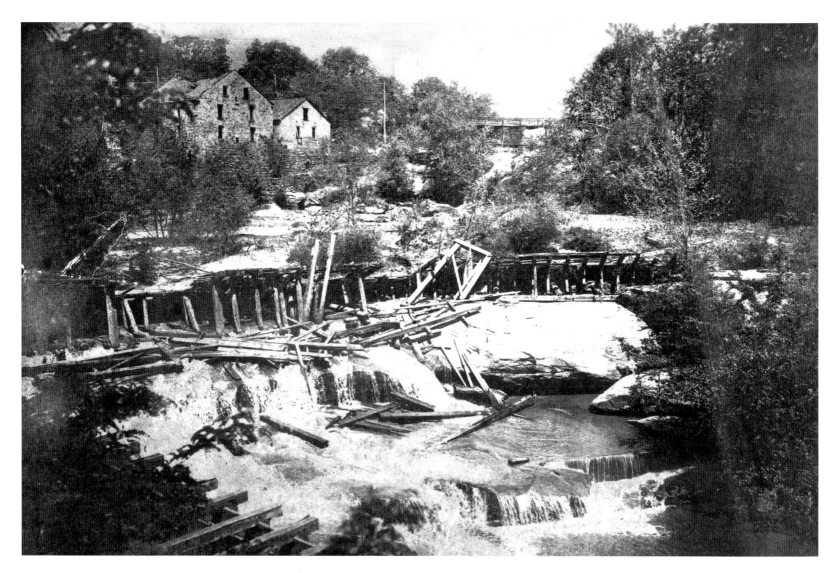

THE CRADLE OF GREENVILLE. Sometime in the late 1760s, Richard Pearis resettled from Virginia to the South Carolina backcountry. Near the falls of the Reedy River, he built a grist mill and a trading store, and established a plantation. From the Cherokee Nation he bought a large tract of land that included all of Greenville's present-day downtown area. Because of his support for the Tory cause, Pearis forfeited all his property at the end of the Revolution and fled to the Bahama Islands. In 1788 Lemuel Alston purchased 11,028 acres consisting of a large section of Pearis's former lands. In 1815 Alston sold his land holdings to Vardry McBee. The many business enterprises started by McBee marked the real beginning of the development of the future city. Vardry McBee has a valid claim to be called the "Father of Greenville.

This view of the Reedy River falls from the Coxe Collection was not taken by Bill Coxe himself. It is part of the collection of older photographs that Coxe acquired. The two small mills on the left of the scene were built by Vardry McBee.

REMEMBERING GREENVILLE

PHOTOGRAPHS FROM THE COXE COLLECTION

JEFFREY R. WILLIS
GREENVILLE COUNTY HISTORICAL SOCIETY

Published by Arcadia Publishing
Charleston SC, Chicago IL, Portsmouth NH, San Francisco CA

Printed in the United States of America

Library of Congress Catalog Card Number: 2003109045

For all general information contact Arcadia Publishing at:
Telephone 843-853-2070
Fax 843-853-0044
E-mail sales@arcadiapublishing.com
For customer service and orders:
Toll-Free 1-888-313-2665

Visit us on the Internet at www.arcadiapublishing.com

CONTENTS

ACKNOWLEDGMENTS

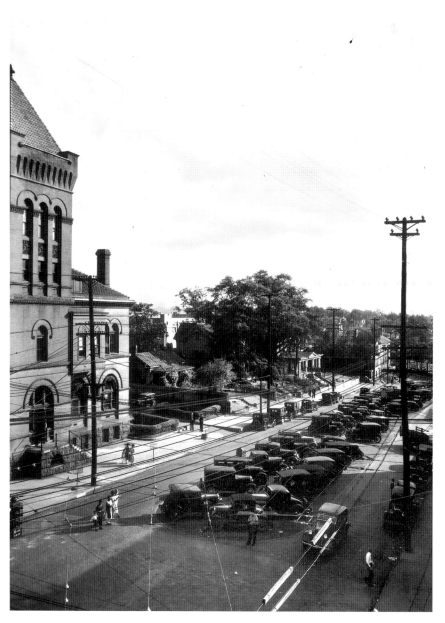

Many persons are responsible for the better features of this book. The author wishes to thank the board of the Greenville County Historical Society for making accessible the Coxe Historical Collection and granting permission to publish several hundred photographs. Board members Choice McCoin, Anne King McCuen, and Cabel Gregory III read the text and made corrections. Alex McPherson also read the text and made suggestions. Throughout the project, the cooperation and assistance of Sidney Thompson, executive director of the Society, has been essential. In addition to those cited above, others have provided information about individual photographs. Among these are Martha Mills, Margaret Brockman, Hosea Marrett Jr., Greg Bruns, Craig Myers, and William M. Gilfillin. Laura Daniels New of Arcadia Publishing was encouraging and helpful throughout the project.

Had it not been for the prior work of the Coxe Collection Committee of the Historical Society, the author's task would have been almost impossible. Jon Ward, Richard Sawyer, Anne McCuen, Brenda Hays, and Sharon Saad undertook the unpleasant task of reviewing deteriorating nitrate negatives and supervising the identification of the most important photographs in the collection. While serving as a summer intern, Whitney Elizabeth Brown completed the organization of the images deemed important and entered each into a database. Her work makes possible the speedy location of any photograph in the files of the Historical Society.

The author has drawn upon a number of published sources. The most notable of these are: James M. Richardson, History of Greenville County, South Carolina; Archie Vernon Huff Jr., Greenville: The History of the City and County in the South Carolina Piedmont; Choice McCoin, Greenville County: A Pictorial History; and The Proceedings and Papers of the Greenville County Historical Society, Volumes I–XI. Articles from the Greenville News and the Greenville Piedmont were useful, as were the files and staff of the South Carolina Room at the Greenville County Public Library.

VIEW LOOKING DOWN BROAD STREET. This is likely one of the older photographs purchased by Bill Coxe. The side of the 1892 Post Office/City Hall is on the left. Curiously, when the print was made, the image was reversed. What is seen here is a mirror image.

INTRODUCTION

After the Revolutionary War, Greenville began its existence as a village with no more than a courthouse, a jail, and a few wooden buildings. Although growth was slow in the first half of the 19th century, the emerging town developed an independent spirit that distinguished it from most of South Carolina. While much of the state was pro-nullification and becoming secessionist, the majority of Greenvillians opposed the Doctrine of Nullification and supported the Union. As has been true throughout Greenville history, its attitudes and its future were in the hands of a small number of independent-minded and progressive leaders. After the Civil War the development of the textile industry, on a large scale, transformed a country town into a small city. In 1860 the population numbered 1,518. By 1900 the number had grown to 13,017. The potential for commercial success was now such that new leaders were enticed to settle and open businesses. Next, in the 20th century, Greenville grew from a small city into a major metropolitan center. During this century there were two major bursts of development, first in the 1920s and then in the 1970s. Since the 1970s, continued development has totally altered the central downtown area. Although some late 19th-century and early 20th-century buildings remain, new construction and new streets have all but erased the Greenville of that time.

Fortunately, early 20th-century Greenville still exists in the photographs of the William B. Coxe Historical Collection. It is precisely the period from 1900 to 1970 that is recorded in these images. With so much beneficial development currently in progress, a question might be legitimately raised concerning the need and desirability of reconstructing a previous era. As Greenville continues to experience rapid change at the beginning of the 21st century, the need is all the greater to remember what went before. A city can look forward to a promising future only if its growth is accompanied by a full knowledge of and appreciation for its past.

Born in Sanford, North Carolina, and reared in Pennsylvania, William B. Coxe arrived in Greenville at the end of the first World War and established himself as a photographer. Almost immediately he undertook to compile a photographic history of his new hometown. In order to record Greenville in the decades prior to his arrival, he purchased the files of two earlier photographers, James Huntington and William Preston Dowling, and also solicited old photographs from individuals. Having assembled a photographic record of Greenville in the late 19th and early 20th centuries, he spent the next 55 years capturing the people and history of his time. From his studio on the top floor of the Woodside Building, he set out to photograph almost every building in downtown Greenville of any significance, and many of no significance. In addition he took pictures of churches, private homes, and textile mills. He photographed weddings, sports events, employee groups, church groups, and mill organizations. Numbered among his clients were many corporations and government agencies. His photographs appeared regularly in the Greenville News and the Greenville Piedmont, and he served as the official photographer for the Southern Textile Exposition. The images of the Coxe Collection breathe new life into a lifestyle that has disappeared in the process of urban growth.

Bill Coxe's success as a local photographer was enhanced by his active involvement in his community. A small, energetic, talkative man, he became a well-known and popular member of the Greenville community. He served as president of both the Kiwanis Club and the Greenville Art Association.

In addition to his work in Greenville, Bill Coxe was hired by MGM-International Newsreels to take photographs all over the United States. He became especially noted for his aerial photography. Once a pilot refused to fly low enough for Coxe to get the shot he wanted. To solve the problem, he got out of the plane, while still in flight, to get his shot. To avoid the problem of pilot temerity in the future, Coxe learned to fly his own plane. His aerial photographs were later used by the Greater Greenville Sewer District to map its trunk lines. In 1937 he was the only South Carolina photographer invited to exhibit at the National [Photographic] Exposition in Chicago.

Coxe was also a portrait photographer, especially known for his photographs of businessmen and families. He had a teasing manner and put his subjects at ease. His celebrity photographs include pictures of Jack Dempsey, John Philip Sousa, Howard Hughes, Charles Lindbergh, and Joanne Woodward. His daughter, Isabelle Coxe Cely, specialized in photographs of women and of children.

William Coxe died at the age of 78 in 1973. Eventually his heirs wished to sell the property on which his last studio stood, near the foot of Paris Mountain. In 1989 the Greenville County Historical Society was offered the contents of the studio. This gift consisted of old cameras, the collection of old photographs purchased by Coxe, and approximately 120,000 negatives of photographs taken by Coxe and Isabelle Coxe Cely. Unless someone was willing to undertake the responsibility for their care, Coxe's legacy was in danger of being lost, along with a significant source of Greenville history. Coxe, before his death, had expressed the desire that the collection not leave Greenville. After accepting the gift, the Greenville Historical Society obtained an agreement with the Duke Library of Furman University to store the collection. At the time, some of the negatives had already begun to deteriorate. Glenwood Clayton and Steve Richardson, of the Furman Library, began the process of organizing the old photographs and also identified

the considerable amount of time and money needed to complete the task properly. When a shortage of space forced Furman to give up the collection in 1991, the Historical Society signed an agreement with the Roper Mountain Science Center, which housed the collection until 1996. Next, for a year, the collection had to be put in temporary storage. From 1997 to 2003 the photographs and negatives were at Bob Jones University.

The reason for this constant shifting was that no organization had the approximately $200,000 needed to save and organize the negatives. With the exception of some images recorded on glass-plates, there were 5,000 on nitrate film and about 115,000 on safety film. It was the nitrate negatives that were the main problem. Nitrate film has a life of about 50 years under ideal conditions. Ultimately, the print emulsion separates from the film, and the image is destroyed. In the decomposition process, the change is imperceptible for many years. Then, rather suddenly,
the film begins to give off a strong odor of acid. When this happens, destruction of the images can happen rapidly. By this time the nitrate negatives were emitting an odor. The crisis stage had been reached.

Fortunately the majority of the negatives were on safety film, which does not present the same problem of decomposition. In time, however, this film also emits a strong odor that makes their storage and handling difficult.

Saving the negatives began on a very small scale. In 1998 the South Carolina Historical Records Advisory Board awarded the Greenville County Historical Society a grant of $2,000. With another $500 from the Society a project began to review and identify the most important images. The funds available made possible the processing of new negatives and prints for only 1,100 of the old nitrate negatives. The job of saving the entire collection was enormous.

During this critical period, Wilbur Y. Bridgers served two terms as president of the Historical Society. Using his skills as a trust officer, he was largely responsible for raising the necessary funds. The major contributors were the F.W. Symmes Foundation, the John I. Smith Charities, the Jolley Foundation, the Graham Foundation, the Belk-Simpson Foundation, the Dorothy H. Beattie Foundation, the Junior League of Greenville, and the Metropolitan Arts Council of Greenville. In 1999 the Historical Society moved into larger quarters at 211 East Washington Street. A gift from Allen J. Graham provided for the furnishing of the new office and archives room and the purchase of special steel cabinets to house the photographs and negatives that were then being processed.

The Coxe Collection Committee eventually made the decision that there was no reason to save all 120,000 negatives. There were, for instance, many duplicates. In some cases Coxe had taken multiple shots of the same scene, while moving his camera just a few inches in several directions. There were also a number of photographs of chickens. The decision not to reprocess all the negatives reduced the cost of completing the project. All of the approximately 5,000 nitrate negatives were

saved. As for the images on safety film, the emphasis was upon saving those of historical importance. By 2002 new negatives and prints had been made of all images deemed to be significant. The new negatives and prints were placed in steel cabinets in the archives of the Greenville County Historical Society and made available to researchers. All were indexed and entered into a database. Inexpensive copies then became available for sale.

While preparing this volume, the selection of several hundred images from the collection was a difficult task. Deciding not to include a photograph was more difficult than deciding on its inclusion. In the first chapters an emphasis has been placed on recording the downtown area as it existed and changed during the first half of the 20th century and, thereby, to trace the evolution of Greenville into a metropolitan center. The story begins at Court Square, moves along South Main Street, and for a short way along Augusta Street. Chapter Two returns to Court Square and heads up North Main Street. First one side of each block is shown and then the other, until the end of the North Main business district is reached. Then follows a chapter on the major streets that intersect North and South Main. The final chapters follow a more topical approach. Although only a fraction of the images preserved in the Coxe Collection is shown herein, the reader can glimpse the richness of the collection and its importance in enhancing the future growth of Greenville by assisting in basing that growth "upon a knowledge of and appreciation for its past."

—Jeffrey R. Willis
June 2003

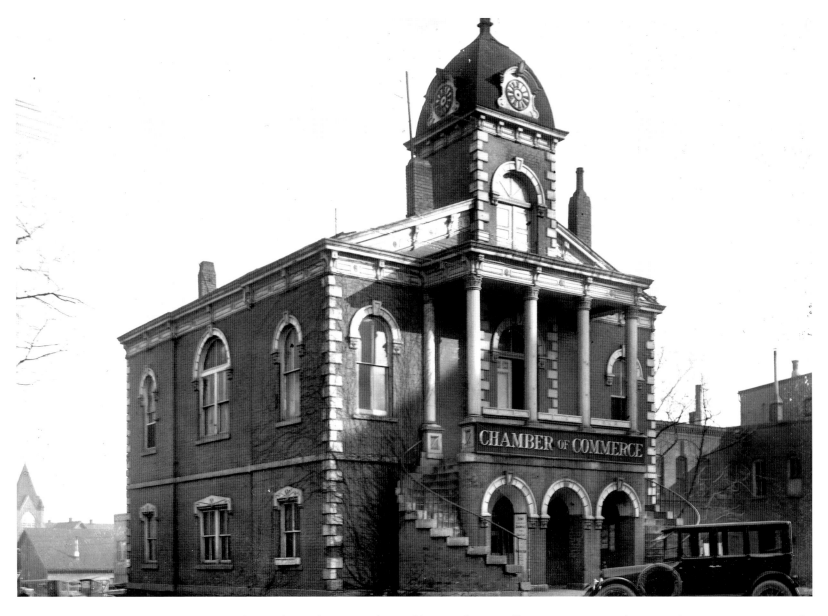

COURTHOUSE AND RECORD BUILDING. The South Carolina General Assembly created Greenville County in 1786 and appointed nine county justices. The site of the first court sessions is unclear and a matter of dispute. Eventually a courthouse was constructed on land belonging to Lemuel Alston in the middle of what is today called Court Square on Greenville's current South Main Street. In 1822 construction of the graceful building shown above was begun. It was undoubtedly Greenville's most notable architectural landmark. Later, when a new courthouse was completed in 1855, this building was used to house county records and also offices for the chamber of commerce. The Second-Empire-style cupola was added in the latter part of the 19th century. Robert Mills, the United States's first professional architect and a South Carolina native, is reputed to have been the architect. The building was thoughtlessly demolished in 1924 to build a multi-story office building. This act of destruction did not go unnoticed or unchallenged. The Upper South Carolina Historical Society was formed in 1928 to work for historical preservation. This organization later evolved into the Greenville County Historical Society.

Beyond the Record Building, on the left, is the John Wesley Memorial Methodist Church, which was built in 1900.

SOUTH MAIN AND AUGUSTA STREETS

After the American Revolution, Lemuel Alston purchased 11,028 acres in the heart of the future city of Greenville. Most of this land had been confiscated during the Revolution from Richard Pearis, a supporter of the British cause. In 1799, on high ground, Alston built an impressive mansion and named it Prospect Hill. In 1797 Alston laid out 52 lots centering on what is Court Square on South Main Street today. The principle road (later Main Street) was labeled simply "the Street." Leading from the Street to Prospect Hill was "the Avenue" (later McBee Avenue). In 1815 Vardry McBee bought the land and Prospect Hill from Alston. The avenue leading from the house to the village was renamed for him.

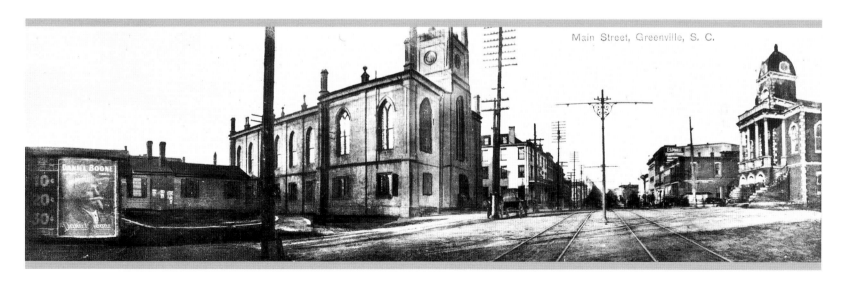

MAIN STREET, *C.* 1900. Greenville's third courthouse was located across Main Street from its predecessor. Constructed in 1854–1855 in the Gothic style, the building featured arched windows, a tower, and simulated corner turrets. The courtroom had space for 500 persons, about half the voting population of the county. The original state appropriation of $8,000 proved inadequate and had to be supplemented by an additional grant of $14,000. When still another courthouse was constructed in 1916–1917 on the same site, this Gothic building was demolished. The Mansion House, Greenville's earliest hotel, is seen on the left just above the courthouse. The view up Main Street shows Greenville's emerging business district. Trolley tracts run down the middle of South Main Street.

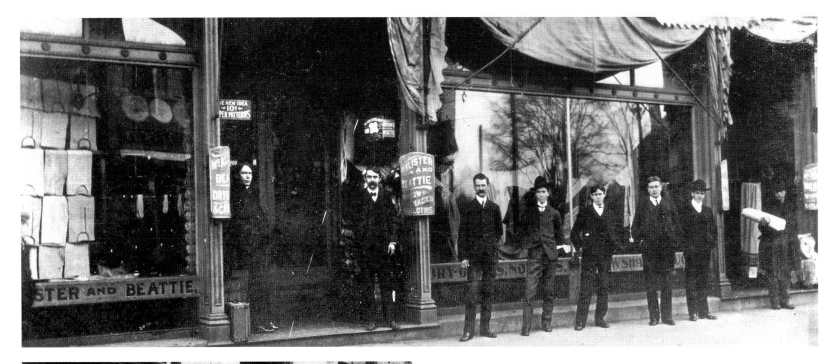

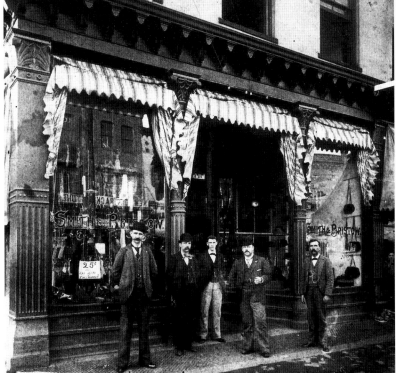

MCALISTER AND BEATTIE. Around the turn of the 20th century, South Main Street was lined by a dwindling number of residences and a growing number of small stores that served the retail needs of the expanding community. Located at what was then 204–206 South Main Street, McAlister and Beattie was one of the largest of these. Charles McAlister moved to Greenville from Charleston and established the business in 1886. In 1894 John E. Beattie, vice president of the National Bank of Greenville, became a partner. The store sold dry goods, carpets, mattings, notions, window shades, and other household goods. By the first decade of the 20th century, the business had 14 assistants and promised the customer prompt attention.

SMITH AND BRISTOW CLOTHING COMPANY. A purveyor of men's furnishings, Smith and Bristow opened in 1891 at the northwest corner of Main and Washington Streets on the future site of a Woolworth's store. Alonzo A. Bristow, a co-owner along with Jesse R. Smith, was one of Greenville's leading merchants. After the Greenville Board of Trade closed during the Panic of 1893, Bristow was instrumental in reviving this businessmen's organization in 1901. He served as president of the board along with the vice president, Alister G. Furman. In 1912 the Board of Trade affiliated itself with the new state-wide chamber of commerce network. Both Bristow and Jesse Smith were also involved in the construction of the Ottaray Hotel.

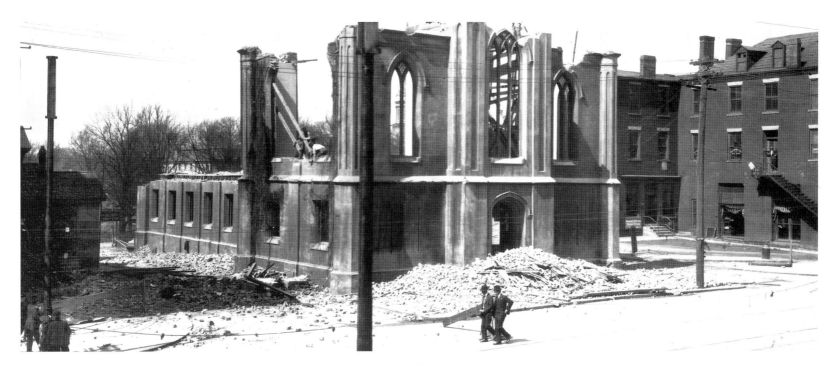

COURTHOUSE DEMOLITION AND REBIRTH. By the first decade of the 20th century the 1855 courthouse had become inadequate for the needs of a growing city. The gothic-style building, with its arched windows, was torn down to make room for the construction of a new building in 1916–1917. Two architects participated in the new design: Thornton Mayre of Atlanta and Greenville architect H. Olin Jones. Mayre was one of the architects of Atlanta's Fox Theater. The contractor for the cream-brick building was the firm of J.A. Jones from Charlotte. At the time the new courthouse was first occupied in January 1918, it was surrounded by "a brood of dinky little wooden law offices," according to Greenville News columnist C.A. David.

On the right in both these views, the Mansion House is seen in its last days. The completion of the Ottaray Hotel in 1909 doomed the aging hostelry. After the hotel closed in 1910, the building was renamed the Swandale Building and adapted for stores and offices.

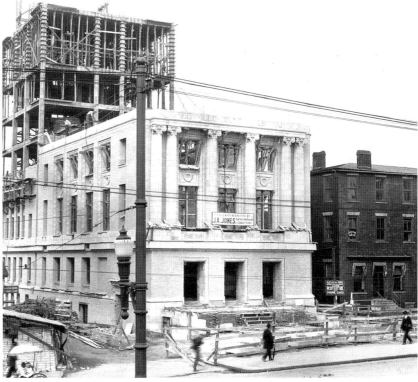

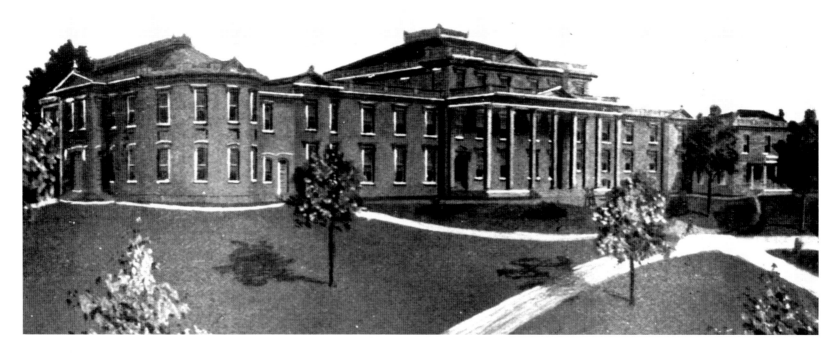

CHICORA COLLEGE. A Presbyterian college for women was established in Greenville in 1893. Two years later the impressive building shown above was constructed on McBee Terrace overlooking the Reedy River and South Main Street. The main building would eventually become more imposing with the addition of a dome over the entrance portico. The college was in Greenville for only 22 years. After it moved to Columbia in 1915, its building was transformed into a movie theater before being destroyed by fire in 1919.

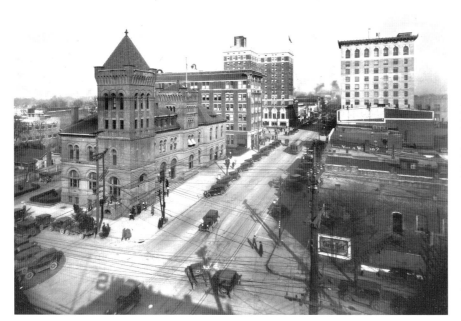

POST OFFICE/CITY HALL. The post office was built in the Romanesque-revival style in 1892 on the northwest corner of Main and Broad Streets on a site once occupied by the home of Col. David Hoke. This was truly one of Main Street's most monumental structures. After the construction of a new post office on East Washington Street, the building became Greenville's City Hall in 1938. The city gave the Washington Street property to the federal government in exchange for the old post office. After serving as a city hall for 35 years, this Greenville landmark was demolished in 1972. On its site, a parking garage was built to the left of a modern, high-rise city hall.

Just above the post office is the multi-storied Masonic Temple. Built in 1910, the building supplied the growing need for office space. The Masonic Temple was demolished in the early 1970s. Greenville's new City Hall was built on its site.

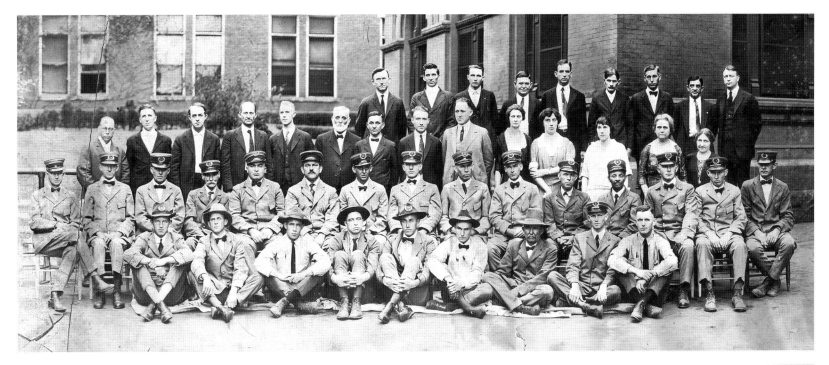

POSTAL WORKERS. This scene, which dates from about 1924, was taken at the rear of the post office. The side of the Masonic Temple is in the left background. Each postman has a number on his cap representing the number of his mail route. Postmaster Charles Withington is on the far right of the fourth row.

SOUTHEASTERN LIFE INSURANCE COMPANY. As Greenville's economic development continued, the city became the home of three insurance companies in the early 20th century. Although originally organized in Spartanburg, the Southeastern Life Insurance Company was reorganized and relocated to Greenville in 1910. Oregon Lawton Jr., who was chief executive officer, played a primary role in bringing the company to Greenville. Among other Greenville business leaders associated with the company were William Sirrine, Lewis Parker, Eugene A. Gilfillin, Harry J. Haynsworth, and Frank Hammond. In 1915 the company occupied its new headquarters on the southwest corner of Main and Broad Streets. The company's logo, a gladiator, was displayed on a large illuminated sign on the roof of the building, which was located on the future site of the Peace Center.

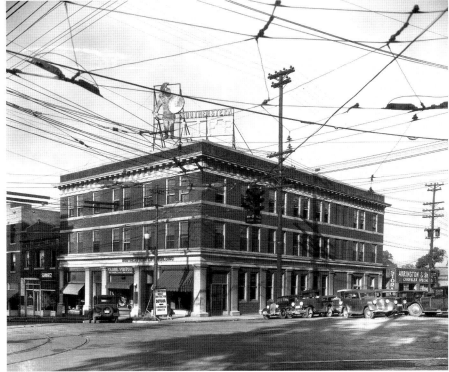

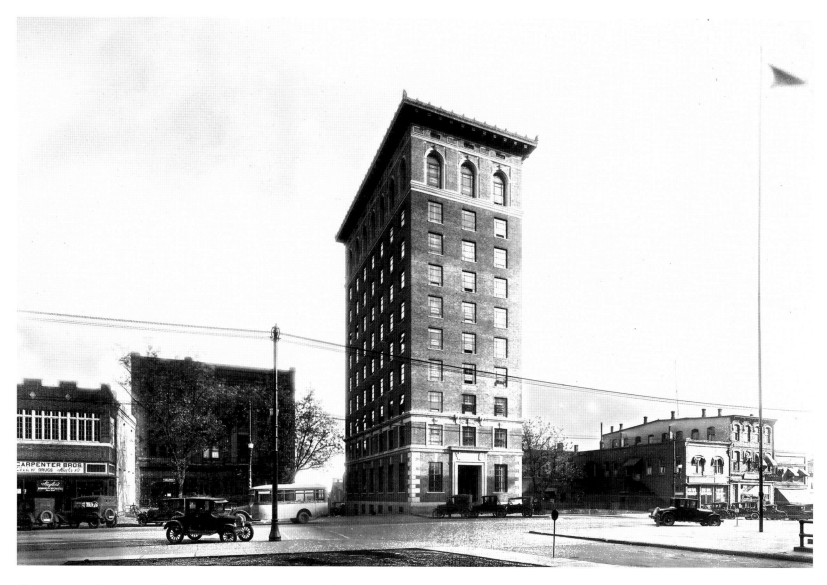

CHAMBER OF COMMERCE BUILDING. Court Square on South Main Street underwent extensive rebuilding in the mid-1920s. After the demolition of the 1822 courthouse/Record Building, a ten-story office building was erected on the site at a cost of $250,000. This skyscraper came to symbolize the "New Greenville." At the top, the building was crowned by an elaborate cornice. The ground-floor facade was decorated by stone quoins at the corners. The chamber of commerce was housed on the first floor. The remaining floors were rented out as offices, and the Haynsworth Law Firm occupied the top floor. When the Depression hit, the chamber of commerce lost ownership. The building then became the home office of the Liberty Life Insurance Company, organized in 1919 by W. Frank Hipp. Within ten years, Liberty Life ranked ninth in the nation in the number of policies written annually. Policies, carrying a premium of two cents a week, were sold door-to-door.

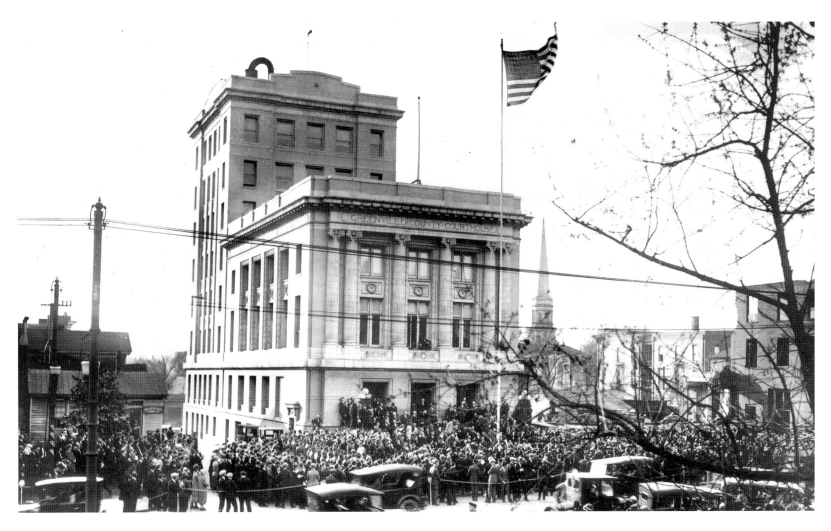

FLAGPOLE DEDICATION, 1924. The 1917 courthouse was in the Beaux Arts style that was popular in the early 20th century. The massive Ionic columns were a dominant feature of the building's facade. An office tower rises in the back. To the left of this view residential property stills survives on this stretch of South Main. To the right of the courthouse, the spire of the First Baptist Church can be seen on McBee Avenue. On the far right, the Mansion House has lost its battle to survive and is shown under demolition to make way for a modern hotel. By this time Court Square had become a rallying place for Greenvillians. The flagpole dedication was perhaps a carry-over of patriotic fervor from World War I.

The 1917 courthouse would be more fortunate than the Record Building across the street. After the construction of a new courthouse on East North Street in the 1950s, the old courthouse housed county offices and the Museum of Art. Later it became abandoned and derelict. By the beginning of the 21st century it was regarded as the most historic public building still standing on Main Street. Fortunately, by this time, Greenville's leaders were becoming more aware of what had already been lost. In 2002–2003, the 1917 building was extensively renovated and converted to office space. Although the interior was altered, the historic exterior was preserved.

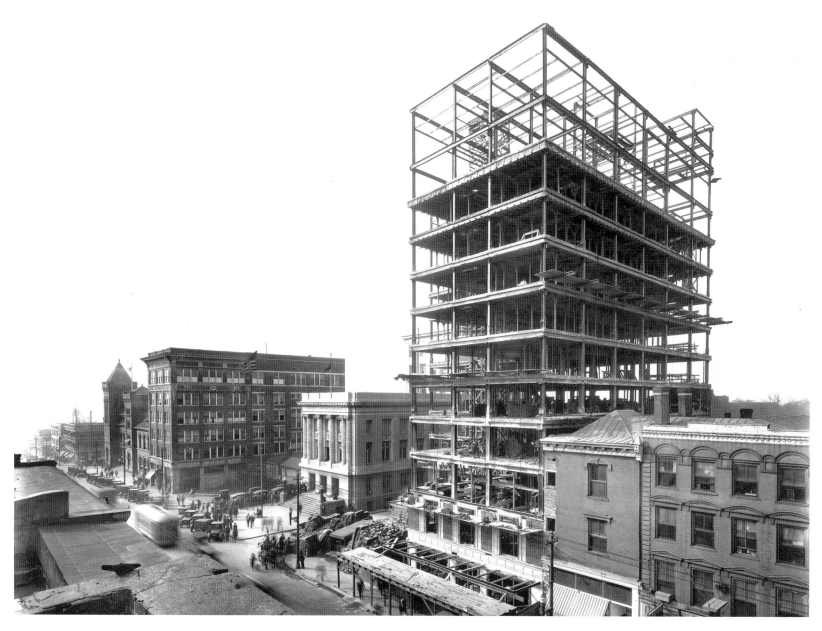

THE POINSETT HOTEL UNDER CONSTRUCTION. Another symbol of the "New Greenville" of the mid–1920s was the Poinsett Hotel. Named for a nationally prominent Lowcountry visitor to the village of Greenville, Joel R. Poinsett, the hotel occupied the site of the demolished Mansion House. The new hotel was built by a corporation formed by John T. Woodside and William Goldsmith. The New York architect W.L. Stoddard was hired to form the design. Construction was carried out by the firm of Hunkin and Conkey from Cleveland, Ohio, at a cost of $1.5 million. Construction began in May 1924, with completion achieved by June 1925. At the time the hotel had 100 rooms. An addition to the rear later doubled the number of rooms.

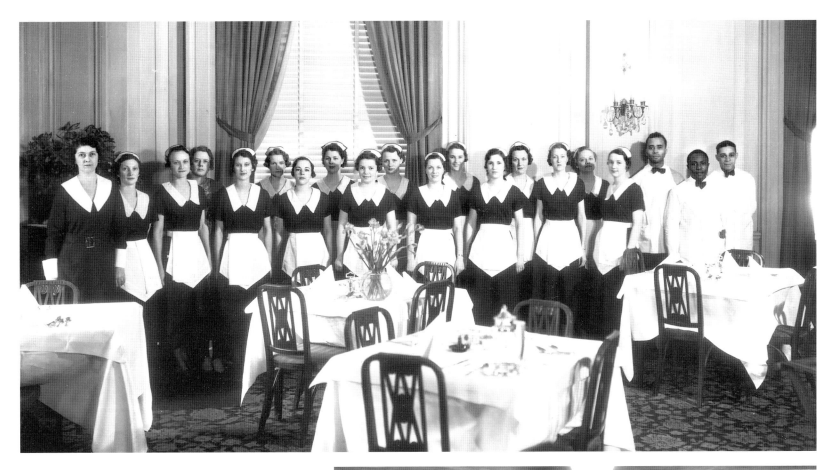

THE POINSETT DINING ROOM AND RECEPTION STAFF.
The Poinsett quickly became known nationally for the quality of its accommodations and especially for its service. Contributing much to this reputation was the dining room, an impressively large room with a high ceiling. When guests sat at their table, each place was set with a striking porcelain plate whose center decoration was, appropriately, a poinsettia. No food ever soiled these plates. When the meal was served, they were whisked away and the food served on different plates. The Poinsett Dining Room was especially famous for its spoon bread, which was often served by an African-American woman dressed, as was the custom of the time, as a "mammy."

The view of the dining room staff shown above demonstrates the social hierarchy maintained in such institutions. At the top of the totem pole was a matronly hostess clothed in a day dress. The lesser position of waitress was held by younger women dressed in uniforms. Separated to the left were the African-American bus boys.

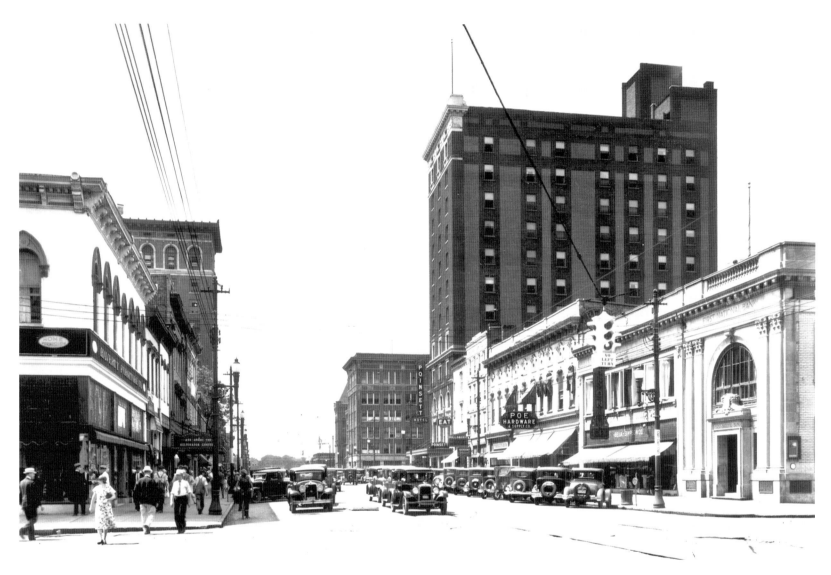

COURT STREET TO MCBEE AVENUE, WEST SIDE. In this Main Street scene from the late 1920s, the Poinsett Hotel looms in the center with the Masonic Temple below it. Farther up is Poe Hardware and Supply Company, and to its right is Belk-Simpson Department Store. Belk's was founded by William Henry Belk and John Montgomery Belk of Charlotte. The first Greenville store was opened in 1916 as Belk-Kirkpatrick. In 1923 physician William D. Simpson, from Abbeville, bought the local partnership. The name was then changed to Belk-Simpson.

On the corner of Main and McBee is Greenville's first nationally chartered bank, the National Bank of Greenville, founded in 1872. Known by the time of this picture as the First National Bank of Greenville, it occupied an especially handsome building. Erected in the first decade of the 20th century, the bank building had a top balustrade, below which was a denticulated cornice and Corinthian pilasters. The bank officers were Hamlin Beattie, president, and J.E. Beattie, vice president.

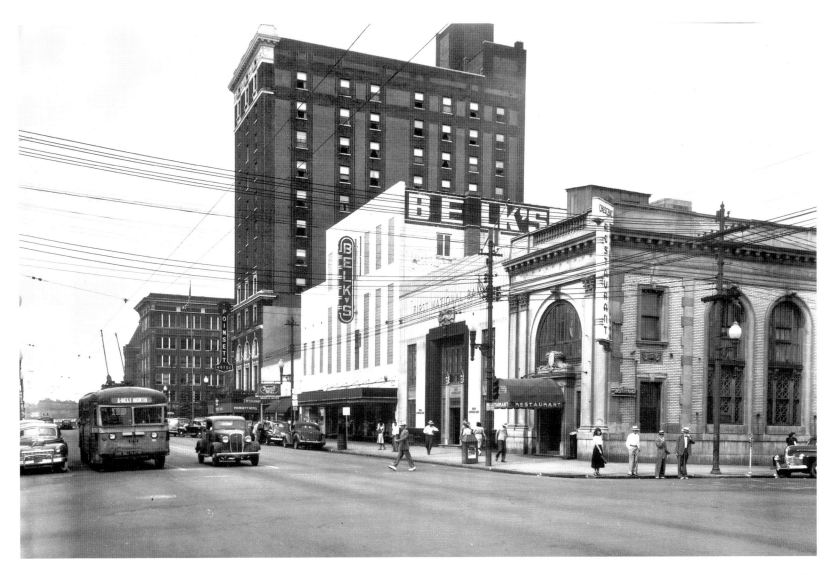

COURT STREET TO MCBEE AVENUE, WEST SIDE. The Main Street block shown on the previous page is seen here a decade or so later. Belk's has built a new building on the former site of Poe Hardware. The First National Bank now occupies a new Art Deco building (*c.* 1930) on the former site of Belk-Simpson. The most striking feature of this scene is the transformation of the corner bank building into a restaurant, with a highly incongruous awning leading to the entrance.

In the 1940s the bank re-occupied the corner building and refaced it to blend in with its Art Deco structure. Unfortunately in the process, the handsome corner building lost all of its exterior decorative features. Later, the expanded bank building and the Belk site were occupied by the Carolina First Bank.

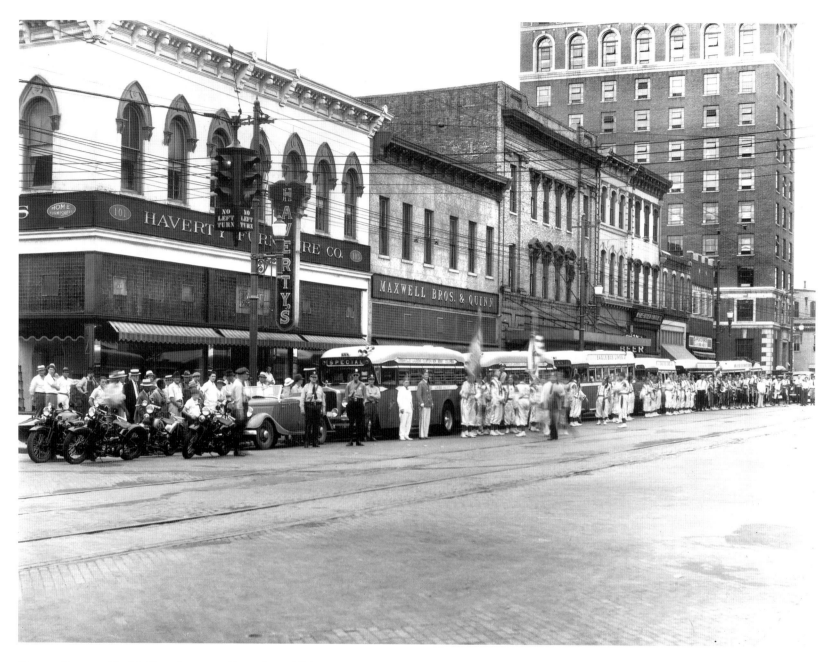

COURT STREET TO McBEE AVENUE, EAST SIDE. This scene moves across Main Street from the block shown on the previous two pages. On the southeast corner of Main Street and McBee Avenue is the Haverty Furniture Company. Next door is Maxwell Brothers and Quinn. Kirby Quinn was the Greenville partner in this national chain. At the southern end of the block is Carpenter Brothers Drug Store, and across Court Street rises the Liberty Life Building. The crowd gathered here seems to be preparing to participate in a parade.

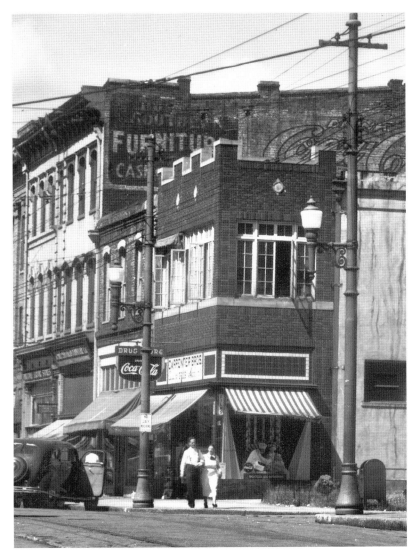

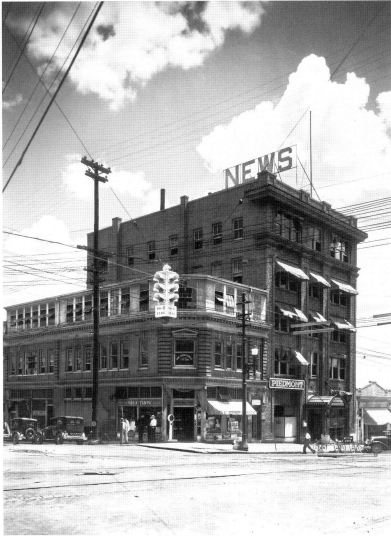

CARPENTER BROTHERS DRUG STORE. In 1883 Alfred Baxter Carpenter opened a drug store in Pelzer. He and his brother, John Lee Carpenter, moved to Greenville and bought the Mansion House Drug Store in 1889. When Thomas Summerfield Carpenter and Walter Brown Carpenter joined their brothers in the business, the name was appropriately changed to Carpenter Brothers Drug Store. For nearly 30 years, the business remained on the west side of Main Street beside the Mansion House Hotel. After moving across to the east side of Main (this photograph), Carpenter Brothers became a Greenville institution and community center, which continued in operation under three generations of brothers until 1996. In 2002 Meador's Sandwich Shop acquired the building and resumed the tradition of community center. The building retained its original mahogany cabinets.

GREENVILLE NEWS BUILDING. The Greenville News Building was constructed in 1914 and dominated the eastern side of the block south of Broad Street. The *Greenville Daily News* had been established in 1874 by A.M. Speights and was published in both daily and weekly editions. Bony Hampton Peace operated a printing business in Spartanburg before moving the operation to Greenville. In 1916 he became business manager of the newspaper and acquired controlling interest in 1919, changing its name to the *Greenville News*. Within 10 years he transformed a languishing newspaper into a leading publication with a daily circulation of 31,000. In 1927 Peace acquired an evening paper, the *Greenville Piedmont*, and added it to his operations. In the 1970s the buildings in this photograph were demolished to make room for the newspaper's new home.

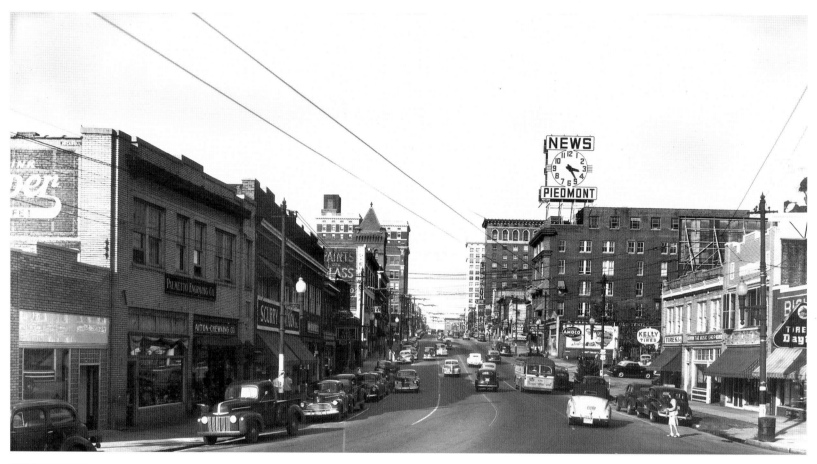

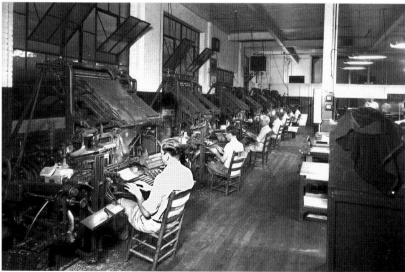

SOUTH MAIN STREET, BELOW BROAD. The News-Piedmont Building became an even more dominant feature of the South Main Street skyline after the erection of a large clock on its roof in 1947. Bony Hampton Peace's three sons, B.H. Jr., Roger, and Charlie, joined their father in the newspaper business and made the newspapers a significant feature of life in the community. The early type-setting machines (shown left) were operated by hand.

The Peace family did not confine itself to the newspaper business. In 1933 they established Greenville's first radio station, known by the call letters WFBC. They had purchased the station license after it was relinquished by the First Baptist Church of Knoxville, Tennessee. Thus, the call letters stood for "First Baptist Church," though many in Greenville thought it was for "Watch Furman Beat Clemson." In 1953 WFBC-TV broadcast its first program. Soon other newspapers and stations were acquired. In 1968 the newspaper and broadcasting operations were combined into Multimedia, Inc.

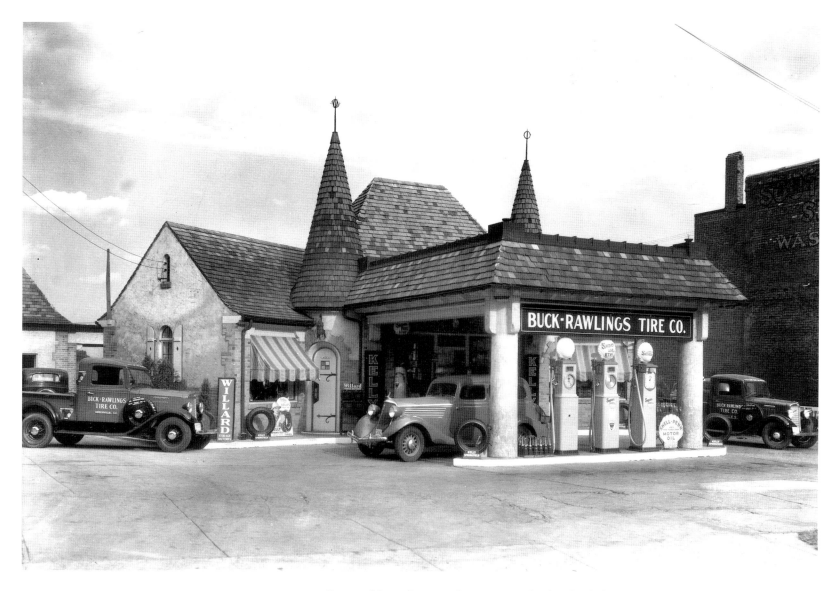

SOUTH MAIN SERVICE STATION. In the first half of the 20th century, downtown Greenville had numerous gas and service stations, many of which were architecturally significant. One of the most whimsical was located below the News-Piedmont Building on South Main Street. A distinctive feature of this station was the location of rest rooms for men and women at corner angles with cone-shaped roofs. The station was recessed from Main Street to provide space for vehicles. Its location is marked on the previous page in the upper picture by the oval Kelly-Springfield Tire sign on the right side.

Buck-Rawlings Tire Company was owned by William F. Buckingham and John W. Rawlings, distributors of Sinclair petroleum products and Motorola radios for automobiles. Later the station was operated by Tires, Inc., which also had an automobile supply store in the adjacent building on the right and a tire recapping plant.

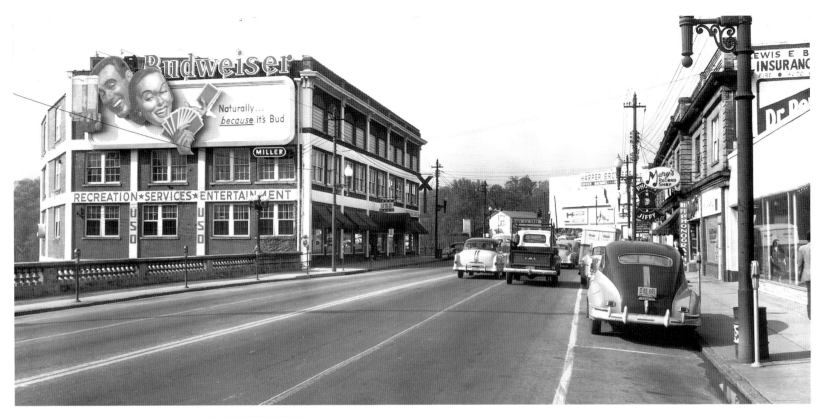

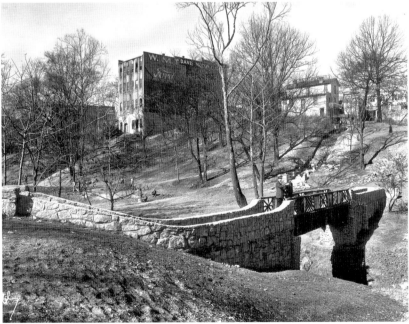

MAIN STREET BRIDGE AND COTTON WAREHOUSE. By the second decade of the 20th century the older bridge across the Reedy River on South Main Street had become unsafe for the increasing number of automobiles. A new bridge, with a decorative balustrade, was built in 1911. Just across the bridge on the left was a large fireproof cotton warehouse built by mill owner and banker Walter L. Gassaway and Dr. Davis Furman. This large structure was built about the same time as the new bridge and has gone through several reincarnations. During its early years it was also the location of the Coca-Cola Bottling Works and the Crescent Grocery Company, and later the Meador's Manufacturing Company. During World War II and its aftermath, troops from the Greenville Army Air Base and its successor, Donaldson Air Force Base, frequented the businesses of Greenville's West End. The Furman-Gassaway Building became the home of the local United Services Organization. Later the former warehouse came into the possession of the Traxler Realty Company and became known as the Traxler Building.

REEDY RIVER PARK. In the 1930s the area behind the South Main Street businesses remained an attractive park but later deteriorated. Uphill can be seen the future Harper Brothers building and Falls Cottage.

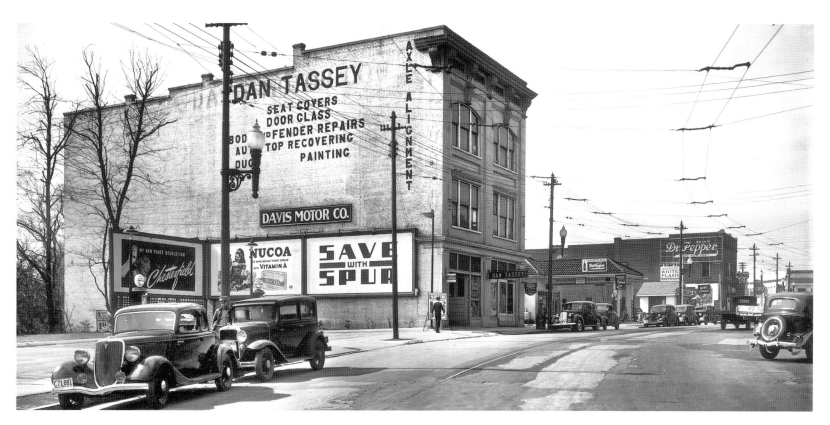

MOTOR MILE. As the number of cars grew rapidly in Greenville after 1910, new businesses sprang up to meet the demand. The West End's "skyscraper" (above left) was built in 1916 as the home of W.M. Thompson's T-Model Ford Agency. Service stations, automotive stores, and more dealers located in the area and on Augusta Street to create Greenville's first "Motor Mile." Later Dan Tassey operated an automotive store in the Thompson building. Toward the end of the 1950s Harper Brothers Office Supply occupied the building.

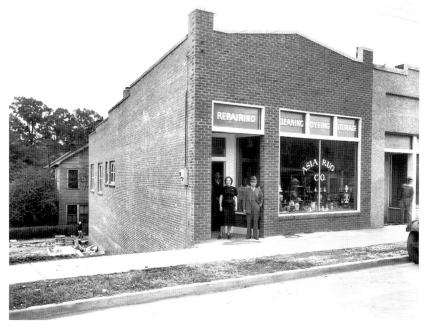

ASIA RUG COMPANY. By the 1940s new stores were opening in the West End. The Syrian-born Charles E. (Charlie) Saad was a respected dealer in oriental carpets. The Asia Rug Company was first located at 227 Augusta Street and later relocated to South Main.

The importance of the West End to Greenville's heritage was recognized in 1993 when the West End Historic Commercial District was placed on the National Register of Historic Places.

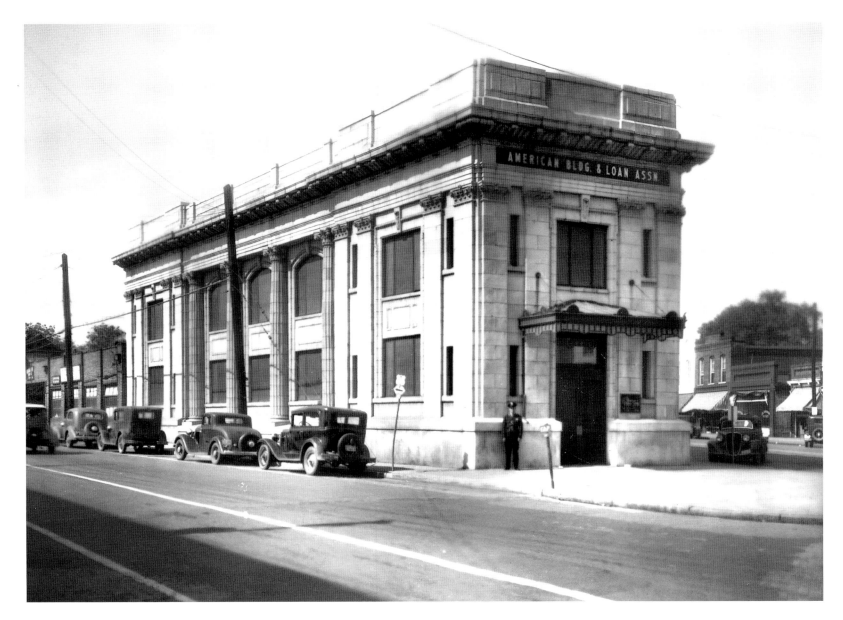

THE AMERICAN BANK. The West End acquired its own bank when Walter L. Gassaway, Henry Briggs, and R.E. Allen organized the American Bank in 1890 and occupied a triangular lot at the intersection of Augusta and Pendleton Streets that had once housed a drug store. About 1905 the bank put up a new building on the same site in the Beaux Arts/neoclassical style. In 1920 the bank reorganized itself as the American Building and Loan Association with Bennette E. Geer, president of Judson Mill, as its president. Although the institution survived the first onslaught of the Depression, its name was changed in 1936 to Fidelity Federal Savings and Loan. In 1939 the renamed institution abandoned its West End location. Its departure signaled a decline of the West End as both a commercial and residential area.

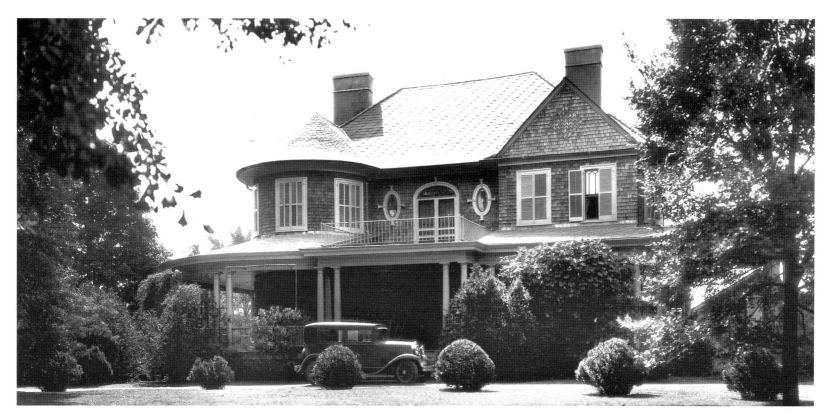

THE OTIS P. MILLS HOME. Beyond the West End business area, substantial homes lined both Augusta and Pendleton Streets. Otis Prentiss Mills and Susan Cordelia Gower Mills built their home in 1900 in the Queen Anne style of Victorian architecture. Located on Mills Avenue, just off Augusta Street, the home was typical of the residences that abounded in the area. O.P. Mills was the founder of Mills Mill. Parked in front of the mansion is a Whippet automobile. Manufactured by the Wyllis Overland Company between 1927 and 1934, the Whippet was so named because of its small size and its speed capability.

CLAUSSEN'S BAKERY. Located on Augusta Street near the West End business district was Greenville's most aromatic business. The large bakery supplied bread and cakes to most of the grocery stores in the county. Claussen's was also the manufacturer of cookies for the Girl Scouts' annual fund-raising sale.

Augusta Street had first developed along one of the early trade roads used by Greenville's earliest European settlers. The town of Augusta was the most accessible port at the time to the early village of Greenville.

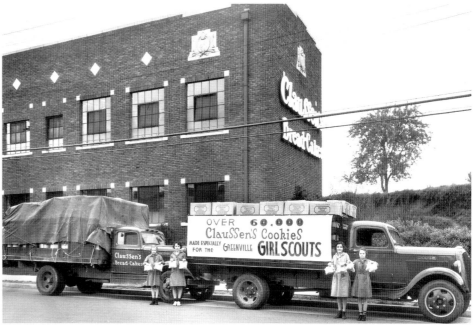

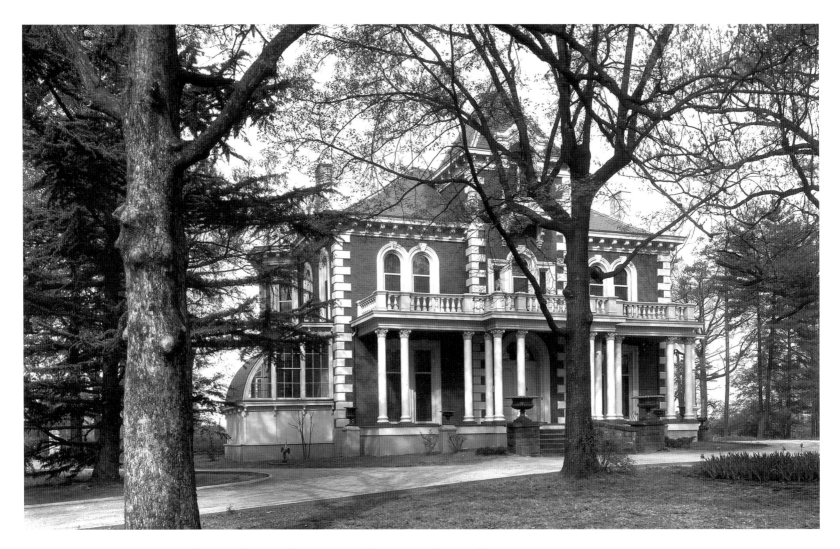

THE WILLIAM AND HARRIET WILKINS HOUSE. The grandest of the Augusta Street residences was that built by William and Harriet Cleveland Wilkins in 1868–1869. The house was designed in the Second Empire style, a popular Victorian design borrowed from the French during the reign of Napoleon III. A typical feature of this style is the mansard roof. Wilkins was a successful business man who was active in the development of Greenville. He was the partner of Nelson C. Poe in Wilkins, Poe and Company Hardware. In 1879 he and several associates built an opera house on the corner of Main Street and McBee Avenue. Unfortunately this auditorium burned a few months after its completion. Wilkins also served on the board of directors of the *Greenville Daily News.* William Wilkins died in 1895. Harriet Wilkins, 18 years her husband's junior, survived him by 35 years and continued to live in the house until her death in 1930. The house was then leased by her heirs to R.D. Jones and used as a funeral home until the 1990s. Jones had previously been associated with Thomas McAfee in the funeral business. The house survived at the beginning of the 21st century as a commercial site and retained its marble mantels and elaborate interior decoration.

NORTH MAIN STREET

Washington Street forms the traditional boundary dividing North and South Main Streets. For reasons of space and organization, the block between Washington and McBee Avenue is also included in this chapter. Greenville's first commercial district was concentrated along South Main Street. North Main was predominantly residential. During the late 19th century and first decades of the 20th century, the commercial district gradually crept northward above Washington Street. By 1930 North Main had become the most desirable location for a business. The residential district was pushed farther north beyond College Street.

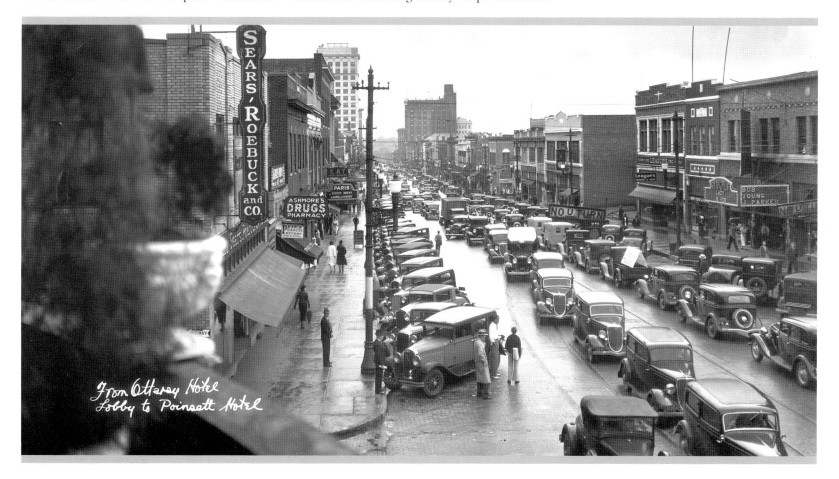

FROM THE OTTARAY TO THE POINSETT. William Coxe took this picture from the balcony of the Ottaray Hotel. It shows North and South Main Streets down to the Poinsett Hotel and is labeled "Christmas 1920s." Perhaps the season accounts for the heavy traffic. In December 1926 Main Street merchants organized Greenville's first Christmas parade. Sears-Roebuck stands at the head of North Main. Across the street is the Rivoli Theater.

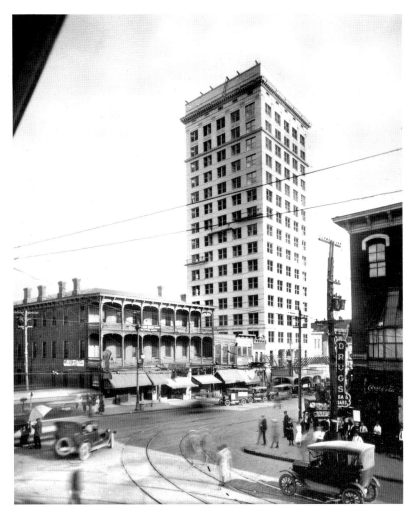

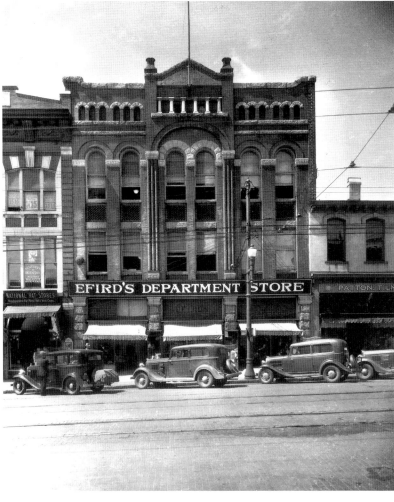

WOODSIDE BUILDING. The most dramatic product of the building boom of the 1920s was completed in 1923. With 17 floors, the Woodside Building was the tallest in South Carolina at the time. Its roof garden became the scene of social events. The skyscraper was financed by the Woodside Securities Company, in which the brothers John T. and Robert I. Woodside were associated along with two of their other seven brothers, J.D. and Edward Woodside. The Woodside Securities Company fell victim to the Depression after 1929. Eventually the South Carolina National Bank acquired possession of the skyscraper and renamed the building after itself.

In this photograph from the 1920s the building with the verandas on the corner of Main and Washington Streets is the old Goodlett House Hotel. During the Civil War it was used as a hospital for Confederate soldiers. By the time of this picture, it was known as the Wilson Hotel. The ground floor was occupied by stores.

EFIRD'S DEPARTMENT STORE. The true eclecticism of Victorian architecture is exhibited in the Efird Building's elaborate facade. Built about 1885 in the Romanesque Revival style, the building features arched windows and brick pilasters. The interior still retains the original tin ceilings. After Efird's closed, the Dollar Store occupied the building. Next door on the right is Patton, Tilman and Bruce Shoe Store.

Although this building was already out of date when the Woodside Building was constructed across the street in the 1920s, the Efird Building has survived and remains one of the oldest structures of significance on Main Street. The Woodside Building was less fortunate. A child of the building boom of the 1920s, it was the victim of the building boom of the 1970s. In that decade Greenville's central business district was being rebuilt as a part of a total development plan. The old Woodside Building was demolished and replaced by a new 10-story South Carolina National (SCN) Bank Building in 1973. SCN later became part of Wachovia Bank.

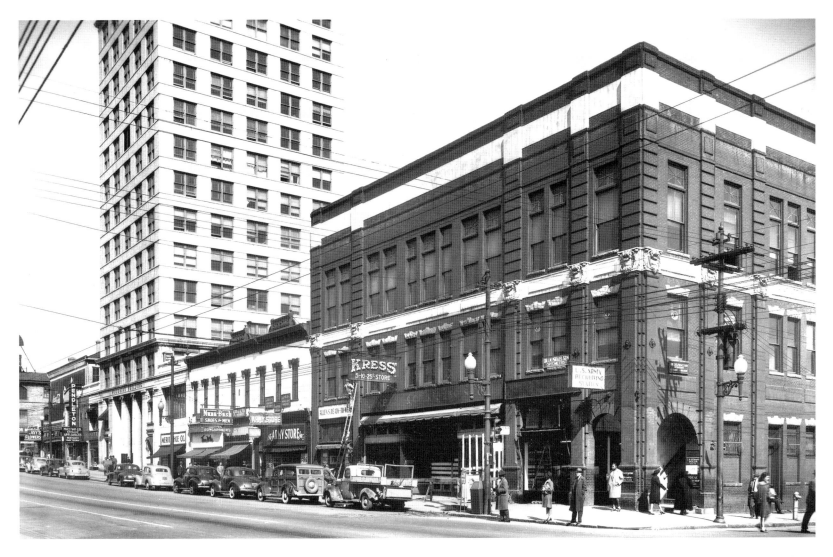

THE CLEVELAND BUILDING. The Cleveland Building was constructed about 1910 on the northeast corner of Main Street and McBee Avenue. It occupied the site of the home of Jeremiah and Sarah Cleveland, who were among the earliest inhabitants of the village of Greenville. Jeremiah Cleveland came to Greenville from North Carolina about 1804 and bought several of the lots laid out originally by Lemuel Alston in the new village. He also acquired extensive farmland in the county and made a fortune from the operation of a general store on Main Street. In the 1820s the Clevelands built a house on the corner of Main and McBee. The home was constructed of brick with a Charleston-like two-story piazza facing Main Street. After Jeremiah's death in 1845, Sarah inherited the home. Following her death it continued to be lived in by several generations of the Cleveland family. By the beginning of the 20th century it was one of the few remaining residences on its end of South Main. About 1910 it was taken down and replaced by the Cleveland Building, occupied for many years by Kress's, and later by the Department of Social Services. It was demolished in 2002.

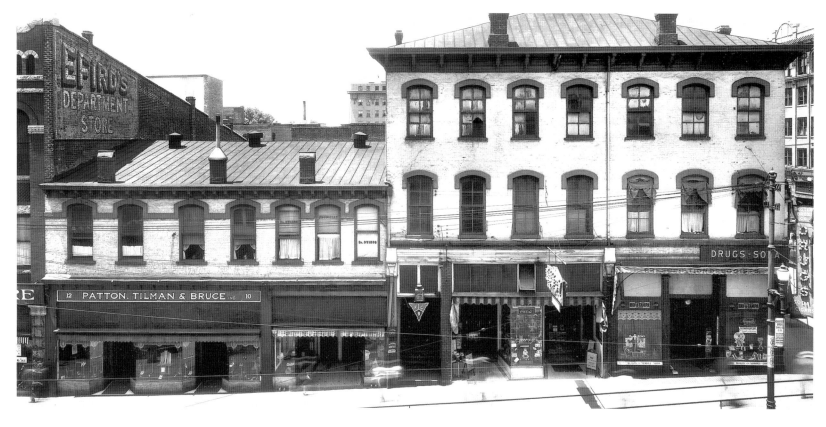

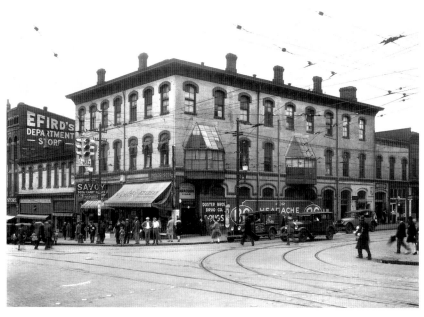

THE EMERGING CITY. Both of these views show the corner of South Main and West Washington Streets in the early 20th century. They illustrate the types of buildings that were being put up on Main Street during this period, as well as in the late 19th century. At the far left is the Efird Building. Next to it is a two-story building with a seamed metal roof that was the first location of Greenville's quality shoe store, Patton, Tilman & Bruce. Later Patton, Tilman & Bruce would move two blocks north into a new building. The next prominent occupant of this building was Hale's Jewelers. Just above the roof line can be seen part of the new Imperial Hotel, built on West Washington Street in 1912. Later this seven-story hotel would be renamed the Hotel Greenville.

The three-story building on the right in the top photograph (and in the bottom photograph) is the Mauldin Building, which had projecting glassed-in bays on the Washington Street side. Various offices occupied the top floors. In the corner store is Doster Brothers and Company Drugs, owned by J.B. Bruce and the brothers J.T. and O.L. Doster. To the left of Doster Brothers, occupying only one bay, is the New York Shoe Shine Parlor. Below the shoe shine parlor is the Savoy Soda Fountain. In between the Savoy and Patton, Tilman & Bruce, Abraham Katz sold clothing.

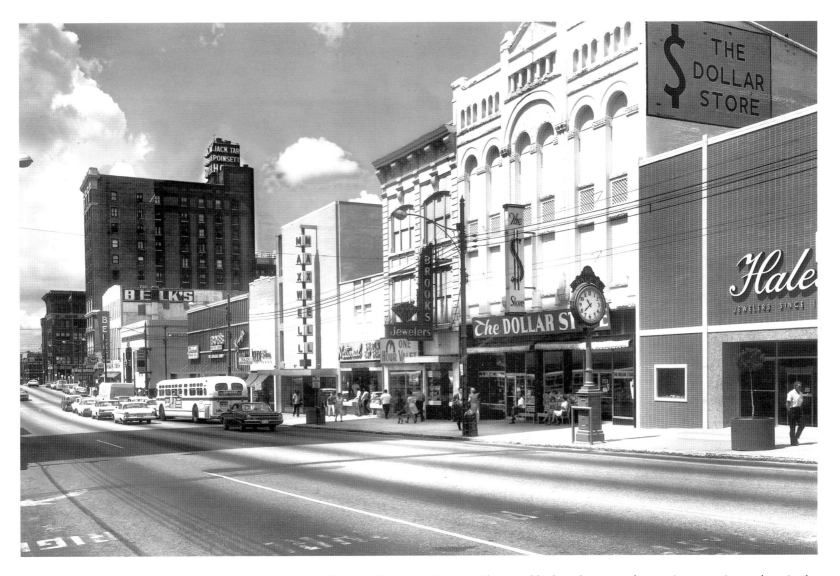

HALF A CENTURY LATER. The same block as shown on the previous page is seen here in the 1960s. The view looks south from Washington Street toward McBee Avenue and beyond. Patton, Tilman & Bruce's location has been replaced by a new building occupied by Hale's Jewelers. The ornamental clock, a reminder of Main Street's 19th-century heritage, was moved from a block north. The 1885 Efird Building, now occupied by the Dollar Store, survives, as does its smaller neighbor to the south. In the 1960s, beyond this point, the entire southern end of the block consisted of new construction.

In the next block, south of McBee Avenue, the First National Bank has re-occupied its original corner building and refaced its exterior. The Belk-Simpson Department Store remains on Main Street, with a satellite store at the McAlister Square mall. Beyond, the Poinsett Hotel, now a part of the Jack Tar hotel chain, struggles to survive in a time of declining occupancy for downtown hotels.

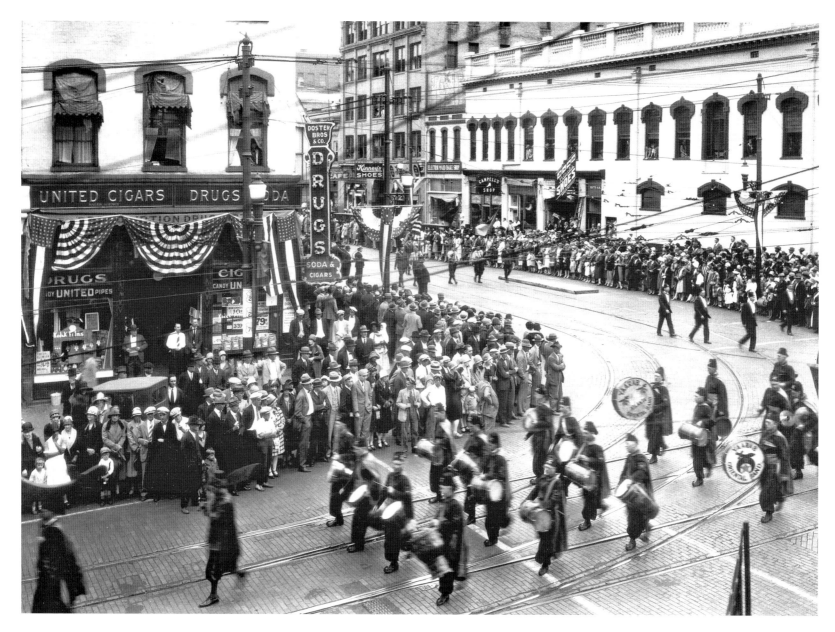

SHRINERS' PARADE. The Shrine Band participated in most Main Street parades. In this photograph, possibly taken about 1930, the band is coming out of West Washington Street and turning down South Main. Considering the patriotic banners on the front of Doster Brothers Drugs and the lampposts, this parade might have been in celebration of Armistice Day or the Fourth of July. To the left is the side of the Beattie Building. The decorative hooded moldings over the windows were a prominent feature of the building's exterior. Campbell's Shoe Shop both repaired and shined shoes. Later it relocated to East North Street. Before the day of no-care, non-repairable shoes, shoe-care was still a viable business opportunity.

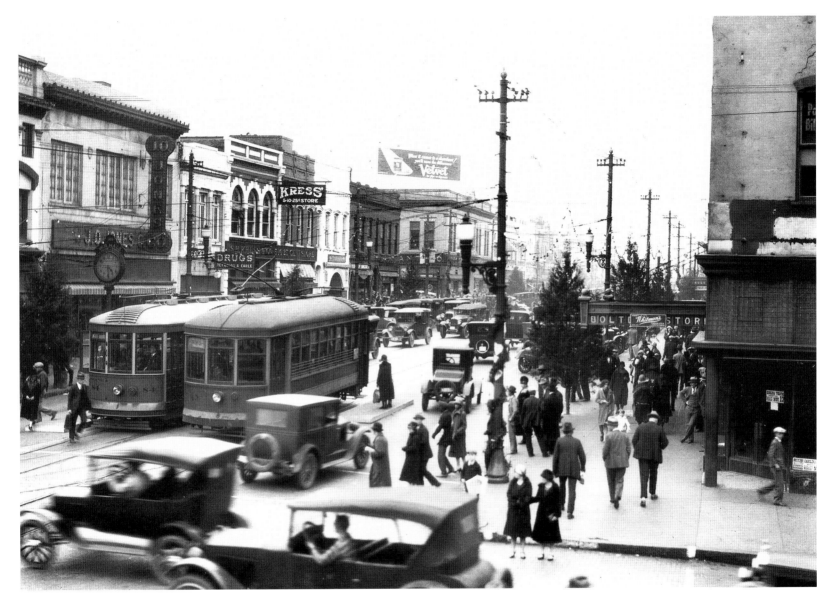

INTERSECTION OF MAIN AND WASHINGTON. This view looks north from Washington Street toward Coffee Street. By the 1920s electric trolley cars were a prominent feature of Main Street traffic. Main Street was also lined by decorative iron lampposts. An ornamental clock on a post was located in front of the J.O. Jones store. Later this clock would be moved a block south and, for many years, was in front of Hale's Jewelers.

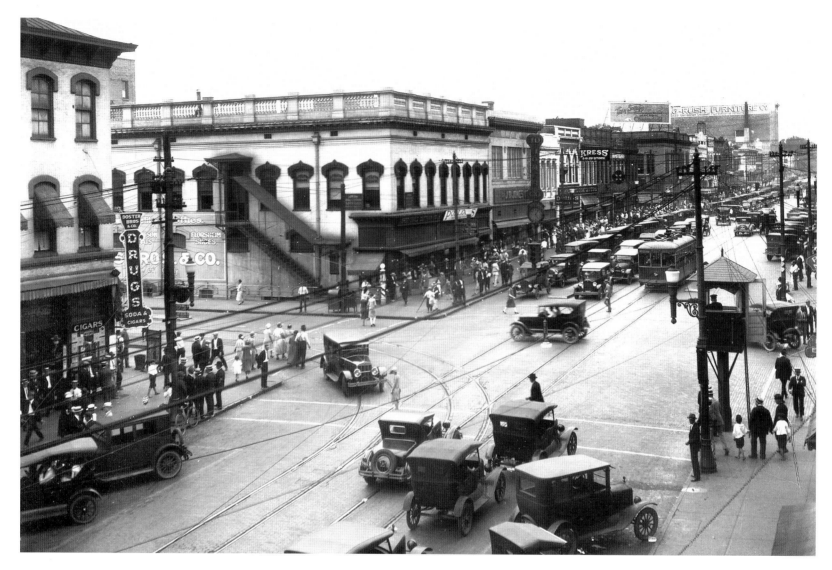

LOOKING NORTH FROM WASHINGTON STREET. The west side of North Main is shown between Washington and Coffee Streets. At the corner of Washington and Main is the Beattie Building, topped by a heavy balustrade and with outside stairs leading to the second-story offices. Occupying the corner store is Smith and Bristow Clothing Company. Woolworth's later occupied this corner. To the right of the Beattie Building is J.O. Jones Company, a furniture store in operation since the later decades of the 19th century. Occupying the middle of the block is the first Main Street location of S.R. Kress. Later Kress's would move a block south into the Cleveland Building. At the corner of Main and Coffee Streets (not clearly seen) is Bruce and Doster Rexall Drug Store, established in 1895. The president of this company (in 1921) was J.B. Bruce, who was also a partner in Doster Brothers Drugs a block south. Later these two stores would be consolidated and relocated next door to the Poinsett Hotel. At the far right, in an elevated hut, a warden oversees the traffic at this busy intersection. The trolley car tracts are visible in the street.

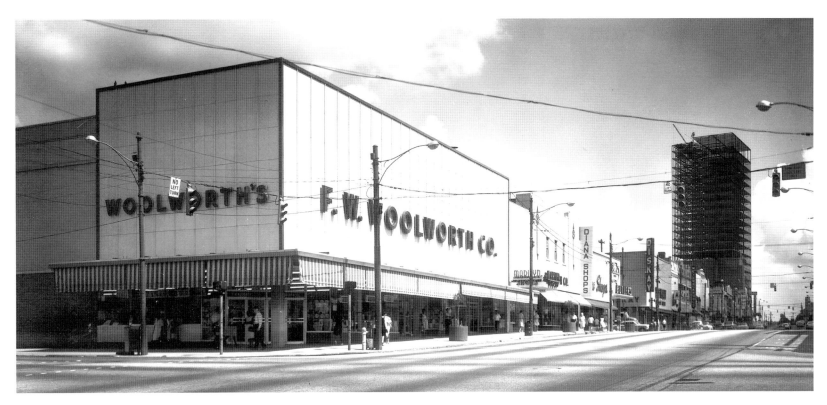

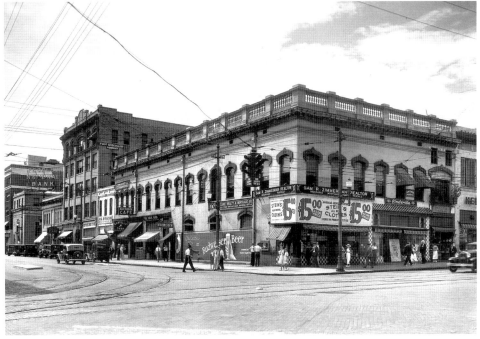

SAME BLOCK, ANOTHER DECADE. The top photograph shows the same block as shown on the previous page but updated to the mid-1960s. The Beattie Building on the corner of Main and Washington Streets has been replaced by a new building housing the F.W. Woolworth Company, which occupied this building in 1936. Woolworth's later closed in 1994. The decorative lampposts, in the previous scene, have been replaced by more functional lighting that harmonizes with the windowless, laminated architecture that replaced Main Street's 19th- and early 20th-century buildings. On the far right, the harbinger of Main Street's brighter future looms in skeletal form at the northern end of the business district. The Daniel Building was under construction from 1964 to 1967.

The bottom photograph from the early 1930s shows, once again, Woolworth's future site and offers a glimpse down West Washington Street. From the corner store, once occupied by the local clothing firm of Smith and Bristow, Stein's Clothes (a national chain) offers all-wool suits for $15. Doing business in the second-floor offices are Caine Realty and Mortgage Company and Sam R. Zimmerman Real Estate and Insurance. At the northwest corner of Washington and Laurens Streets (on the left in this view) is the Peoples' National Bank.

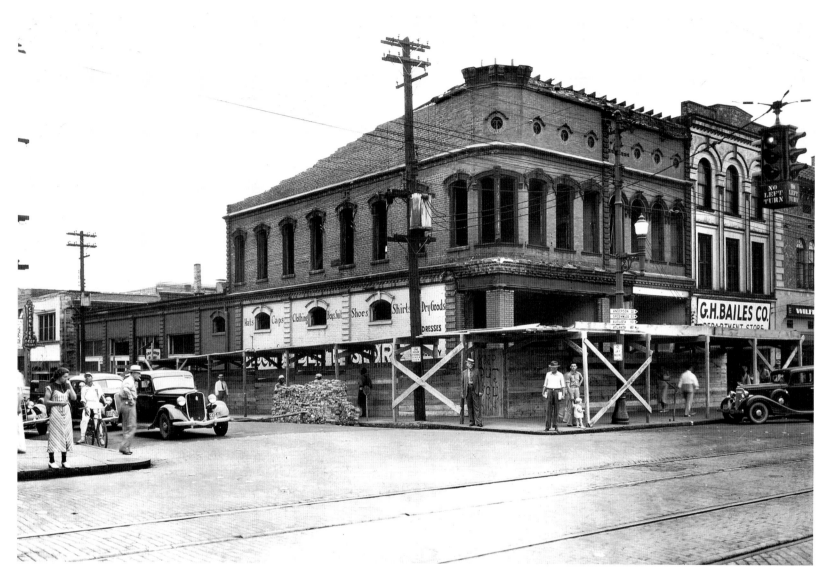

MAIN AND EAST COFFEE STREETS. Between 1900 and 1930 many of Main Street's remaining 19th-century commercial buildings were replaced by more functional structures lacking the ornamental details of their predecessors. A building boom in the 1920s followed World War I. During this rebuilding some older structures survived but had their facades significantly altered or covered over. At the southeast corner of Main and East Coffee Streets one of these buildings is seen under demolition to make way for a modern drug store. A common feature of many buildings of this period was the decorative cornices over the second-floor windows. Porthole-like windows ventilated the upper level of this structure. Accompanying the rebuilding of Main Street at this time was the replacement of locally owned establishments by regional and national chain stores.

Around the corner on East Coffee (far left) is one of downtown's longest-surviving businesses, Charlie's Steak House.

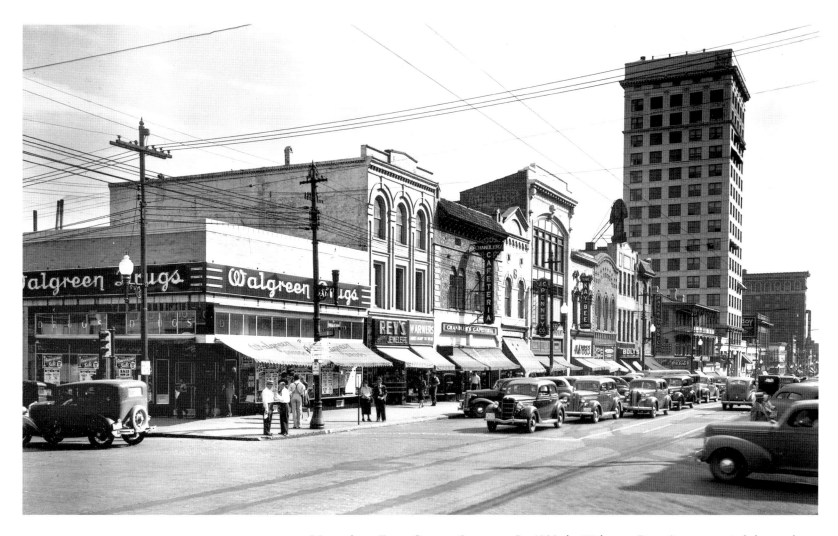

MAIN AND EAST COFFEE STREETS. By 1930 the Walgreen Drug Store occupied the southeast corner of Main and East Coffee. Its new building lacked architectural ornamentation but provided larger display windows. A dominant feature of the exterior was a large neon sign. Such signs were a hallmark of the new building era. Corner buildings were especially vulnerable to redevelopment. Below the Walgreen Store, running south to Washington Street, the older buildings still survive in this photograph.

Adjacent to Walgreen's is a small 19th-century building with arched windows on the third level, above which are decorative dentils. On the street level, Rey's Jewelers has replaced G.H. Bailes Department Store. Next to it is Chandler's Cafeteria, which was a new concept in dining out that was replacing Main Street's smaller cafes. Later the cafeteria site would be occupied by the Jean West Dress Shop. Dominating the central position in the block is J.C. Penney's tall store. Below Penney's is the Kaybee Store, a national clothing chain that was becoming a fixture on most Main Streets. At the far corner of the block, Payne's For Music occupies a coveted corner spot.

Below Washington Street, in the next block, the antebellum Goodlett House Hotel building remains in strange juxtaposition to the building boom's greatest accomplishment, the Woodside Building.

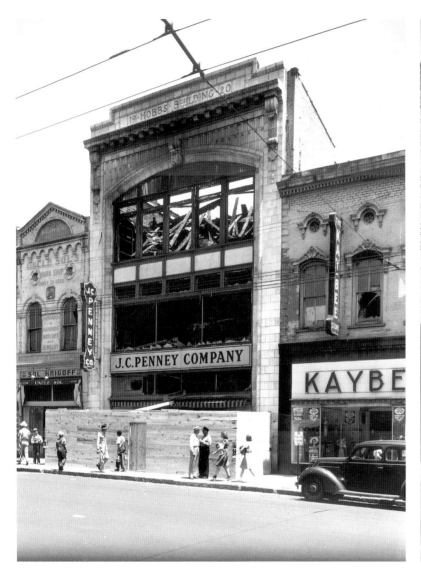

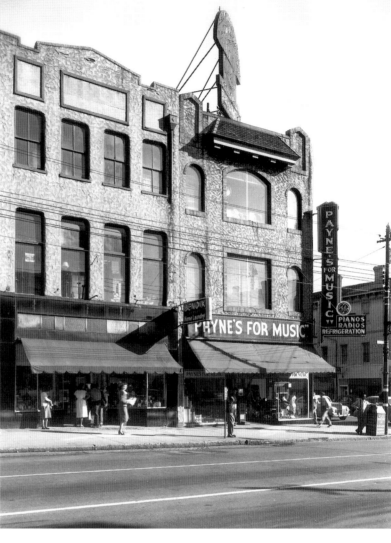

PENNEY'S FIRE. Fire, rather than the demolition ball, was the destroyer of some of Main Street's older buildings. J.C. Penney was in the block between Washington and Coffee Streets (shown on the previous page). To the left of the burned-out store is the narrow Knigoff Building. Its facade, adorned by brickwork in the Romanesque style, was typical of late 19th-century design. Sol Knigoff was the proprietor of Uncle Sol's Pawn shop. In this photograph, the buildings housing both Chandler's Cafeteria and Kaybee's have been "modernized" on the street level; the upper floors retain the original features of their older facades.

PAYNE'S FOR MUSIC. In the 1940s the northeast corner of Main and East Washington Streets was still occupied by a local merchant. Payne's For Music was a combination music and appliance store. In a day when many people made their own music, Payne's sold pianos and offered a large selection of sheet music and band instruments. Also stocked were refrigerators and home washing machines. On the roof a large lighted sign proclaimed the store's name.

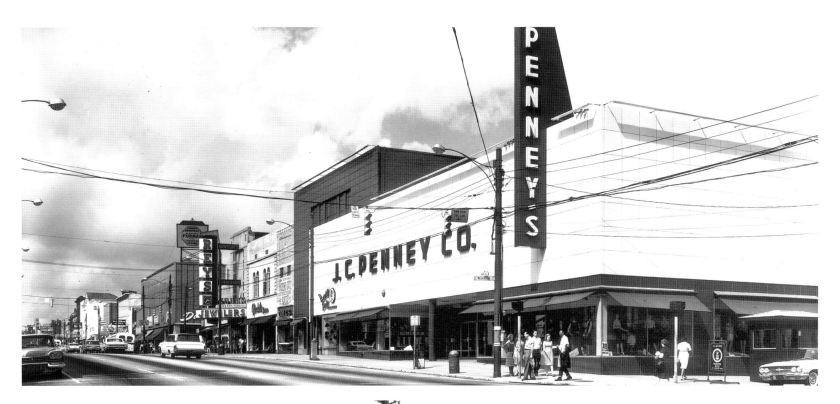

MID-CENTURY. By the middle of the 20th century J.C. Penney occupied the northeast corner of Main and East Washington Streets. The large store, lacking any upper-story architectural detail, was typical of the designs of the mid-century. During its expansion, Penney's absorbed the Payne's For Music location and the smaller stores at the southern end of the block. Rey's Jewelers survived at the block's northern end with a modern facade and sign. The small, wooden structure at the far right of the photograph was used by bus drivers.

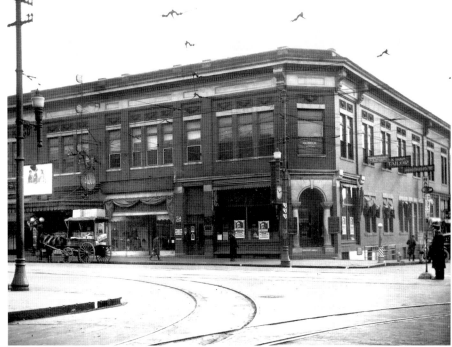

THE CAUBLE BUILDING. Occupying the northeast corner of Main and Coffee Streets, the Cauble Building was a block north of Penney's. Built in 1905, this large building occupied a site where a wooden store had once stood. The corner spot, previously the location of a popular saloon, became the home of the Bank of Commerce. The bank's corner entrance was clearly defined by a rounded arch with a keystone and flanked by a pair of short Romanesque-style columns. The Bank of Commerce was a casualty of the financial problems that followed the post–World War I boom. It closed its doors in 1926 with all depositors being payed in full. By the middle of the 20th century, the exterior of the Cauble Building was covered by sheeting that completely obscured all architectural detail. In the 1980s, during restoration, the covering was removed.

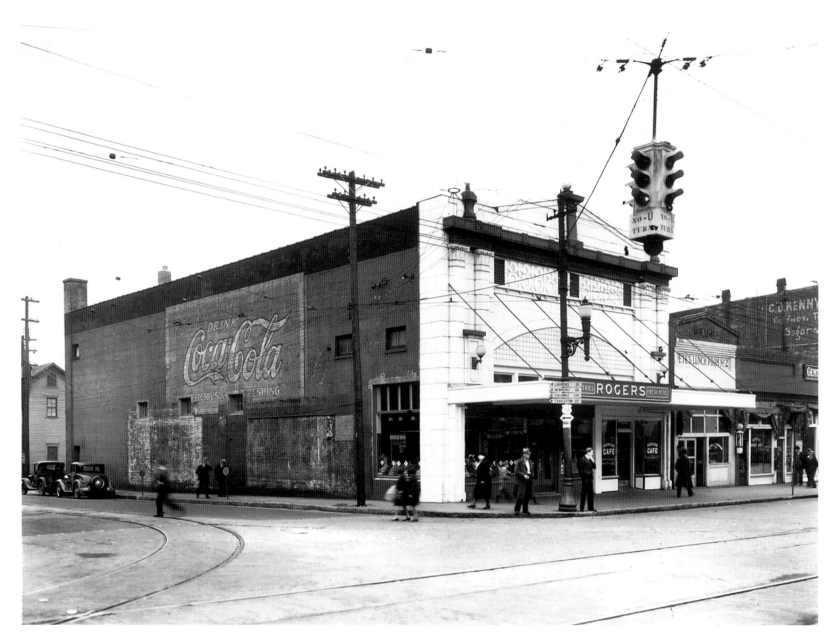

CORNER OF EAST NORTH AND MAIN. The facade of this *c.* 1920 building on the southeast corner of Main and North Streets exhibits neo-classical details similar to those on the fourth (1917) courthouse. Pairs of pilasters with Corinthian capitals flank both sides of the front. Running across the top is a heavy cornice, beneath which are decorative terra-cotta panels (seen more clearly on the next page). In this photograph from the 1920s, the street level is shared by Roger's Grocery and Pete's Cafe. Roger's was a grocery chain with several stores in Greenville. Behind the building, on East North Street, residential property survives in this photograph.

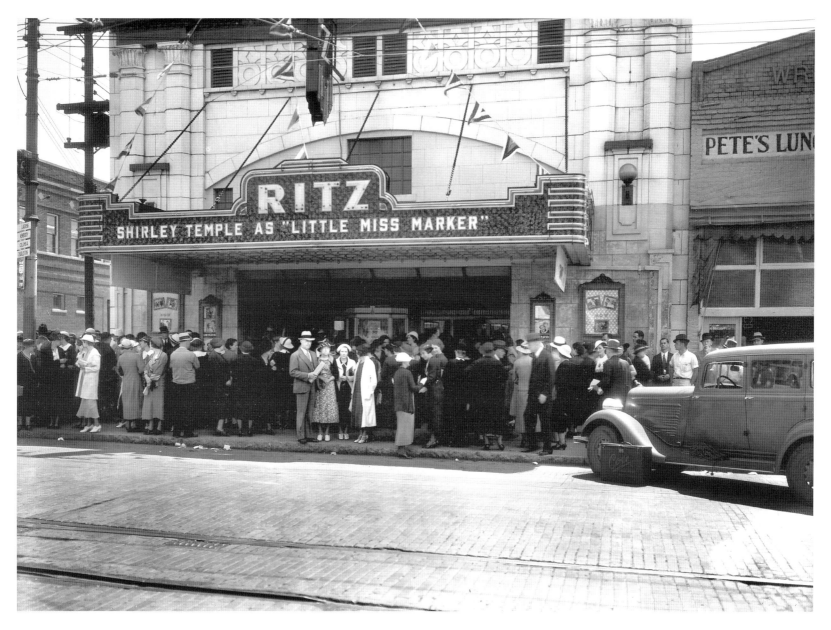

CORNER OF EAST NORTH AND MAIN. By the 1930s Roger's Grocery was gone and Pete's Cafe, now known as Pete's Lunch Room, had moved next door. In their place is the Ritz Theater, one of the growing number of movie theaters on Main Street. In this photograph a crowd waits to be admitted to the latest Shirley Temple movie. In the 1930s most women wore hats on any excursion outside the home. Movies were not shown on Sunday. As shopping malls began to appear in the 1950s and 1960s, the Main Street movie theaters migrated along with the department stores. The former site of the Ritz Theater survived into the 21st century. Sadly, its neo-classical facade was covered over by turquoise-colored panels.

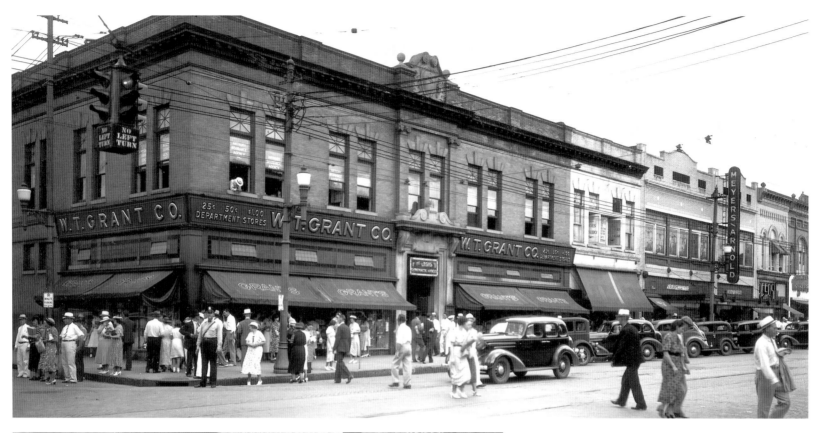

MAIN AND COFFEE—THE WEST SIDE. The west side of the block between Coffee and North Streets offered the Main Street shopper two major department stores: W.T. Grant and Meyers-Arnold. In a *c.* 1920 building on the northwest corner of Coffee Street, Grant's was immediately across Main from the Bank of Commerce (p. 43). The Grant building represented a transitional style between the heavily ornamented facades of the 19th century and the windowless, laminated store fronts of the mid-20th century. Along with Kress's and Woolworth's, Grant's formed a trio of "five and dime" stores to be found on most Main Streets throughout the nation.

In the late 1930s Main Street shoppers still observed the standard dress conventions. Women wore hats, and men wore coats and ties. Throughout the year, hats were standard attire for men. Straw hats were worn in warm weather and felt hats during the autumn and winter.

The photograph to the left shows the Grant's employees at their annual banquet.

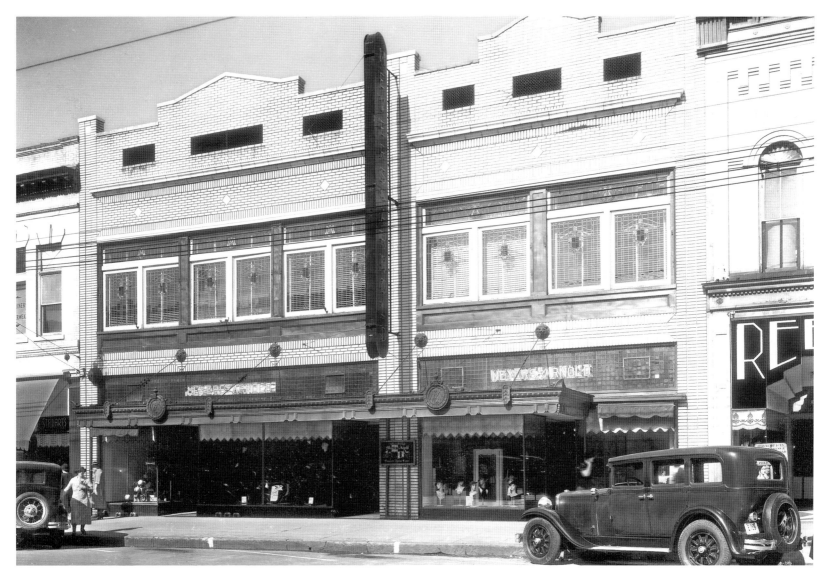

MEYERS–ARNOLD DEPARTMENT STORE. Among the dry goods stores operating on Main Street at the turn of the 20th century was that of J. Thomas Arnold. In the first decade of the century, Manas and Alex Meyers moved to Greenville from Virginia and acquired Arnold's store. Along with their brothers, L.A. and Nolan Meyers, they established Meyers-Arnold Company. The Meyers brothers were able businessmen. Soon Meyers-Arnold became the largest store in South Carolina specializing in clothes for women and children. Later the business diversified its stock to become a full-fledged department store. The Meyers brothers became active in the life of Greenville as business leaders and as civic leaders. Both Manas and L.A. Meyers served as directors of the South Carolina National Bank. When Meyers-Arnold first opened on Main Street, it occupied a building about half the size of the store in this photograph. In the 1920s the larger building was constructed to accommodate the expanding store.

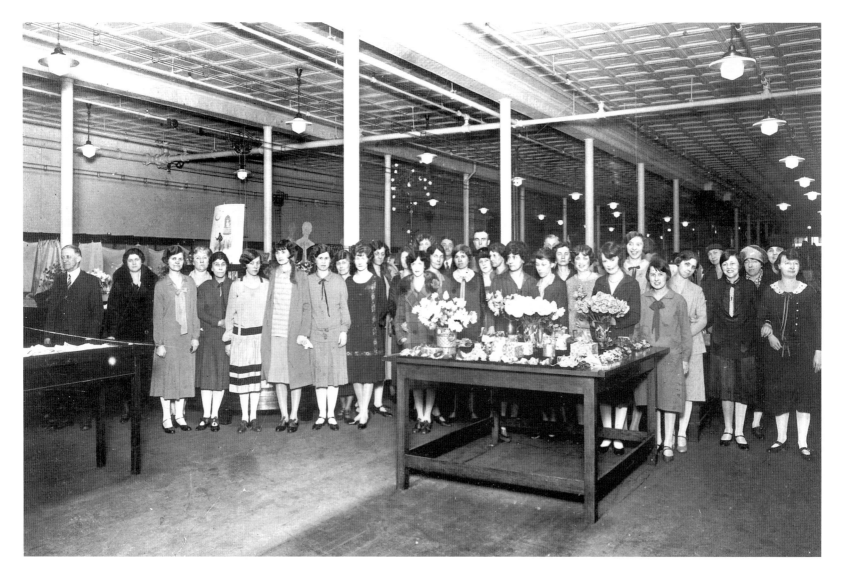

MEYERS-ARNOLD SALES STAFF. The store and staff are shown above in a 1920s photograph. Prior to World War I, it was not easy for a young woman to acquire a job in sales. The war changed social attitudes. Women could vote for the first time in the United States in 1920. Greenville's business boom in the same decade created an increased demand for employees and greater opportunities for young, white women. The Meyers Brothers motto was "the customer is always right." Staff were required to observe this rule. Most of the goods for sale were displayed on table tops in somewhat drab fashion.

Eventually the emergence of shopping malls outside the city center led to the decline of the Main Street department store. Construction of McAlister Square began in 1965. When the mall opened, the largest in South Carolina at the time, Meyers-Arnold was one of the anchor stores. The Main Street store closed in 1971. A second store was opened at the Anderson Mall in 1975. By the 1980s, most locally opened department stores had been absorbed by national chains.

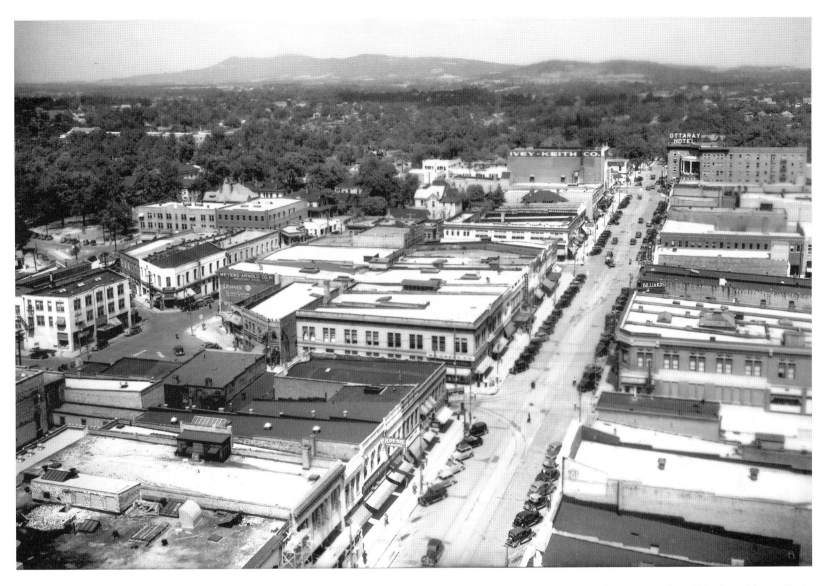

FIVE POINTS. William Coxe probably took this "ariel" view in the 1920s from his studio in the Woodside Building. Running across the center of the photograph is West Coffee Street, which extended at the time from Main through to Academy Street. Laurens Street, parallel to Main one block over, extended from West Washington through to College Street. Where Laurens, West Coffee, and Buncombe Streets intersected there was an open area known as Five Points (left center of the photograph). Meyer-Arnold's back entrance on Laurens Street opened onto Five Points. Across the street, where Buncombe came at an angle into Laurens Street, a triangular building housed a drug store and popular soda fountain. Recessed into the northeast corner of Five Points was a gasoline station. On the west side of the Points was the three-story Hotel Virginia, bordered on the right by Buncombe Street and on the left by West Coffee. This 54-room hotel stood on the site of the 1895 Opera House.

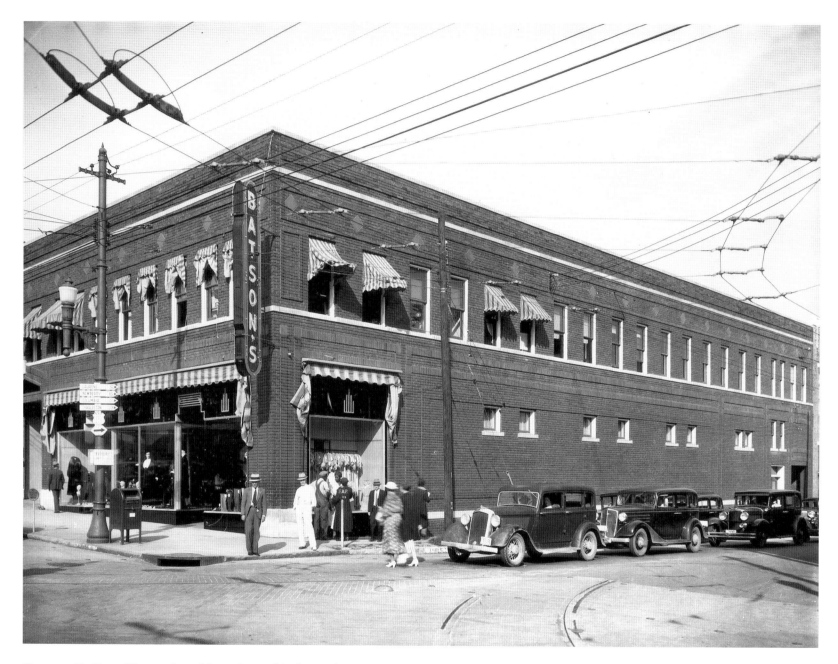

CORNER OF EAST NORTH AND MAIN. Located in the northern-most block of the Main Street business district, Batson's was on the northeast corner of Main and North Streets. Specializing in women's ready-to-wear clothing, the store did business in a building constructed about 1910. The upper floors were offices. Later this corner would be the site of Ivey's Department Store.

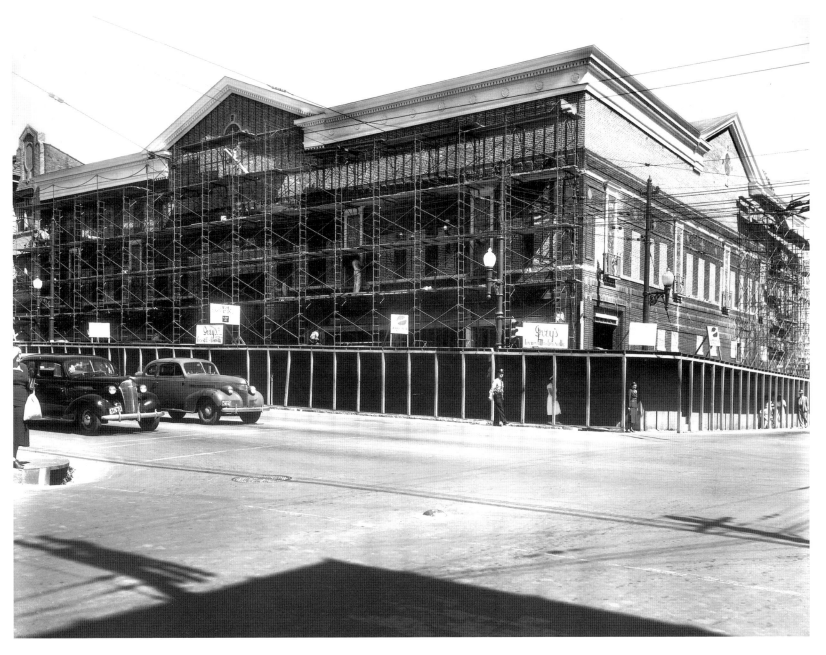

THE IVEY'S BUILDING UNDER CONSTRUCTION. After occupying a building near the College Street end of North Main Street for many years, Ivey's moved into its new building at the corner of Main and North Streets (former Batson's location) in 1949. After the opening of McAlister Square, Ivey's joined Meyers–Arnold as an anchor store. Its Main Street building was vacant for many years. In the 1990s the building was remodeled for shops on the street level and condominiums on the upper level.

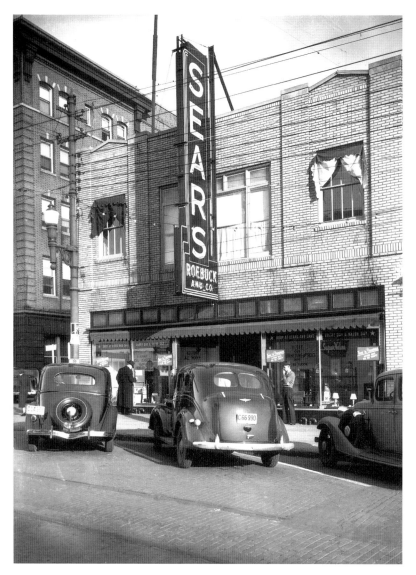

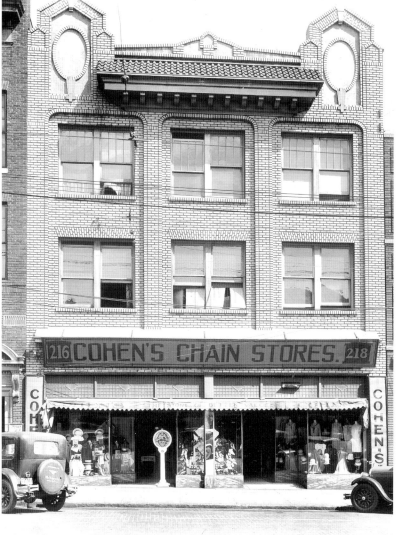

SEARS–ROEBUCK AND COMPANY. The nation's leading retail store opened on North Main Street in the 1920s in a building constructed in the same decade. To the left of the Sears store is the side of the Ottaray Hotel. Sears remained in this location until it moved into a new building on Stone Avenue in the 1940s. Later Sears followed the Main Street department stores in the flight to the shopping malls. The Stone Avenue store was then acquired by the Canal Insurance Company. Sears's Main Street building contrasted with the 19th-century stores that had once lined the street. Lacking in exterior ornamentation, it retained the upper-floor windows. Running vertically across the second-floor facade are several flat brick pilasters, which contrast sharply with the elaborate pilasters on the Efird Building on South Main (p. 32).

COHEN'S DEPARTMENT STORE. Just north of Batson's was "The Store of Better Values." Cohen's Department Store was opened in 1925 by Max, Jack, and Eli Cohen. Cohen's closed in 1937. Its space on North Main Street was taken by Duke Power Company.

The availability of electric power in the Greenville area was increased when the second hydroelectric plant in South Carolina was constructed on the Saluda River in 1903 under the leadership of Alester G. Furman Sr. In the same year Furman founded the Carolina Power Company along with Lewis W. Parker, J. Irving Westervelt, and Harry J. Haynsworth. This company was sold in 1910 to the Southern Power Company, which became the Duke Power Company.

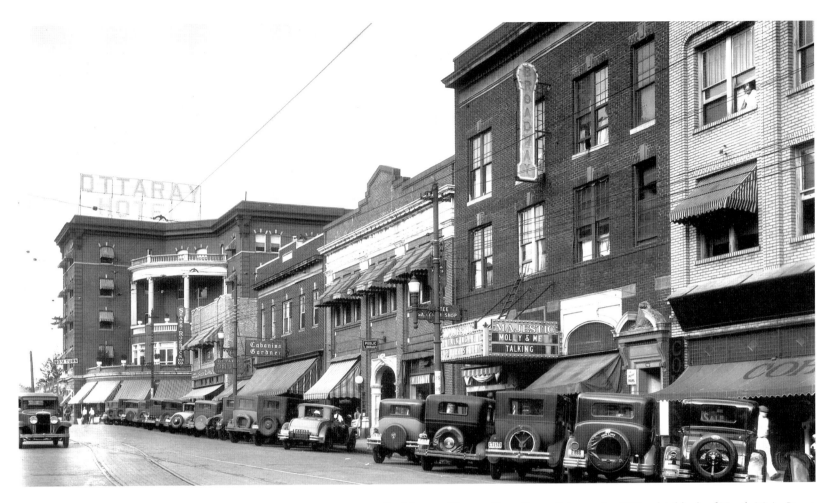

THE 200 BLOCK OF NORTH MAIN—EAST SIDE. Prior to the 1920s, this block of North Main Street retained many of its 19th-century residences. During the building boom of the 1920s, a range of new commercial buildings appeared. At the southern end of the block on the corner of North Street was Batson's Women's Apparel Store (not seen in this photograph). North of Batson's is Cohen's Department Store (far right in this photograph). Cohen's is the three-story brick building that originally had a hotel on the upper floors. The clearly-defined street entrance to the upper floors was topped by a broken pediment supported by consoles. On the street level are a shop and the Majestic Theater. The Majestic later became the Center Theater. Next is the Jervey-Jordon Building or Library Building, so-called because the Greenville County Public Library was housed on the second floor. In 1927, in an effort to begin a museum of art, several plaster copies of statues from ancient Greece and Rome were placed on display in the library. After an outcry against public nudity (and a momentary rush of visitors) the offending statues were removed to the library's upper floor. Not even the placing of shorts on the statue of Apollo had saved the exhibit. To the left of the Library Building is Cabaniss-Gardner, perhaps the most fashionable store for women in the city. The proprietors were G.B. Cabaniss of Charlotte and William H. Gardner. Later Cabaniss-Gardner moved across the street to the corner of North Main and College Streets. Between Sears-Roebuck and Cabaniss-Gardner is the Ottaray Drug Store, which was part of the Carpenter Brothers chain of drug stores. Looming at the top of North Main is the Ottaray Hotel.

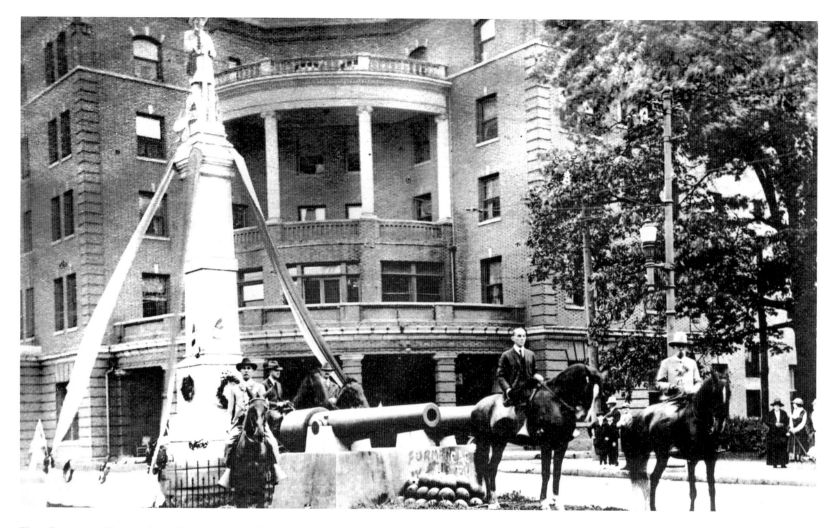

THE OTTARAY HOTEL AND CONFEDERATE MONUMENT. As commercialization crept northward on Main Street, the accommodations business followed. When the Mansion House was built on South Main in 1824, it was at the heart of Greenville's downtown activity. At the beginning of the 20th century, the Mansion House no longer offered the quality accommodations for which it had become famous. Greenville needed a new hotel, and this need was answered by the city's aggressive business leadership. A hotel company was formed by Alester G. Furman Sr. and Harry Haynsworth. They were joined by two Main Street merchants, Alonzo A. Bristow and Jesse R. Smith. The five-story Ottaray Hotel was constructed in 1908–1909. In 1919 J. Mason Alexander became manager and began his legendary career in Greenville as a hosteler.

The memorial to Greenville's Confederate soldiers was placed in the middle of North Main Street in 1892 by the Ladies' Memorial Association. At the time the surrounding area was mainly residential and lacked motorized traffic. During the extensive new construction of the 1920s, the city council decided the monument had to be moved. Although removal began in 1922, there followed a period of confusion as to where the statue should be placed. Finally in 1924 the Confederate Monument was installed to the left of the entrance to Springwood Cemetery, slightly north of its original location.

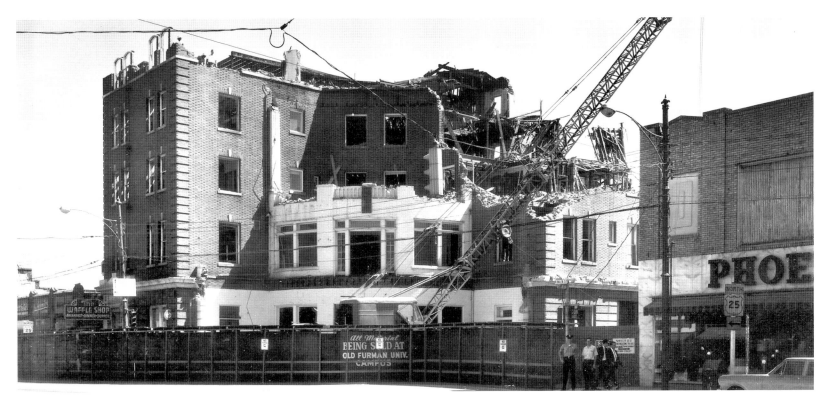

OTTARAY HOTEL UNDER DEMOLITION. In 1960 the Ottaray Hotel, now out-of-date, was demolished to make way for a modern motel. To its left, in this last view, is the marquee of the Carolina Theater, which survived for another decade. On the right, Phoenix Furniture occupies the former Sears-Roebuck building. Running between the furniture store and the hotel is Oak Street. This narrow passage, which probably took its name from the large tree that once stood at its head (see previous page), ran downhill from North Main to Brown Street. Oak Street was later absorbed by the Hyatt Hotel.

THE DOWNTOWNER MOTEL. After the demolition of the Ottaray, this motel was built on the site in the early 1960s. Its exterior, covered by multi-colored panels, was in contrast to the stately appearance of the former hotel. The Downtowner lasted for little more than a decade. In 1979 it fell victim to a second Main Street building boom. As the Hyatt Hotel was under construction, a new, multi-laned thoroughfare cut through to North Main on the hotel's left side. Beattie Place ran through the former site of the Ottaray and Downtowner Motel.

THE DOWNTOWNER MOTEL BUILT ON SAME SITE AS OLD OTTORAY HOTEL. COMPLETED IN 196 . RAZED IN 1979 TO MAKE WAY FOR THE GREENVILLE COMMONS

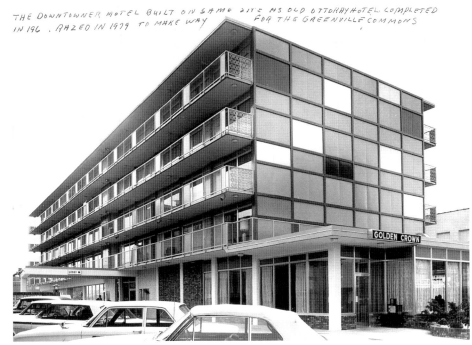

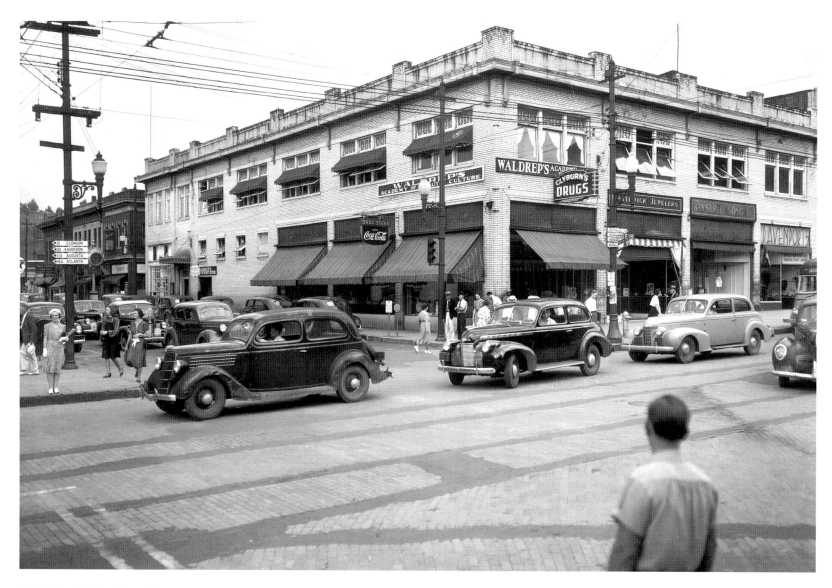

The 200 Block Of North Main—West Side. On this page, and the subsequent three pages, the opposite side of Main Street is shown across from the scenes shown on the previous pages. A large building, dating from about 1920, occupies the northwest corner of Main and North Streets. This building, which survived into the 21st century, was divided into small stores on the street level. Another "corner drug store," Clyburn's, is on the North Street end. Above it is one of Greenville's better jewelry stores, Smithwick's. Next are two clothing stores. Kayser & Long sold women's clothes; Davenport's was a men's shop.

This photograph, from the 1940s, shows that the Main Street dress code was in a transitional stage. The middle-aged woman, waiting on the corner for the light to change (far left), wears the traditional dress and hat. The younger women nearby are hatless. Male attire varied from coat and tie, to shirt and tie, to short-sleeve shirt and no hat. The intersection is paved in brick.

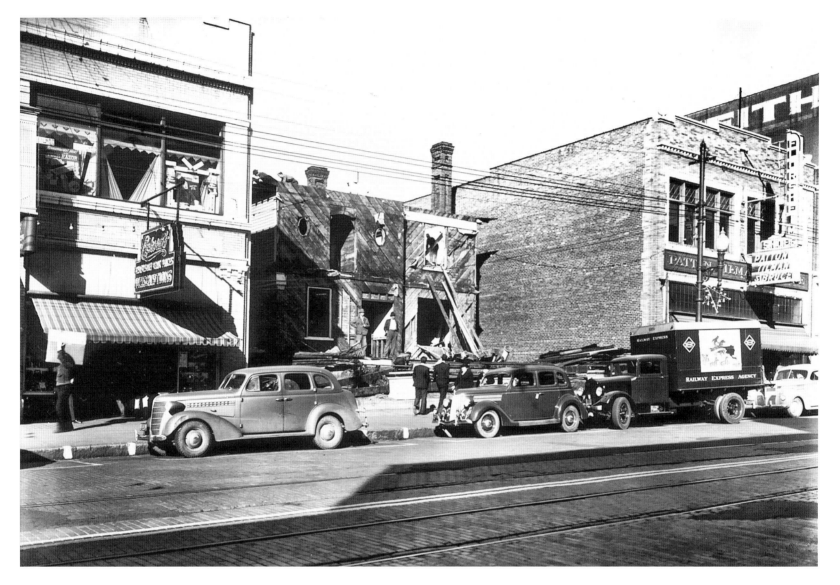

THE JESSE R. SMITH HOME. In 1900 when Jesse R. Smith left his Main Street clothing store (Smith and Bristow) at the end of the day, he merely had to walk a few blocks to his home on North Main. By the 1930s the Smith home was an anachronism in the 200 block, sandwiched in by new construction of the 1920s. To the right of the demolition site is the second Main Street location of Patton, Tilman, & Bruce. In this new store, customers could make certain of a perfect fit by inserting their feet and new shoes into an x-ray machine and view the bones in their feet and toes.

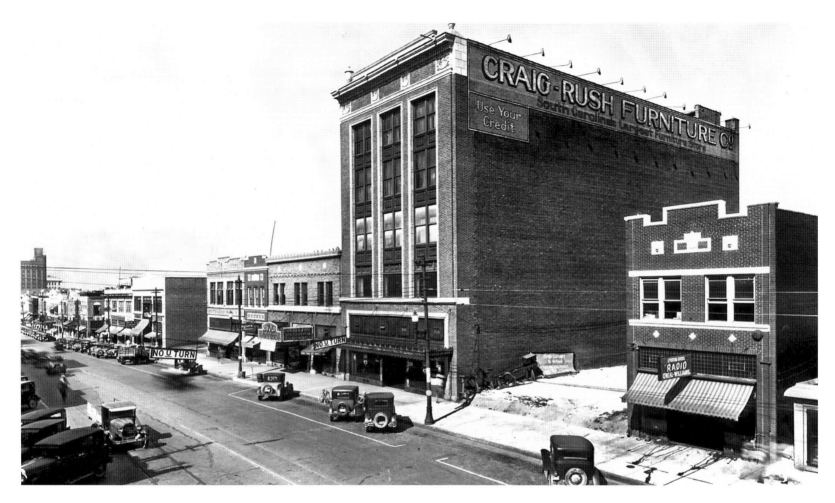

THE 200 BLOCK—THE NORTHERN END. Although the southern end of this block still retained its early 20th-century buildings at the beginning of the 21st century, the northern end was less fortunate. An exception is the two-story building with the crenellated roofline at the far right. At the top of the facade are three terra-cotta plaques, typical of construction in the 1920s. The center plaque obligingly bears the date of construction, 1928. The flanking, smaller plaques have decorative lion's heads. For many years this building was the home of Greenville's principle sporting goods store, O'Neal-Williams.

Dominating the northern end of Main Street in the 1920s is a tall building occupied by the Craig-Rush Furniture Company. The proprietor of "South Carolina's Largest Furniture Store" was Stonewall Jackson Craig. The building was constructed and owned by Col. William Henry Keith. Colonel Keith was a native of Timmonsville, South Carolina, where he had been prominent in business and served as mayor. During the First World War, he was given the rank of colonel on the governor's staff. Greenville's growth and business opportunities convinced this able leader to relocate in 1920. Seeing the potential for commercial development of the 200 block of North Main, he acquired the property that had been the residence of Hyman Endel, a prominent member of Greenville's Jewish community and proprietor of the Globe Clothing House. On the property, Colonel Keith constructed the multi-story building, which was leased to Craig-Rush. Next door, Keith built the Rivoli Theater. He intended that his theater be the finest in Greenville. Designed by the local firm of Beacham and LeGrand, the 750-seat Rivoli Theater opened in 1925.

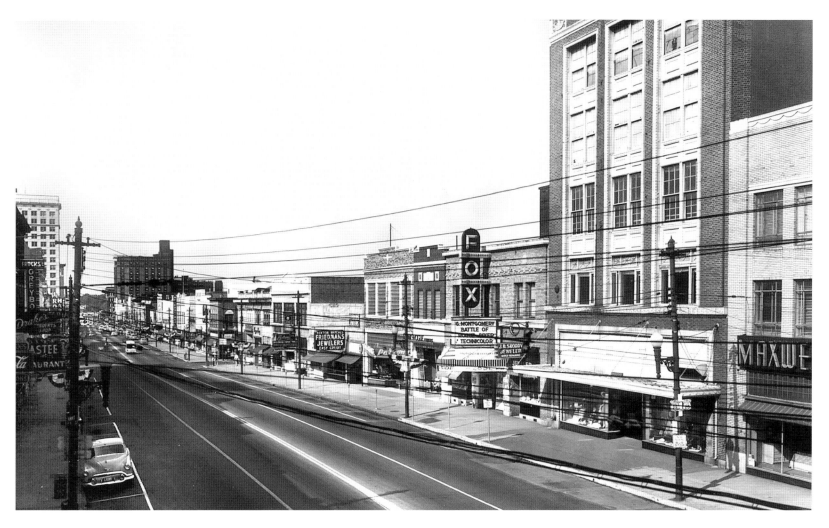

IVEY-KEITH DEPARTMENT STORE. In 1925 Colonel Keith founded Keith's Inc., a department store that was first located on East Washington Street. In 1935 the Colonel claimed his North-Main high rise (previous page) for his own store. Craig-Rush moved to East North Street. In 1937 Keith's Inc. allied itself with the Ivey Stores of Charlotte, North Carolina, to form Ivey-Keith. Meyers-Arnold, Belk-Simpson, and Ivey-Keith became Greenville's leading department stores. Later while its new building was under construction at the corner of North Main and East North Streets in the late 1940s (see p. 51), Ivey-Keith occupied temporary space in the 100 block of North Main. The store moved into its impressive new quarters, on the corner of Main and North Streets, in 1949. The building at the top of North Main, shown in this photograph, was then leased to J.B. White Department Store. Main Street now had four major department stores. In the early 1960s, the Keith family severed its connection with the Charlotte chain. J.B. White eventually followed Meyers-Arnold and Ivey's to the shopping malls. In the 1980s Colonel Keith's fine building in North Main's 200 block was demolished.

In this photograph from the 1950s, the Rivoli Theater has been remodeled as the Fox Theater (1949). The formerly empty space between Craig-Rush and O'Neal-Williams (p. 58) is now filled in by Maxwell Brothers and Quinn Furniture Store.

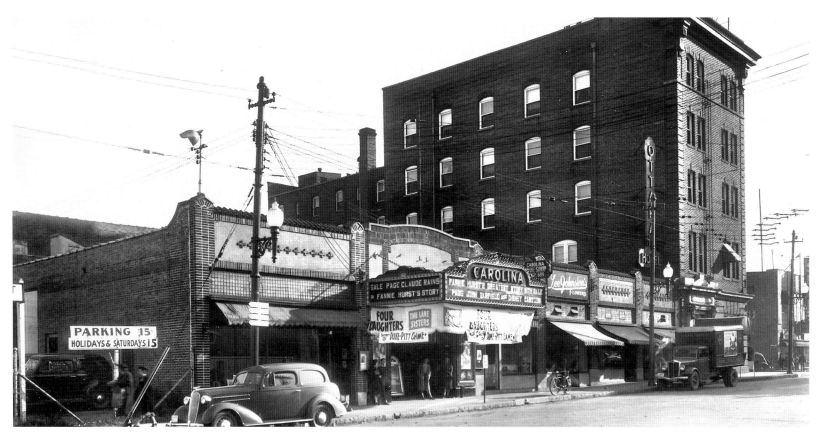

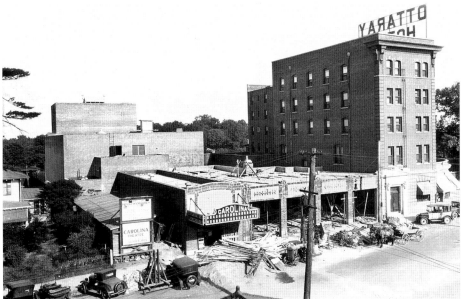

THE CAROLINA THEATER. Between the Ottaray Hotel and Springwood Cemetery was a tract of land that was once part of the property of Chancellor Waddy Thompson (1769–1845). When Greenville built a new courthouse in 1822, Waddy and Eliza Thompson bought the old, wooden courthouse and moved it to the North Main Street location. With the addition of two wings, it became their new home.

In 1925 North Main acquired two new motion picture theaters. Several months before W.H. Keith opened the Rivoli (p. 58), the Carolina Theater opened on the Thompson home site. The Carolina was built by the same company that owned the Ottaray Hotel next door. On both sides of the theater, space for small stores was constructed. In the photograph on the bottom left, Bill Coxe captured the Carolina Theater and its neighboring stores under construction in the mid-1920s.

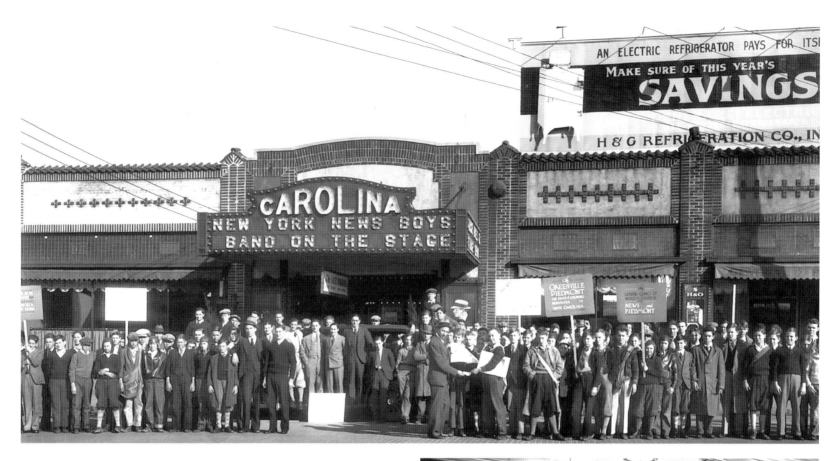

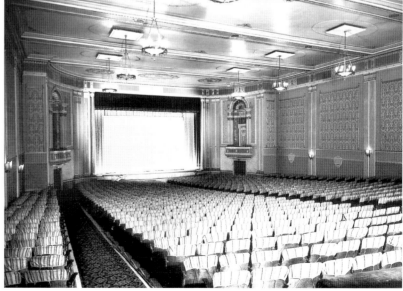

NEWS CARRIERS AFTERNOON OUT. One distinction between the Carolina Theater and the Rivoli, Majestic, and Ritz was the Carolina's ability to accommodate live stage-performances in addition to motion-picture presentations. The tall projection at the rear of the theater facilitated scenery changes. In this scene from about 1930, area news carriers are being treated by their newspaper companies to a live performance of The New York News Boys' Band. They carry placards proclaiming the newspapers that they deliver. At this time newspapers for a particular neighborhood were delivered by trucks to a central corner. There the news boys would collect their bundles and place the papers in a large canvas bag with a strap that could be slung across the shoulder and chest. Papers were then delivered by foot or on bicycle to the front door of each subscribing household.

The Carolina's interior was the most elaborate and largest on Main Street. It had a seating capacity of 1,218. Its size, glistening chandeliers, and large stage flanked by impressive balconies gave it the aura of an opera house.

THE MACKEY MORTUARY. Shortly after the Carolina Theater opened, James F. Mackey & Sons constructed a new home for its funeral business in 1926–1927 in the 300 block of North Main Street. The mortuary was first established in 1872 and for many years was located on East Washington Street. Its new building, which was separated from the Carolina Theater complex by a parking lot, was on the corner of North Main and Elford Streets. Elford Street at the time was a narrow two-lane street. Proximity to Springwood Cemetery was an obvious factor in the site selection for Mackey's. The building, which was in the neo-classical revival style, had a well-proportioned portico supported by Ionic columns and corner quoins of brick. When Mackey's moved in 1969 to a new building off of Highway 291, the Main Street building became a bank. It was demolished in 1998.

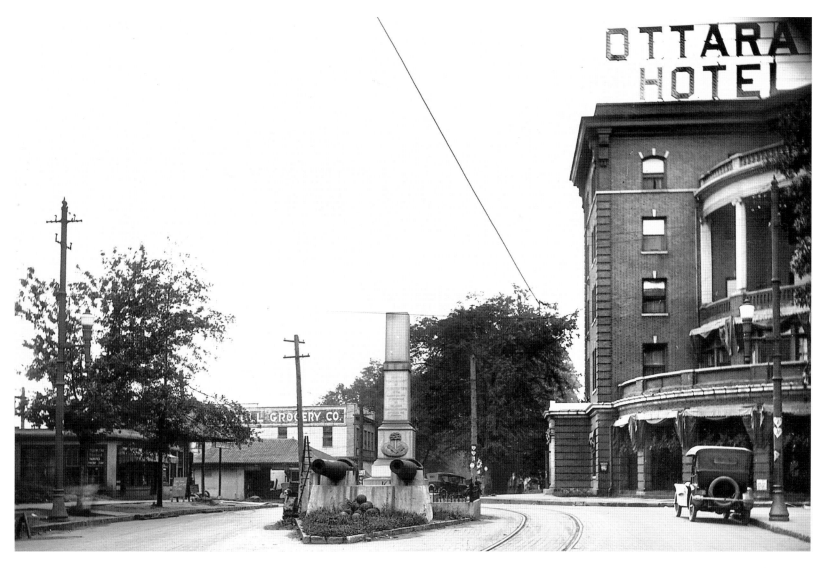

NORTH MAIN AND COLLEGE STREETS. Across North Main from the Ottaray Hotel, a light-colored building occupied the northwest corner of North Main and College Streets. This building, which was used as a grocery store in the 1920s, was the future site of the Daniel Building. College Street takes its name from the Greenville Woman's College, which was several blocks down on the future site of Heritage Green. The absence of the Confederate Soldier from his pedestal indicates that William Coxe took this photograph sometime between 1922 and 1924. In 1922 the statue was removed during discussions concerning relocation, followed by a period of confusion as to where to place it. Some citizens wanted the monument placed in front of the courthouse on South Main Street. For a while the whereabouts of the statue were completely unknown. After the statue was discovered in a barn on a farm outside of Greenville, there followed a period of litigation between the United Confederate Veterans and the city council. In 1924 the statue was restored to its pedestal, which had been moved to the Springwood Cemetery site.

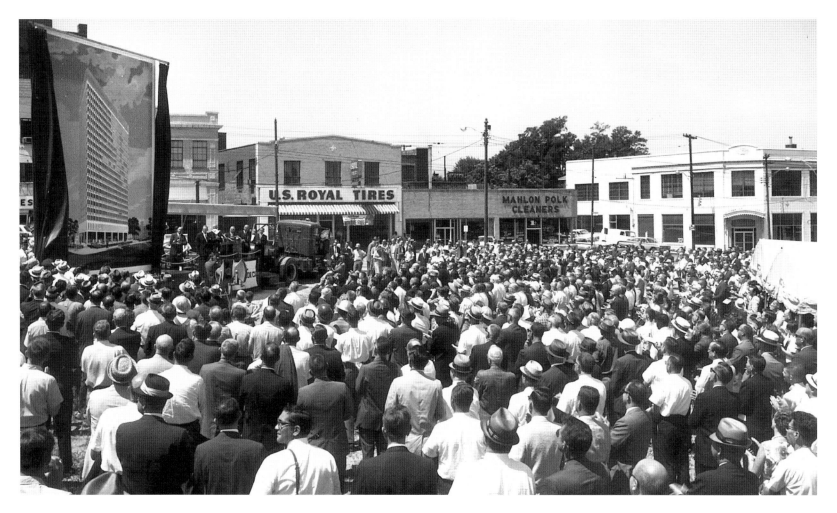

DANIEL BUILDING GROUNDBREAKING. After Greenville's premier department stores left Main Street for the shopping malls in the 1960s, Main Street lost its place as the retail sales center for the community and began to decline. There then followed a period of downtown revitalization comparable to the re-building of Main Street in the 1920s. High-rise office buildings replaced retail stores as the downtown's life-blood. Playing a key role in this revitalization was Charles E. Daniel.

Charles Daniel was born in Elberton, Georgia, and grew up in Anderson, South Carolina. He attended the Citadel and served in the United States Army in World War I. Following the war, he worked 10 to 12 hours a day, 7 days a week, in the lumber and construction business. Seeing the South's potential for industrialization, and undaunted by the Depression, Daniel founded his own company. Daniel Construction Company, established in 1934. In 1941 the company headquarters moved into a Georgian-style brick building on Greenville's North Main Street. On June 29, 1964, Daniel Construction Company held the groundbreaking for a 25-story headquarters building on the northwest corner of North Main and College Streets. The buildings shown in the background of this photograph are on the south side of the first block of College Street. The new building, the tallest in South Carolina at the time, was completed in 1967. Charlie Daniel died a few months after the ground breaking in 1964.

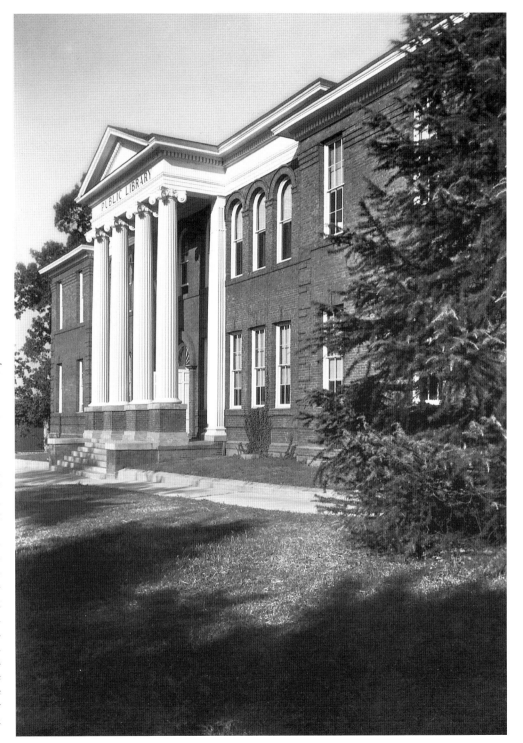

THE PARK SCHOOL AND PUBLIC LIBRARY. The Park School was located on North Main just north of Springwood Cemetery and the relocated Confederate Monument. Built in the neo-classical revival style of the turn of the 20th century, its second-floor windows in the central section had rounded tops reminiscent of the earlier Romanesque-revival style. In 1940 the Greenville County Public Library moved to the former school.

Textile magnate Thomas F. Parker had sensed the need of the growing Greenville community for a public library and organized the Greenville Public Library Association in 1921. It opened a small library on East Coffee Street and went on to achieve tax support through a public referendum in 1922. Public status and tax support made possible the lease of the Jervey-Jordon Building in the 200 block of North Main (see p. 53). In 1936 the non-renewable lease on the Jervey-Jordon Building expired. The library then spent several years in temporary quarters. The Park School building was acquired in 1939 for $32,500. With the assistance of the WPA and another $10,000 raised by citizens, the Greenville County Library opened in the former school in 1940. The library remained on this site until it moved to its first purpose-built home on the old Greenville Woman's College property on College Street in 1970. In the autumn of 2002, the county library occupied a large new facility on the former Coca Cola Bottling Company property on Buncombe Street.

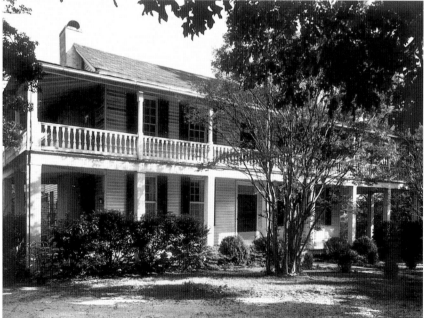

NORTH MAIN STREET RESIDENCES. As the commercial district of Main Street crept north in the1920s, the residential district moved still farther out. Dr. William D. Simpson moved from Abbeville to Greenville and joined in partnership with his half-brother, William Henry Belk of Charlotte, in the Belk-Simpson Department Store. On the corner of North Main Street and Hillcrest Drive, he and Lucy Simpson built a substantial home in 1926. Spanish architectural styles achieved a degree of popularity in the 1920s under the influence of the Florida construction boom.

WHITEHALL. One of the major residential streets intersecting North Main is Earle Street. Whitehall (left) was built on what would become Earle Street in 1813 by Henry Middleton. This Lowcountry planter and his large family were anxious to escape from their Ashley River plantation to a healthier climate in the summer months. Middleton, who was born in London, may have taken the name from that section of government buildings in London that stretch from Trafalgar Square to Parliament Square. In 1820 Whitehall became the property of George Washington Earle, from whom it descended to his daughter, Eugenia Earle Stone. Her descendants have continued to occupy the residence.

THE CROSS STREETS

Beginning at the southern end, the major streets and avenues intersecting Main Street are Broad, McBee, Washington, Coffee, North, and College. In the 1970s Beattie

Place was created and joined North Main opposite the beginning of College Street. As the central business district expanded, the side streets, primarily residential to begin with, became more and more commercial. At the beginning of the 20th century, residences predominated. By the middle of that century, they had almost completely disappeared. In the midst of constant demolition and rebuilding, churches have been an enduring feature of the cross and side streets. It was here that they were founded, and it is here that they have survived.

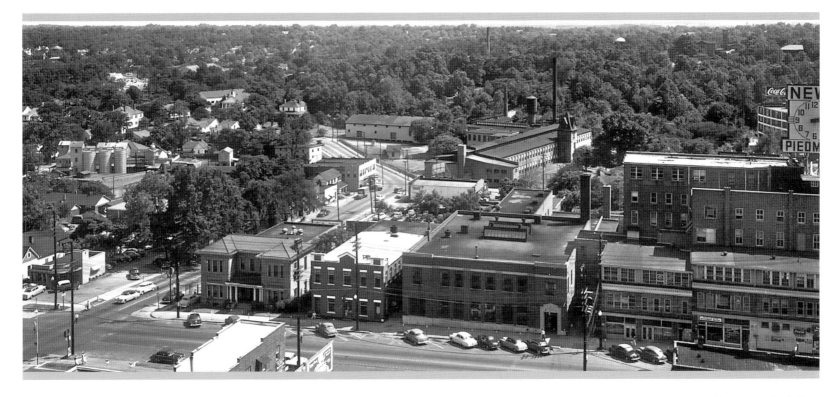

EAST BROAD STREET. In this aerial view of East Broad Street, the Camperdown Mill is in the central background, and its mill village is to the left in the trees. To the right of the mill is the News-Piedmont clock and beyond it the old Furman-Gassaway Warehouse (Traxler Building). In the far-right background, Furman University's Old Main and Bell Tower are just visible in the trees. The county jail is in the left foreground at the corner of East Broad and Fall Street. Built of cream brick in 1915–1916, the jail had a recessed entrance supported by Doric columns. The firm of Jamison & Morris was the contractor. The front part of the jail had offices and quarters for the jailer. In the rear an extension contained cells for prisoners. After the Greenville County Law Enforcement Center was opened in 1976 on East North Street, the Broad Street jail was leased for brief periods by several businesses before becoming vacant in the late 1980s. The Greenville News Company acquired ownership and demolished the old jail in 1997.

THE HUGUENOT MILL. In 1882 the Huguenot Mill began operations on West Broad Street. Constructed of red brick, the mill's most distinctive feature was a tower in the Italianate style. The mill organizers were Charles E. Graham and Charles H. Lanneau. Lanneau also served as the first superintendent. The origin of the mill's name is not clear. It is speculated that Lanneau's Huguenot descent was the source. In 1910 the Huguenot Mill was acquired by the newly-formed Nuckasee Manufacturing Company, under the presidency of Frederick W. Symmes. In 1929 Union-Buffalo Mills took over operations. Subsequently the building was used by several textile companies. By the 1980s it was abandoned and in danger of demolition. Fortunately, the 1882 mill was renovated and adapted for modern office use.

GREENVILLE CITY HALL. The population of Greenville grew rapidly during the second half of the 19th century. From a population of 1,305 in 1850, the number of inhabitants increased to 13,017 in 1900. The growth of the community warranted a new status. In 1869 Greenville was officially incorporated as a city. Ten years later, as recovery from the Civil War was achieved, funding was finally available to build a proper city hall in 1879. Samuel A. Townes was mayor at the time. Located on the corner of West McBee Avenue and Laurens Street, the two-story building had a heavy cornice around the roof line and windows that were slightly arched at the top. The corner entrance was in an Italianate tower, which, in this photograph from the 1930s, offers a curious juxtaposition with the Woodside Building, the symbol of Greenville's new growth in the 1920s. This site continued to serve as the city hall until the Federal Post Office building on the corner of South Main and West Broad Streets was acquired in 1938.

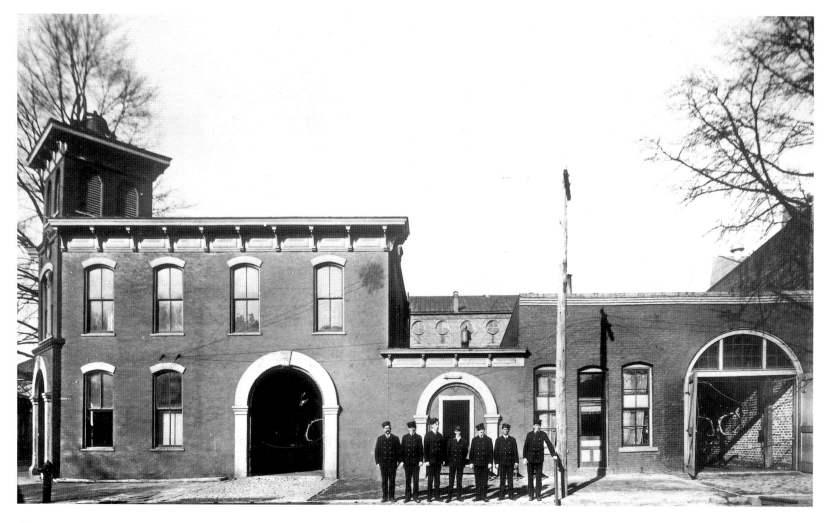

CITY FIRE DEPARTMENT. The fire department was located on the McBee Avenue side of the 1879 City Hall. The tower bell was used to warn residents of fires. First the bell would be rung constantly for about one minute. After a brief pause, the bell would ring the number of the city ward where a fire was burning. Volunteer firemen would then scramble to their station and on to the scene of the fire. By the time the new City Hall/Fire Department was built in 1879, there were already three volunteer fire companies. The Robert E. Lee Company, composed of white citizens, took up residence in the new building on McBee Avenue. The Palmetto Company, consisting of African-American volunteers, was located on the corner of Washington and Brown Streets. Another African-American company, the Neptune, had a station near the West End on South Main Street. A few years earlier, in 1876, the city council appointed the first fire chief to coordinate the work of all three volunteer companies. Not until 1902 was the first paid city fire department established. By that time the job of firefighting had been made easier by the establishment of a city water system. Beginning in 1890, water mains were laid throughout the city to supply water from the reservoir on Paris Mountain. The new water system included the first fire hydrants in Greenville. They were tested for the first time in 1891.

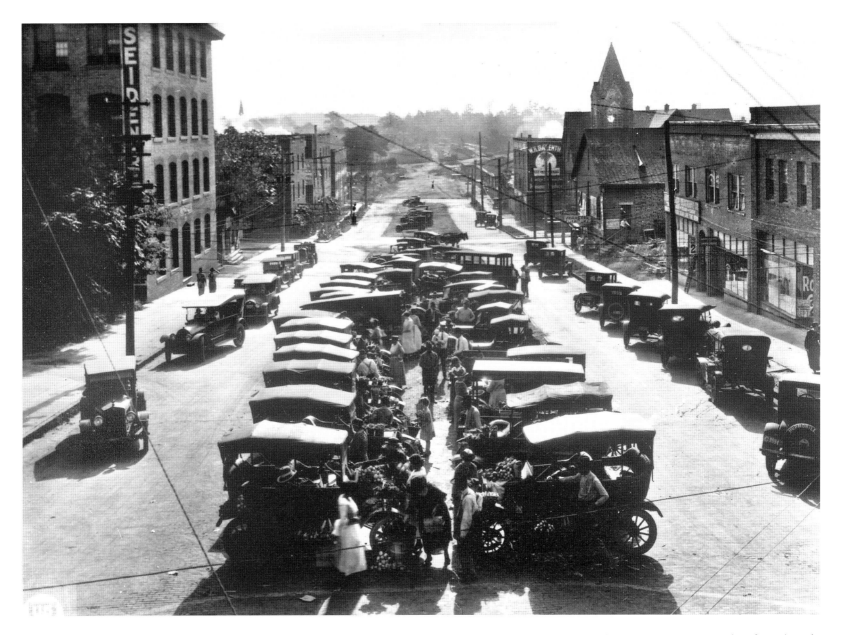

COURT STREET CURB MARKET. This photograph of East Court Street was taken from directly behind the second courthouse/Record Building in 1922. The multi-story building on the left is the Cigar Factory (see p. 72). On the south side of Court Street is the Balentine Packing Company and, above it, the John Wesley Memorial Methodist Church. In the center of the street farmers sell fresh produce from their new motor cars. Before the automobile, farmers sold produce on the streets of Greenville from horse-drawn wagons. By the 1920s the center of East Court Street was designated as a curb market. Eventually covered stalls were built down the center of the street. The City Curb Market moved to Elford Street in 1950.

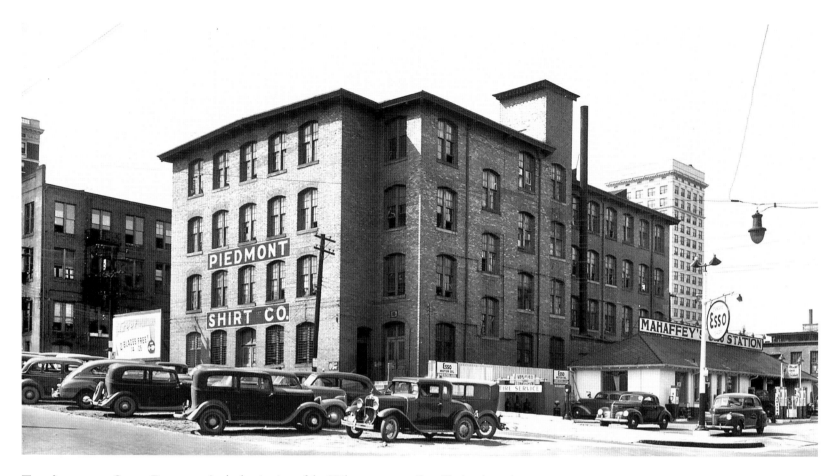

THE AMERICAN CIGAR FACTORY. At the beginning of the 20th century textile mills dominated Greenville's industrial economy. Recognizing the need for a more diversified economy, the Greenville Board of Trade raised funds in 1903 for the construction of a large factory near the corner of East Court and Fall Street for the American Cigar Company. Built by the local construction firm of Ebaugh and Ebaugh, the factory was one of the largest brick buildings in the city at the time. The factory succeeded and gave increased employment opportunities to young women. About 200 women workers were employed making cigars by hand. Three decades later, this method of manufacture was no longer cost efficient. In 1930 the cigar factory closed. The building was next taken over by the Piedmont Shirt Company, owned by Shepard Saltzman. When a 19-year-old Austrian refugee from the Third Reich arrived in Greenville in 1938, he was given a job at Piedmont Shirt. Thirty-three years later, Max Heller was elected mayor of Greenville.

In 1933 Eugene E. Stone III started Stone Manufacturing Company in a plant on River Street equipped with five sewing machines. The company grew and moved into the Court Street factory in 1942. Stone Manufacturing continued to expand and became the largest manufacturer of underwear in the world. In 1951 it moved into the modern Cherrydale Plant on Buncombe Road. By the 1990s the old cigar factory was abandoned and endangered. Restored for use as office suites, the 100-year-old building serves as a prime example of the successful adaptation of an historic structure.

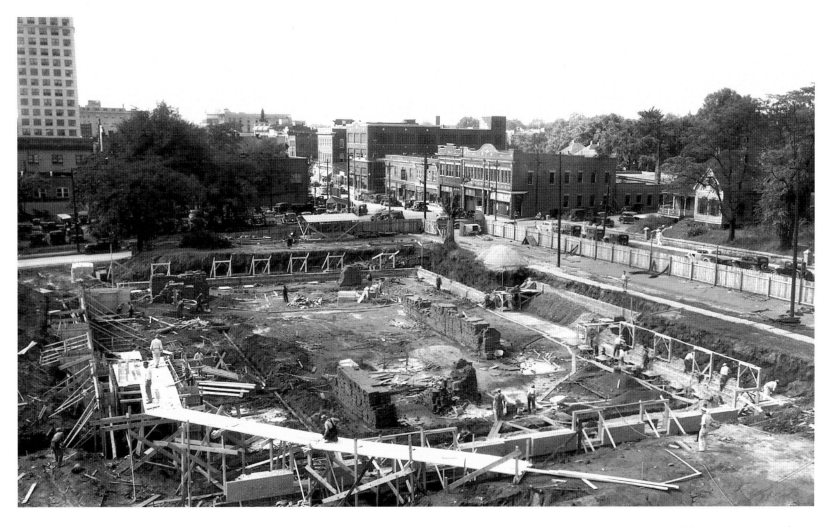

POST OFFICE CONSTRUCTION SITE. During the Depression Greenville was anxious to obtain federal grants to help relieve unemployment in the county. The fact that South Carolina and Greenville County voted solidly for Franklin Roosevelt in the 1932 and 1936 presidential elections helped in this effort. A half-million dollars in federal money was secured to build a new post office on East Washington Street. The city gave the Washington Street property to the federal government, along with the property at the corner of West McBee and Laurens Streets (see p. 69) where the old city hall was located. In return the city got the old post office building at the corner of South Main and Broad Streets (see p. 14) as a new city hall. Construction on the Washington Street post office began in 1936 and was completed in 1937. To express its gratitude for Greenville's political support, the Roosevelt Administration sent Postmaster General James A. Farley down for the dedication. When a new post office was later built on West Washington Street in 1960–1961, the East Washington building became the Clement F. Haynsworth Jr. Federal Building.

Bill Coxe probably took this photograph of the post office under construction from the third floor of the Davenport Apartment Building (see p. 74). In the 1930s, residences still survived on East Washington across from the post office site.

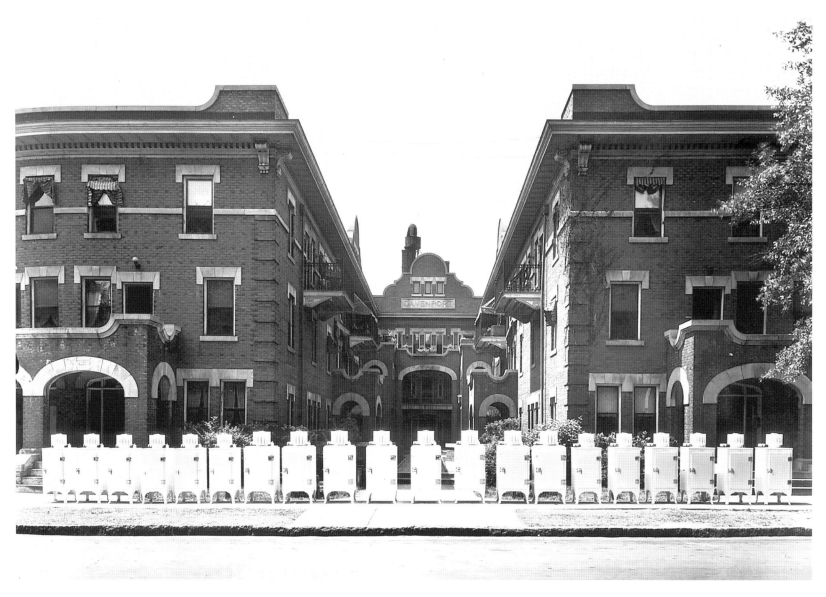

THE DAVENPORT APARTMENTS. One of the most adventuresome building projects of the early 20th century was the construction of the Davenport Apartments on the corner of East Washington and Church Streets. This was Greenville's first large apartment complex. Previously single persons and young couples lived in boarding houses or in one of the small apartment buildings that existed. This three-story complex was built in 1915–1916 for G.D. Davenport by real estate developer Eugene A. Gilfillin. Later Gilfillin became owner of the building. Designed by local architect J.L. Lawrence, the U-shaped structure had a central court with a Jacobean-style gable at the end. Several of the apartments had porches. The sight of refrigerators, with motors on top, lined up for installation must have presented Bill Coxe with an irresistible opportunity for a photograph.

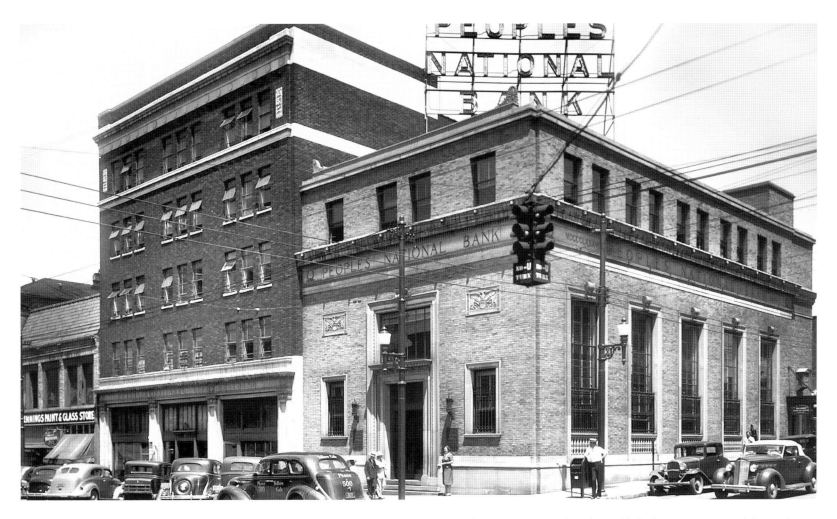

THE PEOPLES NATIONAL BANK. The Peoples National Bank (established in 1887) occupied the northwest corner of West Washington and Laurens Streets, where a livery stable had once operated. Previously the bank had been located on the corner of Main and East Washington Streets in the old Goodlett House/ Wilson Hotel building. In 1926 the bank moved to its new home constructed on West Washington Street by Morris-McKoy Building Company for $84,490. The architects were James D. Beacham and Leon LeGrand. Beacham's father, William C. Beacham, was the bank president. The exterior of the fireproof building was faced with Winnsboro granite. Two terra-cotta plaques, bearing the image of an eagle, testified to the bank's national charter. On the interior much marble was used. In 1972, a high-rise Peoples National Bank Tower was built on Laurens Street where the Virginia Hotel had once stood (see p. 49). By the time the new tower was completed, Peoples National had merged with the Bankers Trust Company. The bank tower blocked off West Coffee Street. At the same time, Laurens Street in this block was narrowed by 20 feet. In 1987 the bank joined with North Carolina National Bank and later became part of Bank of America. The sturdy building, shown in this photograph, was demolished about 1972.

To the left of the bank in the photograph is the Wallace Building or Franklin National Life Building, which was also demolished in the 1970s. This five-story building had retail space on the street level and offices on the upper floors.

THE COFFEE STREET YMCA. The Greenville YMCA was organized in 1876 by a committee of representatives from various churches. Before the organization had its own building, it had several rooms in the Record Building (the 1822 courthouse). Its accommodations there included a gymnasium and other recreational space. In 1912 the first downtown YMCA building was completed on the northeast corner of East Coffee and Brown Streets. The new building was on the site of the former home of Dr. Clinton C. Jones, mayor or Greenville from 1901 to 1903. A double staircase led from the street to the main floor on the second level. The gymnasium was on this level. On the bottom floor was the swimming pool. The top two floors had residence rooms where young men could find secure accommodations. In 1914 John M. Holmes became general secretary of the YMCA. "Uncle Johnny" held that position until he retired in 1942. His successor, W.B. (Monk) Mulligan, served as general secretary until 1968. Altogether, Mulligan was on the staff from 1922 to 1968. In addition to the downtown facility, the YMCA had several other branches in the mill villages and other sections of the city. After the Cleveland Street YMCA was opened, the Coffee Street building was vacated and demolished in 1958. The entire block then became occupied by a modern office building.

THE CUNNINGHAM BUILDING. In addition to the taller and more elaborate buildings constructed on Main Street, there were many smaller and architecturally significant commercial buildings on the cross streets. One of these was the Cunningham Building, which was constructed in 1925 on the northeast corner of East Coffee and Spring Streets. This small building is also seen on the previous page, just beyond the YMCA. The eclecticism of the 1920s led to a revival of interest in the Tudor style of architecture. Because this style was especially popular for larger homes, it became known as "Stockbroker Tudor." The Cunningham Building was constructed of mellowed-brown brick. Double street entrances were surrounded by elaborate stone work. The second floor casement windows had diamond-shaped leaded glass panes. It is no wonder that this little building was an architectural gem, as it was designed by architects as a home for architects. Among the prominent design firms in Greenville in the 1920s was that of the brothers Frank Harrison Cunningham and Joseph Gibert Cunningham. They designed the Coffee Street building as a home for their firm. Among their other commissions was Trinity Lutheran Church on North Main Street and Judd Science Hall on the Converse College campus. The Cunningham Building was demolished to make way for the widening of Spring Street from two lanes into four lanes in the 1970s.

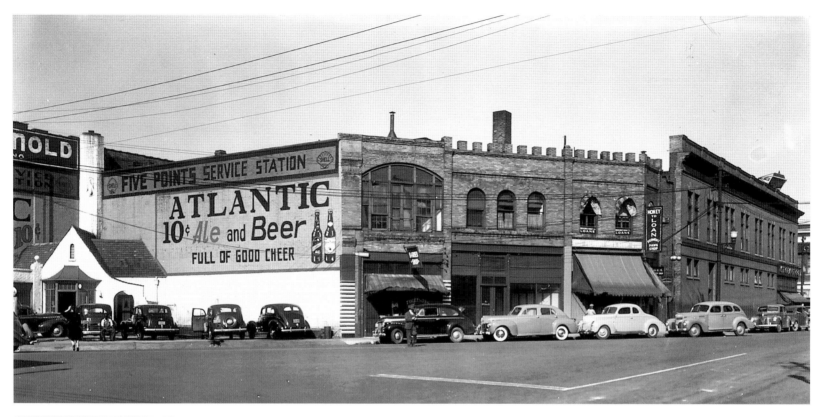

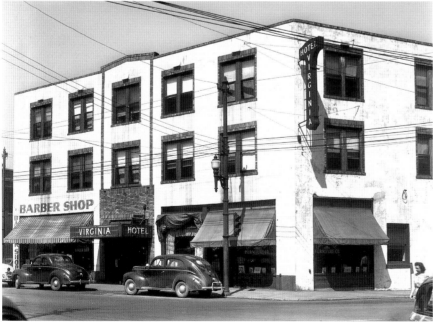

EAST COFFEE STREET. On the far left is the rear portion of Meyers-Arnold. Five Points Service Station is nestled in a small corner. The entrance to the station interior is through a bay that projected from the facade. Tollison's Barber Shop is to the right of the station. The building with the castellated roofline is divided into two stores. The Home Furnishings Company is on the left; to the right is the Piedmont Pawn Shop. On the far right, at the corner of East Coffee and Main Streets, is W.T. Grant's.

THE VIRGINIA HOTEL. Located on the western side of Five Points (see p. 49), the Virginia Hotel is bordered on the left by East Coffee Street and on the right by Buncombe Street. It occupies the former site of the Greenville Opera House and later became known as the Earle Hotel. With 54 guest rooms, the Virginia was numbered among Greenville's first-class hotels when it opened in 1925. The building was demolished in the early 1970s to make way for the Peoples National Bank Tower (later the Bank of America). The new bank building not only took over the hotel property but blocked off East Coffee and Buncombe Streets as well.

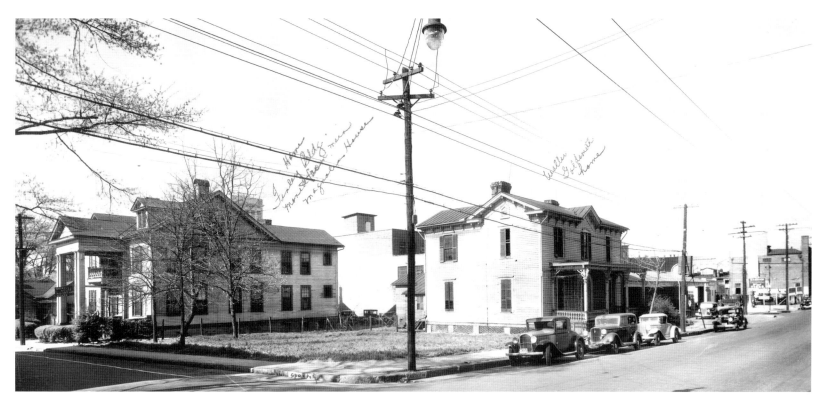

CORNER OF SPRING AND EAST NORTH STREETS. The large house on the left was located at 117 North Spring Street and was one of several downtown boarding houses. At the time this photograph was taken, about 1930, it was operated by Alonzo H. and Mary Bagwell. The house on the right, at 200–202 East North Street, was moved from the corner of North Main and East North. In 1930 it was the McDavid Apartments.

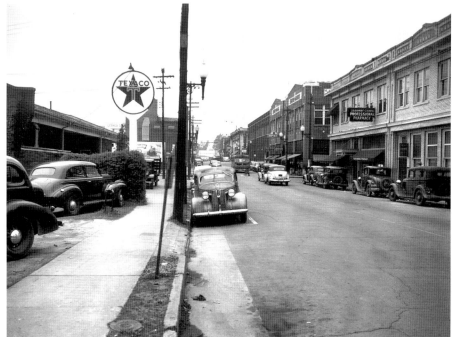

EAST NORTH STREET. On the left side of East North is still another downtown gasoline station. Across the street, occupying most of the second block of East North is the Professional Building, which was on the site of the former home of clothing merchant Lee Rothschild. The Professional Building was erected in 1920 by a consortium of physicians. H. Olin Jones was both the architect and the contractor. A door led from the street, up a broad set of stairs, to a large second-floor lobby. The physicians' offices all opened from the lobby. One receptionist served all the offices, and retail space occupied the street level. The Professional Pharmacy was owned by Douglas Ross and John D. Ashmore.

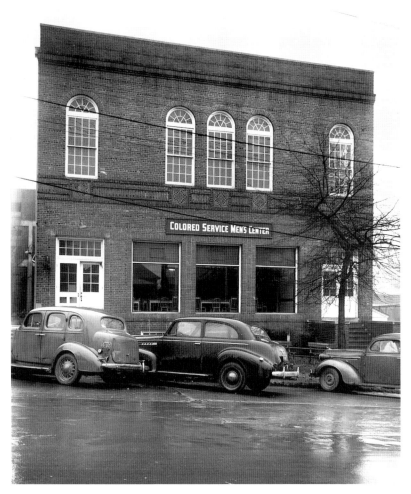

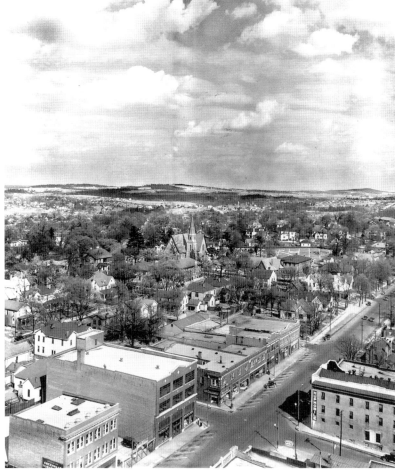

PHILLIS WHEATLEY COMMUNITY CENTER. By the 1920s, Greenville had a small but active middle class from the African-American community. One very active member was Hattie Logan Duckett. After graduating from Claflin College, she attended schools for social work in New York and Chicago. Seeing the need for a social center for young African-American women, she founded the Phillis Wheatley Association in 1919 and bought a house on East McBee Avenue. The center was named for Phyllis Wheatley, who rose from slavery to become the first person of African descent to publish a book of poetry in English (1773.) Desiring to expand the operations of the center to include both young men and women, Mrs. Duckett appealed for support and aid from industrialist Thomas F. Parker. A joint campaign by white and African-American citizens raised funds to build a three-story brick building at 121 East Broad Street in 1924. A branch of the county library was placed in the center. It was the first public library for African-Americans in South Carolina. During World War II, the center provided activities for African-American soldiers.

AERIAL VIEW OF EAST WASHINGTON STREET AND CHRIST CHURCH. Bill Coxe had an excellent view of much of downtown Greenville from his Woodside Building Studio. In this photograph from the 1920s, much of East Washington, East Coffee, and East North Streets is still residential. The only buildings on both sides of East Washington (seen in this photograph) that survived into the 21st century are the two-story buildings on the north side of the 200 block (center foreground). In the center background, the spire of Christ Episcopal Church marks the location of the oldest church in the city. Organized Episcopal worship began in Greenville in 1820 with the founding of St. James Mission. Services were sometimes held in the courthouse. Soon summer visitors from the Lowcountry swelled the number of the Episcopal faith. Christ Church developed from St. James Mission. On four acres of land donated by Vardry McBee, the first service was held in 1826 in a small building constructed in front of the present chapel. The current, larger Gothic building was completed in 1854 after designs by the Rev. John D. McCullough.

THE CITY CURB MARKET. In 1950 the City Curb Market moved from the center of East Court Street to a new facility on Elford Street. On Saturdays the market and the parking lot were full. County farmers continued to bring fresh produce and baked goods for sale. Many Greenvillians had standing orders for eggs and cakes and other products. The skyline in this photograph from the 1950s is dominated by North Main Street's first high-rise apartment building, Calhoun Towers, which opened in 1950. The back of the county library (former Park School) is above the Curb Market. Springwood Cemetery sprawls across Elford Street. By the end of the 20th century, the area covered by this photograph was completely unrecognizable. The widening of Elford and other streets in the late 1970s and the construction of skyscrapers transformed the landscape.

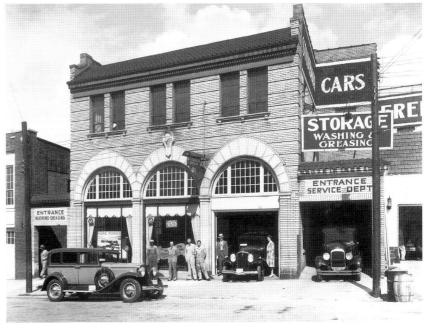

STUDEBAKER SALES COMPANY. At one time the first two blocks of College Street were home to four automobile dealerships and could be considered Greenville's new "Motor Mile." The Erskine Studebaker Company was on the site where the Daniel Building was later built. Bill Coxe was hired to photograph most of the businesses in downtown Greenville.

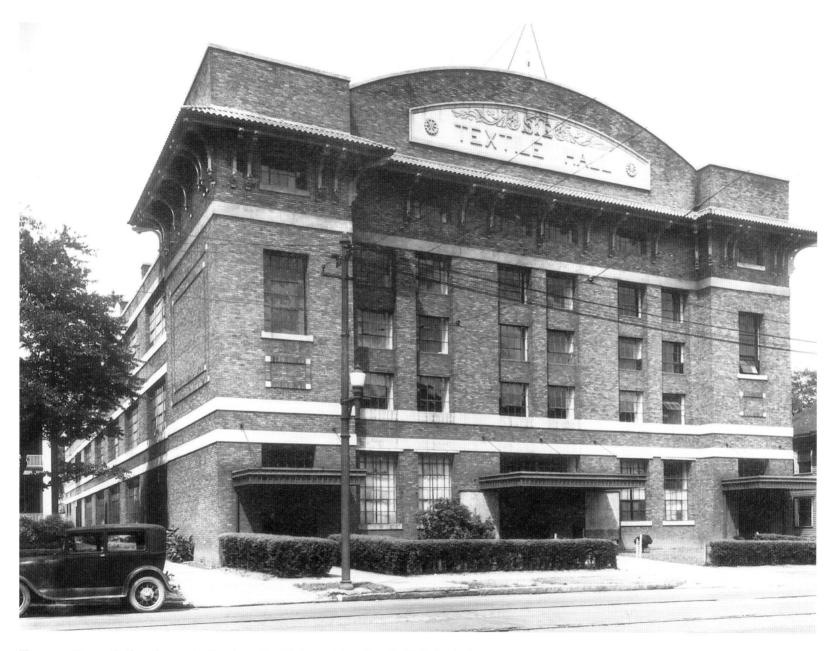

TEXTILE HALL. Built to house the Southern Textile Exposition, Textile Hall also had a stage and backstage equipment suitable for theater productions and could accommodate an audience of 5,000. The first Southern Textile Exposition held in Greenville was in 1915 in the warehouse of the Piedmont and Northern Railroad. Textile Hall was built in 1916–1917 on West Washington Street at a cost of $130,000. The last textile show took place in the old building in 1962. The new Textile Hall opened on Highway 291 in 1964. The Washington Street building was demolished in the 1980s.

SCHOOLS, HOSPITALS, AND CHURCHES

Institutions of learning, service, and worship have been a central feature of life and growth in Greenville. The coming of Furman University and the Greenville Female College played an important role in attracting businesses and keeping able leaders in the community. Medical facilities were equally important. As Greenville grew, so did the Greenville Hospital System. Private institutions, such as St. Francis Hospital and the Shriner's Hospital, provided specialized care. Early religious groups met in private homes. From these beginnings developed some of the most powerful spiritual and social forces in the community.

THE NEW FURMAN UNIVERSITY CAMPUS. Furman was founded in 1826 in Edgefield, South Carolina, and then spent brief periods in High Hills and Winnsboro. In 1851 the move to Greenville was made. In December 1850, the institution had received a state charter designating its legal name to be "The Furman University." The presence of the "article" proved to be awkward. In 1866 the legal name of the institution was changed to "Furman University." By the 1950s Furman had two downtown campuses, more than a mile apart, and no space for expansion. Under the leadership of president John Laney Plyler, a new campus was built on the Poinsett Highway. The move from the old men's campus took place in the summer of 1958. At the time the grounds resembled a tundra. Half a century later, the campus resembled an arboretum. Scenes of the old Furman campuses are on the following pages.

THE OLD COLLEGE. The first building erected on Furman's Greenville campus was a two-room clapboard structure in which the first classes were taught. It stood on the future site of Geer Hall. In 1910 the board of trustees voted to demolish the "Old College." Upon application from several alumni, the board turned over the use and care of the little building to the Quaternion Club, a senior leadership society. By this time the Old College had been moved to University Ridge, a two-lane street that ran downhill from the campus to Cleveland Street. Founded in 1903, the Quaternion Club is Furman's oldest campus organization. Each year at graduation time, prior to the annual reunion of the alumni members, the current senior members are obligated to whitewash their meeting place. In 1958 the Old College was moved to the new campus and placed near the lake on back campus.

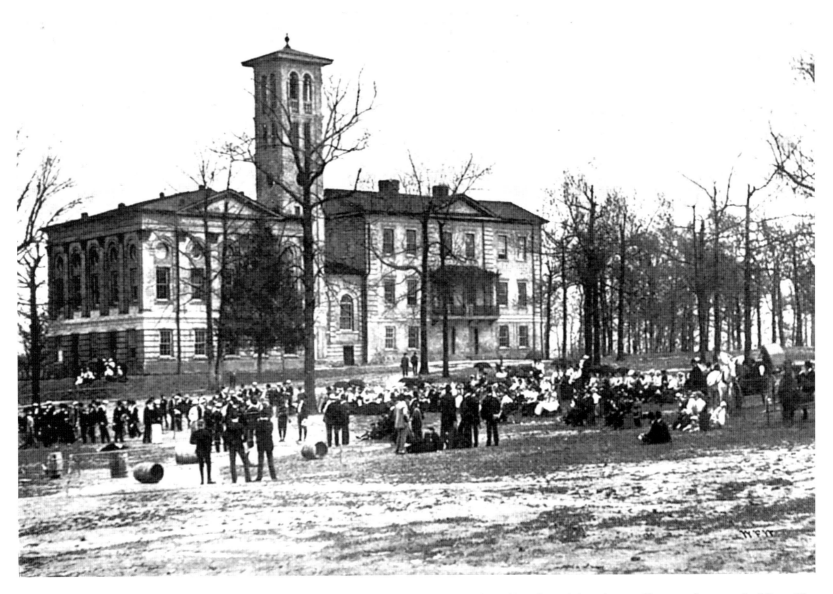

RICHARD FURMAN HALL. The Old College did not long suffice as a classroom building. The Charleston architectural firm of Lee and Hall was commissioned to design a main building. Construction began in 1852 and was completed in 1854. The result was the most architecturally significant building in Furman's history. Designed in the Italianate style so popular in the early Victorian era, the main hall consisted of a central section flanked by an east wing and bell tower. The original plan to add a west wing and tower was never carried out. The building was named in honor of the clergyman who had been instrumental in founding the institution in 1826. The same Charleston architects designed a similar main hall for Wofford College in the Italianate style. The bell tower would become the enduring symbol of the university. A replica was erected in the lake on the new campus.

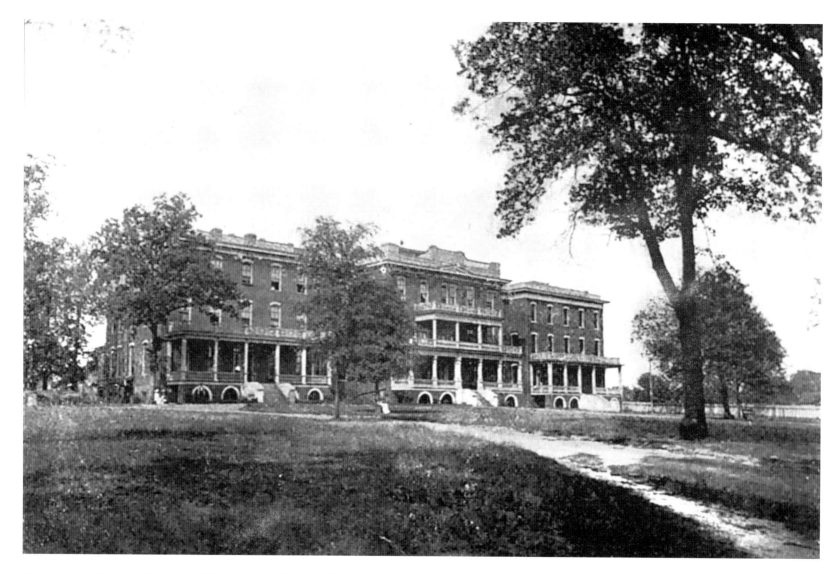

GREENVILLE FEMALE COLLEGE. Not long after Furman University moved to Greenville, the Baptist Convention voted to establish a female college under the same board of trustees. The town of Anderson urged against locating the two institutions in the same town, arguing that "you cannot shut up the chambers of the heart." Nevertheless, Greenville out-bid Anderson by a gift of the property of the old Male and Female Academies. Classes began at GFC on a limited scale in 1855. The first full session was in 1856. The college's main building was begun in 1858, with the additional wings added later. It provided space for classrooms, offices, and dormitories.

In 1914, the name of the institution was altered to Greenville Woman's College. It was supposedly Eudora Ramsay, the feminist daughter of the college president, that convinced her father to drop the offensive word "female." During the Depression, matters of finance dictated that GWC become the Woman's College of Furman University. The process of union began in 1933.

RAMSAY FIRE ARTS BUILDING. The Ramsay Fine Arts Building was completed in 1922 and named in honor of David M. Ramsay, who served as president of GWC from 1911 to 1933. The architects were the local firm of Beacham and LeGrand. The building, with its 1200-seat auditorium, served both campuses and was located where the Greenville Little Theater was later built.

THE WOMAN'S COLLEGE LIBRARY. During its first years, GFC experienced financial difficulties and had to sell some of the land granted by the city. Several acres, and a building that had been part of the Male Academy, were acquired by Judge James Orr. In 1912 the college reacquired the property and the Orr family home, to which extensive improvements had been made. This home became the Judson Library. Previously the library had been in the east wing of the main building. The Judson Library was demolished in 1964 following the move to the new campus.

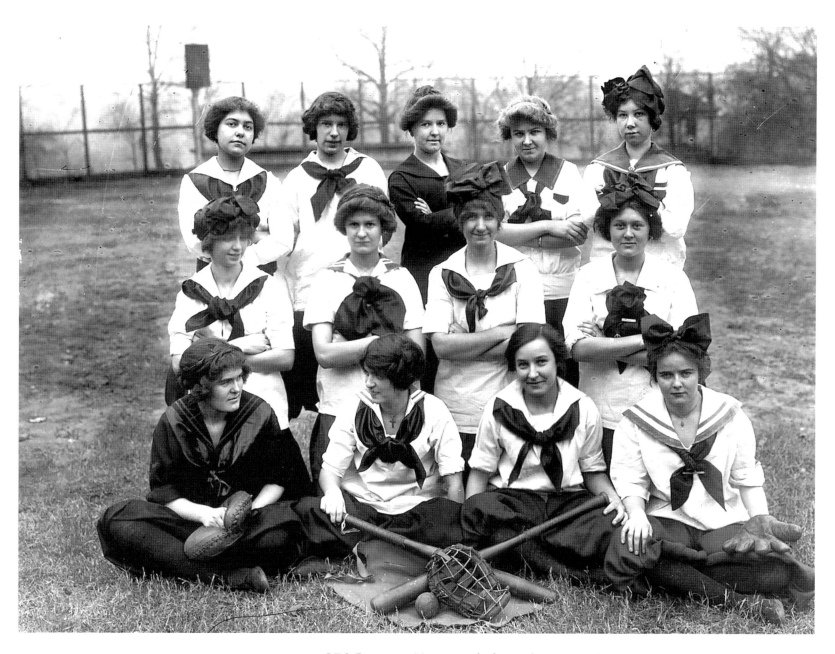

GFC Baseball Team. By the late 19th century, athletics were becoming popular at colleges for women. The Greenville Female College had basketball and tennis teams. The Athletic Association organized six basketball teams that were named the Fiddlers, the Invincibles, the Reds, the Swift Birds, the Scrubs, and the Golds. In addition, there were two tennis teams. Instead of playing teams from other institutions, the campus teams competed against each other for an annual prize. Baseball was another popular sport at GFC. This photograph dates from about 1915 and shows the proper sports attire for women at the time.

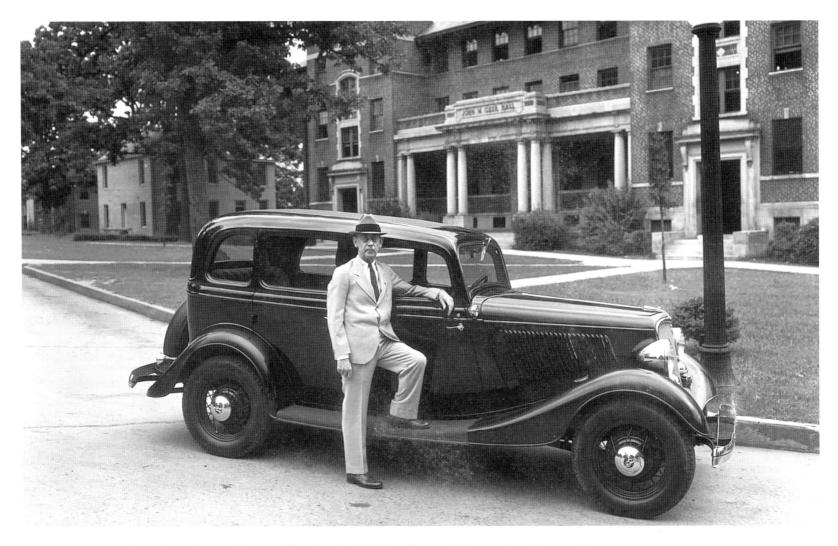

PRESIDENT GEER AND GEER HALL. After receiving both bachelor's and master's degrees from Furman, Bennette Eugene Geer joined the faculty in 1897 to teach Latin and English. From 1907 to 1911, he served as dean. Although he left the Furman faculty to enter the textile business and became president of Judson Mills, he returned as a member of the board of trustees. In this capacity he convinced his friend, James B. Duke, to include Furman as one of the beneficiaries of the Duke Endowment in 1924. This connection proved to be of enormous aid to Furman in becoming a leading university. Ben Geer served as Furman's president from 1933 to 1938. This picture was taken by Bill Coxe as part of a series of promotional photographs for Ford motor cars.

Geer Hall was completed in 1921 at an approximate cost of $275,000. The board of trustees named the dormitory in honor of former trustee and benefactor, John M. Geer, who was also a brother of B.E. Geer. The large building had a recessed porch supported by Doric columns. The interior was designed around a surprisingly modern concept for residence halls. Each residence unit had a small study room with separate bedrooms on each side. The smaller brick building to the left of Geer Hall is Fletcher Hall, which served as a student center. It was the former residence of O.O. Fletcher, professor of philosophy. At the far left of the photograph, the columns of the Webb Memorial Infirmary are just visible. Later this building was converted into administrative offices.

DuPre Rhame. After receiving a bachelor of music degree from Furman, DuPre Rhame (far left) studied at the Eastman School of Music and Julliard. He returned to Furman as a faculty member in 1925 and remained for the next 45 years, retiring in 1970. He organized the Furman Singers, directed the band, and served as dean of students. Rhame organized and conducted an annual performance of the "Messiah," which became a seasonal highlight in the cultural life of Greenville. He also directed the chorus at Greenville High School. This photograph is not clearly identified and probably depicts the GHS chorus.

THE WESTFIELD STREET HIGH SCHOOL. The first city school system was established in Greenville in 1886. There had previously been several schools in the city but without organization and coordination. The first superintendent of schools, W.S. Morrison, was given an annual salary of $950. Two years later, in 1888, two new schools were opened. Oakland School was on Pendleton Street and Central School was on what would become Westfield Street. In 1920 Greenville Senior High School (shown in this photograph) was built on Westfield Street. To clear the site, the Central School was demolished as well as Prospect Hill, one of Greenville's oldest homes. Built by Lemuel Alston in 1799 and bought by Vardry McBee, the house had become the property of John Westfield after McBee's death in 1864. After only 16 years, the Senior High School moved to a new building on Augusta Street in 1936. The Westfield Street school then became the Greenville Junior High School. In the 1950s and 1960s, as subdivisions proliferated around Greenville, the concept of a central junior high school became obsolete. The Westfield Street school was demolished to make way for the Greenville Water Works.

GREENVILLE SENIOR HIGH SCHOOL. With the aid of WPA funds, a new Greenville Senior High School was completed in 1936 at the intersection of Augusta and Vardry Streets. The cream-brick building, which had a modern gymnasium and library, could accommodate 1,000 students. GHS included the 9th through 11th grades. In the 1947–1948 academic year, the 12th grade was offered for the first time. The Class of 1947 was given the option of graduating or remaining for the 12th year. The 9th grade was then moved to the Westfield Street Junior High. At the time there were three high schools in the Greenville metropolitan area, including GHS, Parker High School, and Sterling High School, the latter being for African-American students. Sterling High was close in 1970, by which time Greenville High had been racially integrated.

DONALDSON ELEMENTARY SCHOOL. Located on Tindall Avenue, Donaldson Elementary School was named for Thomas Quinton Donaldson. When the Greenville city school district was created in 1886, Donaldson served as the first chair of the school board. The large wing on the back was originally for junior high students.

In 1939 Donaldson School had the distinction of a visit from Albert Einstein. Noted Furman University scientist John R. Sampey had a daughter in the fifth grade and asked Einstein to speak to the students. Einstein told his young audience to learn "only what they could not find in books." He was in Greenville visiting his son, H. Albert Einstein, who was an hydraulic engineer employed in Greenville by the Division of Sedimentation Studies of the USDA Soil Conservation Service.

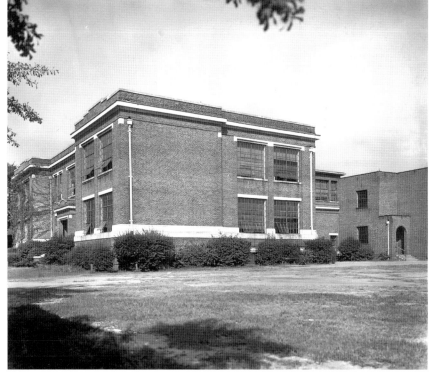

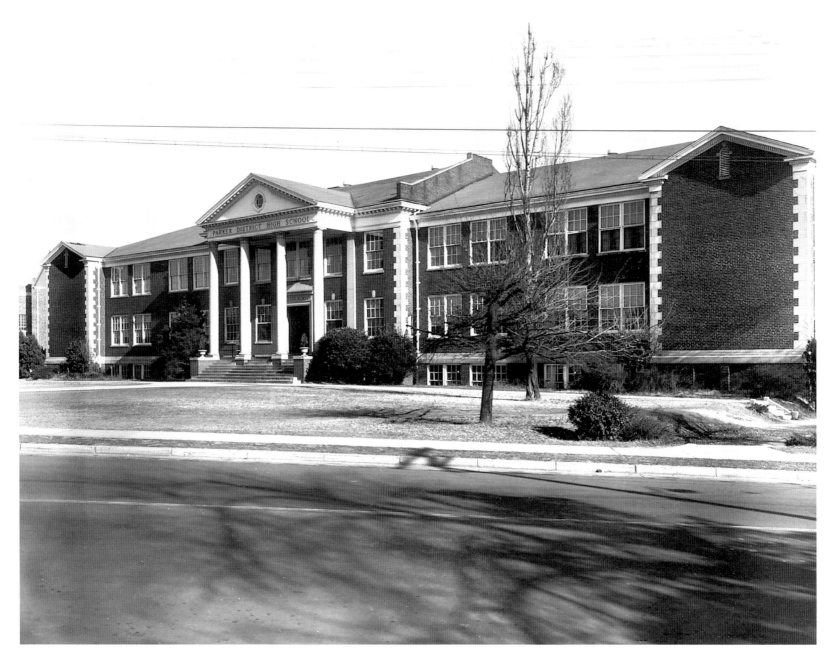

THE PARKER SCHOOL DISTRICT. In 1922 the Parker School District was created and named in honor of Thomas F. Parker. As president of Monaghan Mill, Parker had shown genuine concern for the welfare of the mill operatives. The new school district was extraordinarily fortunate in the appointment of Lawrence Peter Hollis as the first superintendent. Although not a professional educator, Hollis knew what type of education would best serve the needs of the mill communities at that time.

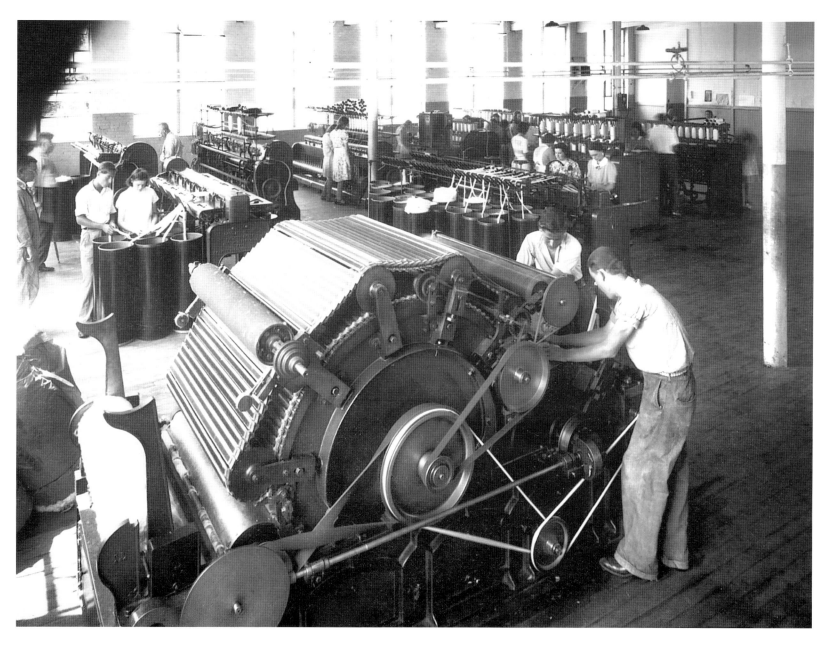

ON-THE-JOB TRAINING. A traditional curriculum was combined with vocational education, which included actual training on the job. Parker High School graduated its first class in May 1924. Sixty years later, the need for a separate school district for the mill communities was no longer a necessity. This was a change brought about in part by the disappearance of the mill villages and by changing social conditions among the mill workers. The last class to graduate from Parker High School was in 1985. The old high school building then became the Parker Middle School.

PARKER HIGH SCHOOL CHORUS. The curriculum and extra-curricula activities at Parker High School were strongly influenced by Lawrence Peter Hollis's understanding of the meaning of progressive education. Above all, the programs were designed to instill self pride in the individual student. Educators from all over the United States and the world came to observe the extraordinary program in the Parker School District. Hollis believed that the goals of education should be determined by the needs of the students, rather than requiring the students to conform to pre-conceived requirements.

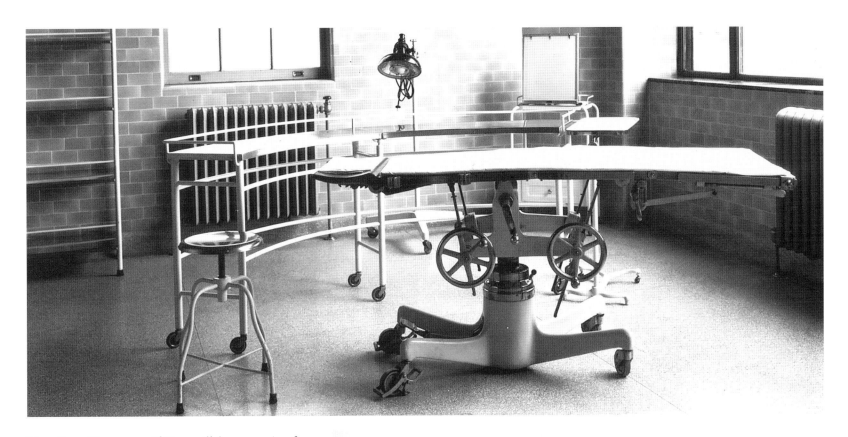

THE CITY HOSPITAL. If Greenville's progression from town to city was to continue, adequate hospital facilities became essential. The private clinics and sanatoriums that existed at the beginning of the 20th century were not adequate. Essential to this process was the Ladies' Auxiliary of the Greenville Hospital Association, which was organized by a group of citizens in 1896. The ladies, more active than the men in fund-raising, eventually dropped their auxiliary status and reorganized as the Women's Hospital Board of Greenville. After years of agitation and fund-raising, the Women's Board and the Hospital Association bought the Corbett Private Hospital on Arlington Avenue for $20,000. The result was Greenville's first public hospital, which opened on January 10, 1912, with 84 beds. Five years later, in 1917, the city of Greenville bought the hospital. In 1921 the Greenville City Hospital completed a large addition (bottom photograph), which fronted on Memminger Street. The new addition had the most up-to-date operating room facilities (top photograph). The hospital remained in this area, with more additions, until the new Greenville Memorial Hospital opened on Grove Road in 1972.

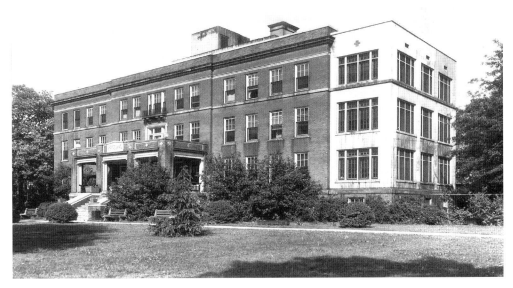

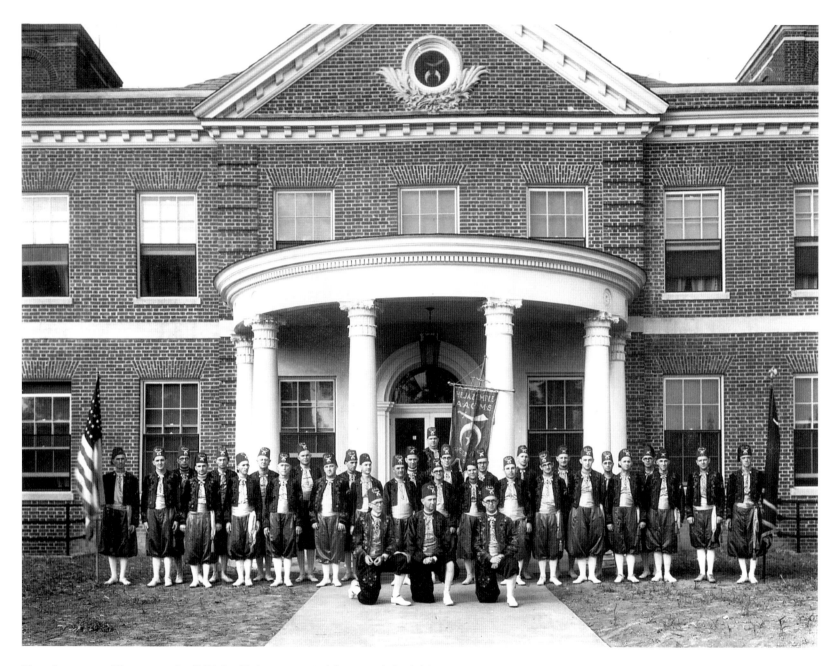

THE SHRINERS HOSPITAL. In 1927 the Shriners Hospital for Crippled Children opened in a handsome Georgian-style building, the entrance of which was marked by an elliptical porch. W.W. Burgess contributed $350,000 for the construction. The operating expenses were undertaken by the Shriners. Children under 14 years of age with an orthopedic condition, and who could not pay their expenses, were admitted. An out-patient clinic was added in 1957. In the early 1970s the hospital moved to Grove Road, near the Greenville Memorial Hospital.

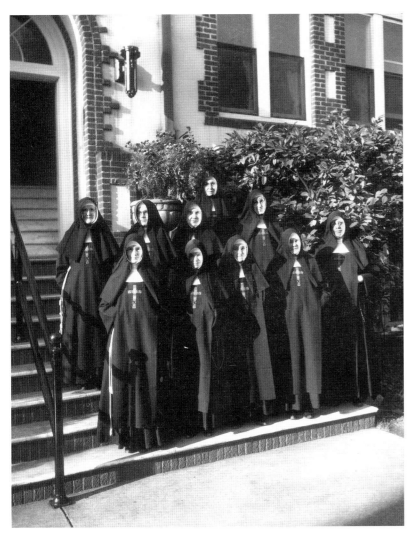

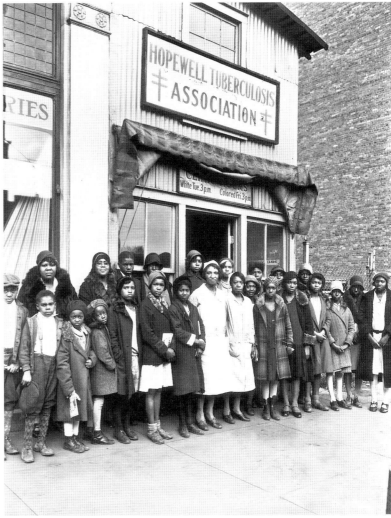

ST. FRANCIS HOSPITAL. In 1924 the Salvation Army took over a clinic for mill operatives and named it the Emma Moss Booth Hospital. Financial difficulties forced the hospital, which specialized in the treatment of young women, to close in 1931. The facility reopened in 1932, in the care of the Sisters of the Poor of St. Francis, as St. Francis Infirmary. A wing was added to the building with the assistance of WPA funding.

TUBERCULOSIS HOSPITAL. Tuberculosis, a communicable disease, continued to afflict many people in the 20th century. The Hopewell Tuberculosis Association was formed in 1915 by a group of Greenville women. The association held a camp on the grounds of the County Home and a clinic at the city hospital. In 1930, with public funding, a tuberculosis hospital was opened outside the city on Piney Mountain. Owned and operated by the county, it was the only hospital for the treatment of tuberculosis in South Carolina. A clinic was also operated in town and is shown above. The clinic saw white patients on Tuesdays and African-Americans on Fridays.

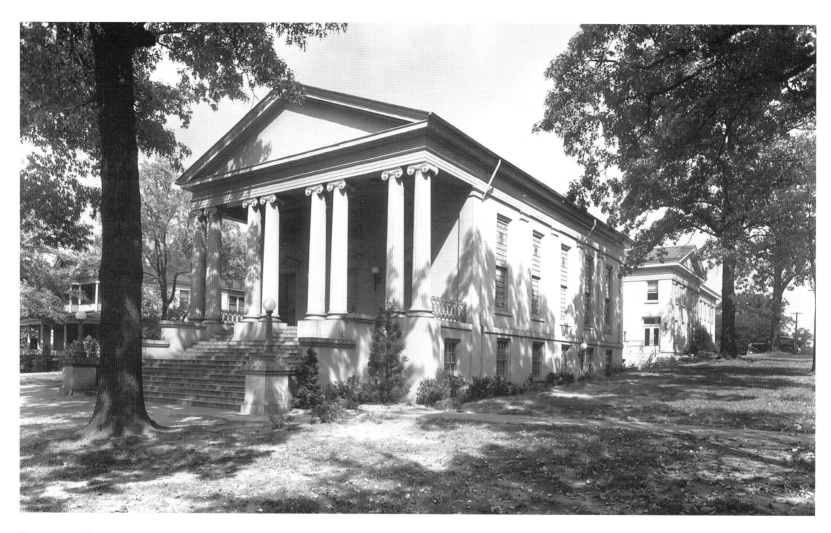

BUNCOMBE STREET METHODIST CHURCH. Vardry McBee donated land to all the downtown churches. To the trustees of the Methodist Episcopal Church, in return for the payment of one dollar, he gave a lot on Coffee Street "on the eastern boundary of the village." Now the possessor of the property, the Greenville Methodist Church was formally organized in 1834. On land donated by Vardry McBee, the small congregation constructed a clapboard church at the corner of East Coffee and Church Streets. Forty years later, when more space was needed, the Coffee Street property was sold and a large block of land was purchased from J.W. Stokes. The front of this property bordered on the intersection of Buncombe, Richardson, and West North Streets. The back extended all the way to College Street. Unfortunately the back end of the land was later sold off. Begun in 1871 and completed in 1873, the new church originally had a cupola-like tower without a spire. It was not until 1892 that the Greenville Methodist Church was officially renamed Buncombe Street Methodist Church. By the time Bill Coxe took this photograph in the 1930s, the tower had been removed. The education building to the rear of the new church was completed in 1927. When a large section of the sanctuary ceiling fell in 1951, construction began on the renovation and extension of the church. The new section of the sanctuary, completed in 1952, extended almost to Buncombe Street. On the interior, the old church had a continuous chancel rail with the pulpit in the center. The new sanctuary, with a seating capacity increased from 550 to 850, had a divided chancel.

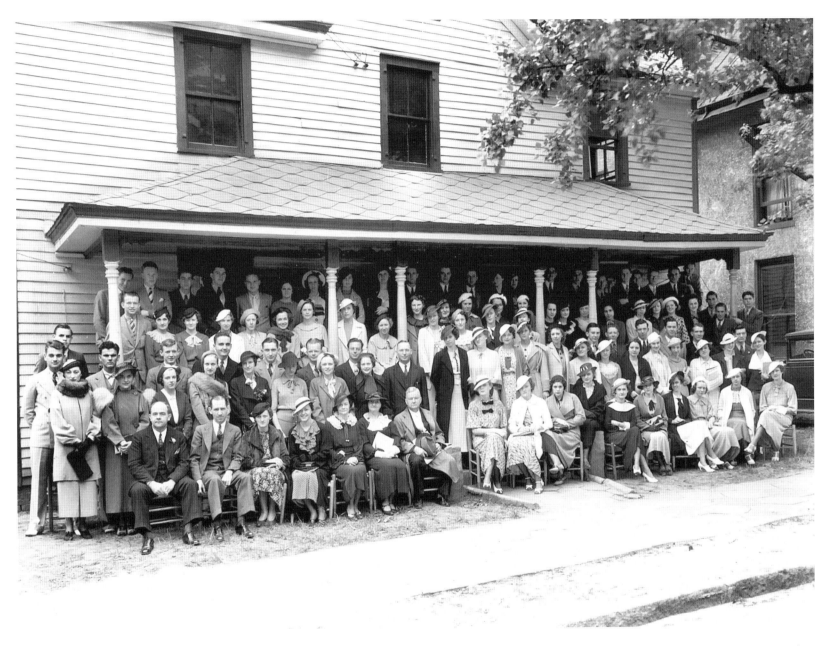

PENDLETON STREET BAPTIST CHURCH. Pendleton Street Baptist Church was organized in 1890 by a group of 82 members from the First Baptist Church. Known at first as the West End Baptist Church, the congregation's original building faced Pendleton Street at the corner of Perry Avenue. Bill Coxe took this photograph of the Young Adults Sunday School Department in the 1930s. The structure in the background is possibly the old Oaklawn School building. Before the Hahn Educational Building was completed in 1938, Sunday school classes met in the former school, located across the street from the church.

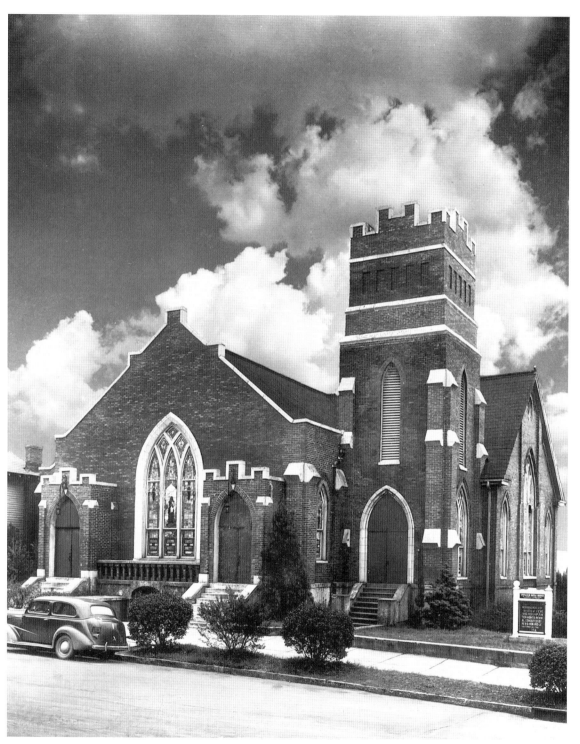

SPRINGFIELD BAPTIST CHURCH. Prior to the Civil War, the Greenville Baptist Church (later First Baptist Church) had African-American slaves as members. After the conflict, a group of ex-slaves desired to form their own congregation. After holding services for several years in the basement of the Greenville Baptist Church, they occupied their new, small, wooden church in 1871 near the corner of East McBee Avenue and McDaniel Avenue. The congregation called itself the Springfield Baptist Church. The large, Gothic-style church photographed by Bill Coxe was constructed in the 1890s on the site of the wooden building. During the Civil Rights Movement of the 1950s and 1960s, Springfield Church served as the base for the organization of the Greenville branch of the NAACP and was at the center of the movement to end segregation. Jackie Robinson was one of the nationally known speakers at rallies that the church organized. Upon departing from the Greenville airport, Robinson was denied the right to sit in the white waiting room. A protest march was organized, which began at Springfield Baptist Church and processed out to the airport.

In January 1972, in the midst of renovations, fire completely destroyed the historic building. Only the bell in the tower survived. That bell was incorporated into a brick marker at the entrance to the rebuilt church. Insurance was inadequate to cover the costs of rebuilding. With help from the community, and with hard work on its own part, the congregation completed a modern church in 1976.

TEXTILE MILLS AND TEXTILE PEOPLE

Although the Civil War brought the "Cotton Kingdom" to an end, more cotton was grown in Greenville County after the war than before. Chemical fertilizers now made possible the continued cultivation of worn-out land. Southern cotton, however, was being sent to Northeastern mills to be manufactured into cloth. In the 1880s and 1890s large mills were built, which would in time give Greenville the right to claim to be the textile center of the South and then of the world. Most of these new mills were built on the western side of Greenville near the Southern Railroad line. Clustered together, they formed an arc that became known as the "Textile Crescent." At the heart of the crescent was the community known as West Greenville. The communities that developed around the mills became a significant factor in the life of Greenville.

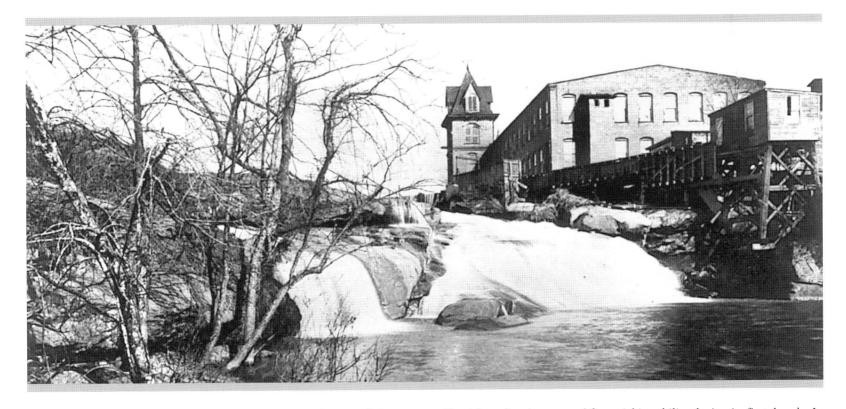

CAMPERDOWN MILL. Organized in 1876, the Camperdown Mill Company suffered from fire damage and financial instability during its first decade. In 1879, the company was bought by Henry P. Hammett, the highly successful founder of Piedmont Manufacturing Company. In the 1880s Camperdown was the second largest mill, after Piedmont, in Greenville County. Camperdown closed in 1956. The building was demolished in 1959.

HOSEA'S RESTAURANT, WEST GREENVILLE. Before it was annexed by the city of Greenville, West Greenville was an incorporated town with its own government and elected officials. One of the most popular eating places in the community was Hosea's Restaurant, located on Pendleton Street. In 1949 Hosea Marrett Sr. purchased the corner restaurant from his uncle, Red Whitney. The location was in walking distance of three mills, which included Brandon, Judson, and Dunean. Because the mills operated on a 24-hour schedule, the restaurant itself never closed. On its matchbook was the slogan "Hosea's Never Closes." Before there was Krispy Kreme and fast-food restaurants, the mailmen met at Hosea's before their deliveries every morning. They drank coffee, ate doughnuts (made in a deep-fat fryer), and read the newspaper. The milkman stopped by also. Hosea's (pronounced "hosey") also served as a convenience store. Behind the counter were cigars, pocket knives, medicines, and handkerchiefs. At lunch and dinner, meat and vegetables dominated the menu. At Sunday dinner, patrons lined up on the street to be seated. Hosea Marrett was an active Shriner and sent a cake to every child at the Shriner's Hospital on his or her birthday. Following his death in 1975, the restaurant was sold.

DUNEAN MILL VILLAGE, 1929. The first mill village in the South was established in the 1840s by William Gregg at his Graniteville Mill in Aiken County. In many instances the mill villages were a practical necessity. Many of the mills were built in areas where adequate housing for the workers was not available otherwise. Housing for the operatives was heavily subsidized by the mills. In the early decades of the 20th century, the rent for mill houses averaged between 25 and 50 cents per room a month for a two- to four-room house. Prior to 1930, the villages had no electricity, and kerosene was the main source of lighting. Cooking was done on a wood stove. For water, each house had its own well. Toilet facilities were outside.

VICTOR MILL VILLAGE IN GREER. Conditions in the early mill villages differed very little from conditions in rural areas of Greenville County. Most of the roads were unpaved. There was a good bit of paternalism on the part of the mill owners. The workers in the villages were expected to be of good moral character. The use of alcohol was prohibited. Church attendance was expected.

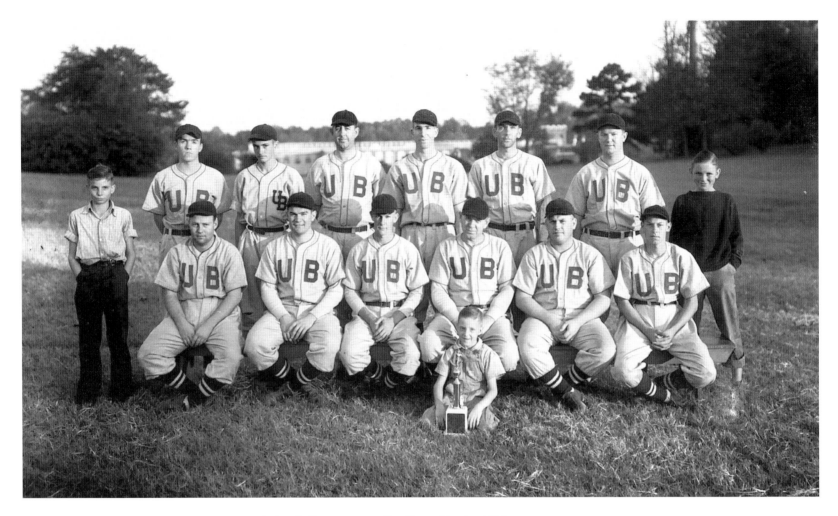

UNION BLEACHERY BASEBALL TEAM. Textile baseball teams were first formed in the 1880s. For both the players and spectators, the games provided a source of recreation and community pride. Operatives worked all week and had little time for diversions. When the work day ended at noon on Saturdays, the games were a welcomed outlet for the village-bound folk. The Greenville Cotton Mill Base Ball League was organized in 1907. The popularity of textile baseball reached its zenith in the 1930s. In addition to games between mill teams, mills sometimes played against college teams. In 1938 WFBC began broadcasting textile league games during the opening week of the season. The decline of the textile leagues began with the sale of village houses and the loss of a sense of community. Then came the wider ownership of automobiles and finally television. During the 1950s, almost all of the textile leagues discontinued their seasons. While it existed, textile baseball was a part of the mill way of life. The leagues gave mill people a sense of place in local society.

Athletics were encouraged at Union Bleachery. Across Buncombe Road from the mill, a well-equipped baseball field with bleachers was constructed. The Union Bleachery community building had a gymnasium, and a nine-hole golf course was laid out on land that had once operated as a mill farm.

SHOELESS JOE JACKSON. Joseph Jefferson Jackson grew up in Brandon Mill village, to which his parents had moved from a farm. Without learning to read or write, young Jackson began working in the mill at the age of six as a sweeper. By the age of 13 he was a full member of the Brandon men's baseball team. Jackson's first professional job was with the Greenville Spinners of the South Atlantic League for a salary of $75 a month. When he removed an uncomfortable pair of new cleats during a game with the Anderson Electricians, he acquired his famous nickname. Greenville News sportswriter Scoop Latimer supposedly first used the nickname, which he overheard from a fan. Graduating from the minor leagues to the majors, Jackson was hired by the Chicago White Sox club in 1915 for a salary of $6,000 a year. Shoeless Joe and several other teammates were charged with throwing the World Series of 1919. Acquitted by a jury, he was still barred from ever playing professional baseball again. Eventually returning to Greenville, he operated several businesses and played semi-professional baseball. Jackson died in 1951 in the midst of efforts to clear his name. He always denied the well-publicized "Say it ain't so" remark.

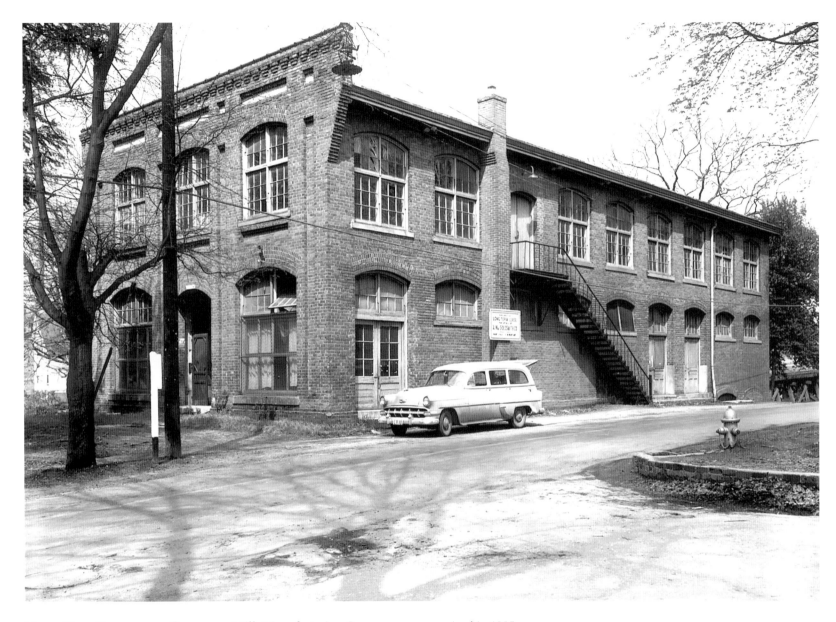

MILLS MILL COMMUNITY BUILDING. Mills Manufacturing Company was organized in 1895 by Otis Prentiss Mills. About this time, low wages, long hours, and the use of child labor began to attract criticism about the conditions in the mills. In response to this, and in hopes of creating a more stable labor force, many mills undertook a program of company-sponsored activities. In their limited free time, workers had little inclination or facility for far-flung recreational activities. Mills built community centers, such as the one photographed by Bill Coxe at Mills Mill. Local branches of the YMCA and county libraries were accommodated in these centers. Recreational and educational activities were provided. Baseball teams and brass bands were organized, and nurseries were provided for mothers.

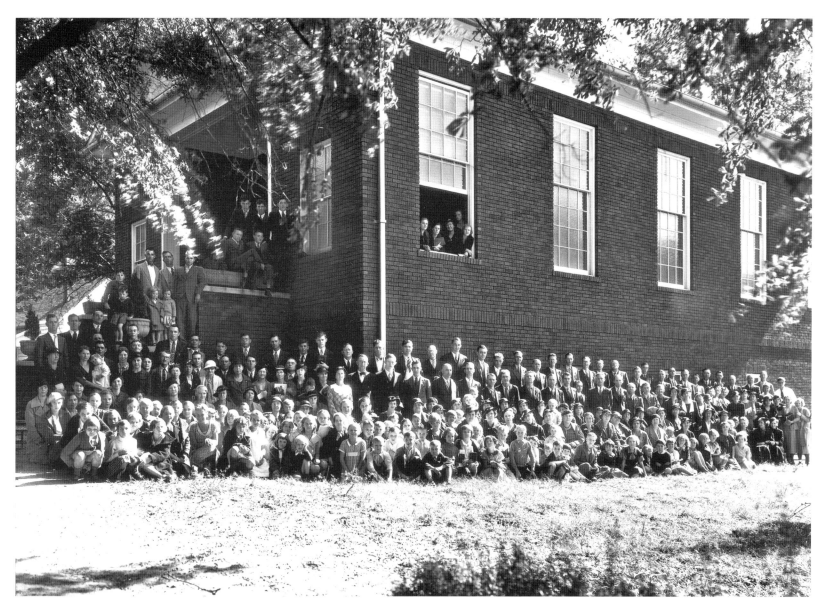

MILLS MILL BAPTIST CHURCH. A typical mill village consisted of the workers' cottages, a superintendent's house, a school house, a company store, and one or more frame churches—all provided by the company. The church buildings would be shared by several denominations. The mill owners favored the Baptist and Methodist churches, denominations that taught a proper work ethic. Evangelical and holiness churches were discouraged, as these sects stirred up the workers emotionally and sometimes gave them a sense of independence. As the mill villages matured, the company often donated property and partial construction cost for the building of separate churches by mill congregations. The company often contributed toward the salary of the minister as well.

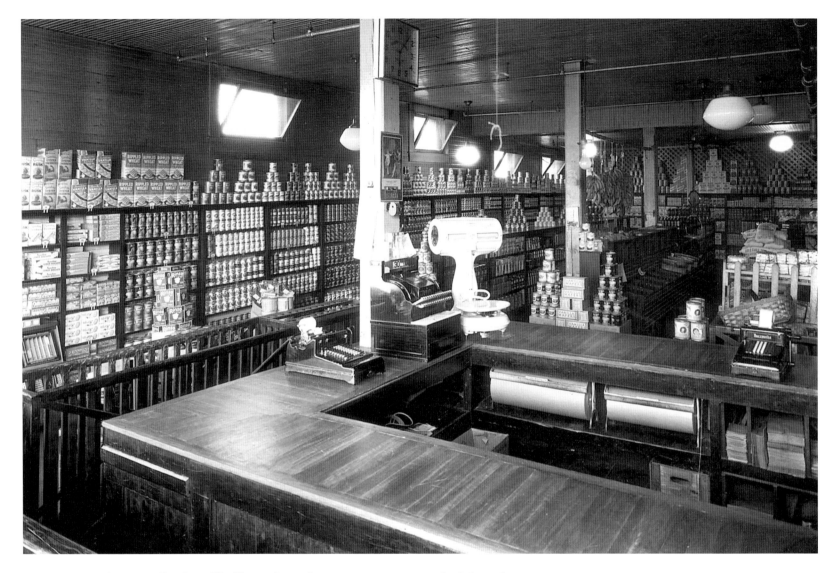

JUDSON MILL STORE. Like the mill villages themselves, company stores resulted from the relative isolation of the mills and lack of transportation by the workers. Travel into nearby towns on buying trips would have been a burden, if not impossible. In the long run, the company store often came to be despised by the workers. The stores served not only the needs of the workers but the needs of the owners as well. Many of the early mills began with limited capital investment. The company store was a way for the owners to get back some of the capital paid out in wages. One problem for the owners was the frequent changing of jobs by the workers. A stable labor force could be maintained more easily by keeping the workers constantly in debt. Textile workers had difficulty obtaining credit elsewhere, but they could get it at the company store. Many mills deducted bills form the workers' wages. Sometimes a worker got little or nothing from a week's salary. By the 1920s the company stores were becoming less of a necessity for both workers and owners, and they began to disappear.

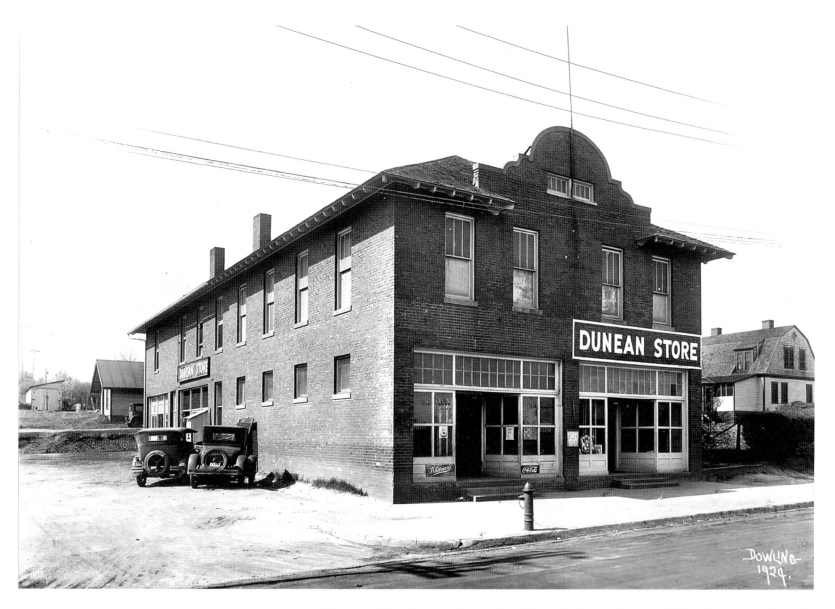

DUNEAN MILL STORE. Founded by Ellison A. Smyth, Dunean Mill took its name from the river in Ireland where Smyth's forebears had manufactured linen cloth. J.E. Sirrine and Company of Greenville was the architect and engineer for the mill, which began operations in 1912. In addition to cottages for the workers, the mill operated a day-care center and built a gymnasium, ball park, and the first YMCA building at a South Carolina mill.

The mill store, shown in this photograph by William P. Dowling, was utilitarian in its construction but included a striking Jacobean-style gable on the front. On the second floor was a meeting room, which served the operatives as both a community center and a church until other facilities could be built. Eventually Dunean was acquired by J.P. Stevens and Company. The mill store was demolished in 1994.

UNION BLEACHERY. Northern investors established a bleachery on the Buncombe Road in 1903. Almost immediately, the bleachery suffered from bad management and faced bankruptcy. In 1904 John W. Arrington was brought from North Carolina as mill treasurer. Using his experience as a mill manager, Arrington turned the operations around and eventually acquired ownership. In 1922 the mill was named the Union Bleachery. Arrington was joined by his three sons in managing the business. The Arrington brothers became associated with improvements in the mill village. One worker commented that at Union Bleachery he was not a number but a person, whose name was known by the owners.

Bill Coxe took this photograph of the Arringtons with a group of long-time employees in 1930. John W. Sr. is seated in the first row. The Arrington brothers are on the far right of the third row. From left to right are Richard (without a jacket), John W. Jr., and Nelson.

SOUTHERN BLEACHERY. Harry R. Stephenson came to Greenville in 1911 as superintendent of Union Bleachery. A native of Tennessee, he had attended the Philadelphia Textile Institute. John W. Arrington, president of Union Bleachery, encouraged Stephenson to found his own company. Southern Bleachery opened at Taylors in the spring of 1924, with H.R. Stephenson as its president. The new mill, for which a village and a high school were built, was the first in the area equipped to both bleach and dye cloth manufactured at other mills.

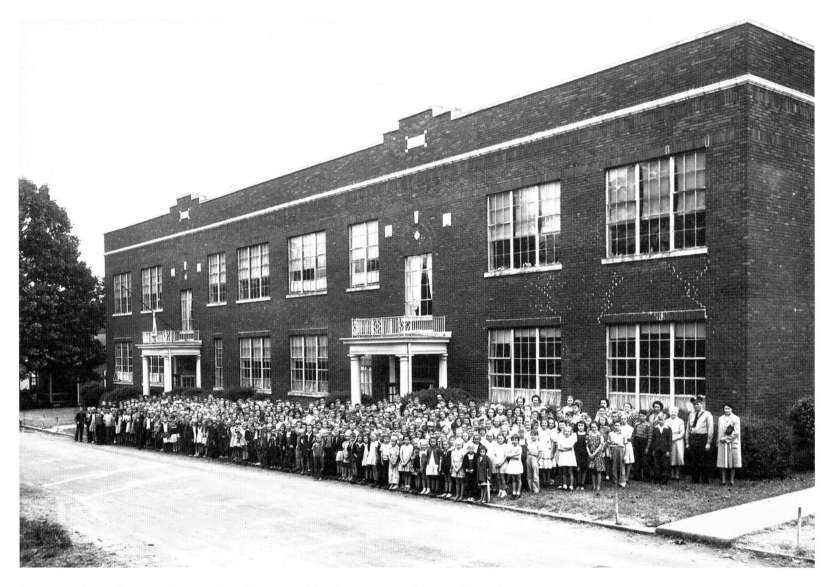

BRANDON MILL SCHOOL. The textile mill communities that surrounded Greenville at the beginning of the 20th century were not included in the City School District. The mills established their own elementary schools. Mill owners provided the buildings, and the teachers were on the mill payroll. Small cash rewards were sometimes made to pupils with perfect monthly attendance records. Education stopped, however, after the sixth grade. The expectation was that the children would then begin work in the mills. To continue their education, mill youths had to pay tuition at city or county high schools.

After the Parker School District was established in 1922, the schools in the mill villages were separated from the companies. As is shown in the photograph on this page, better facilities were provided. Also, mill youths could now go on to acquire a secondary education without paying fees. Bill Coxe took many school pictures.

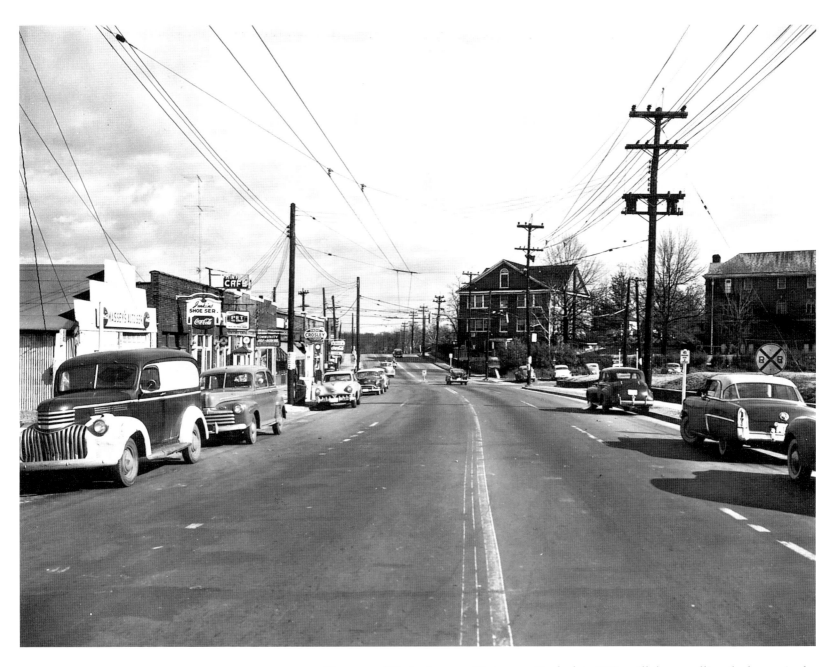

HIGHWAY 123 AT JUDSON CROSSING. By the late 1930s mills began selling the houses in the villages to the workers and also to non-employees. It was thought that home ownership would give workers a greater stake in a community and, at the same time, reduce their mobility. In most cases, the appraised value of the houses was below the market value. The process of selling off the mill houses was accelerated after World War II. By the 1950s and 1960s, virtually all the villages had been sold.

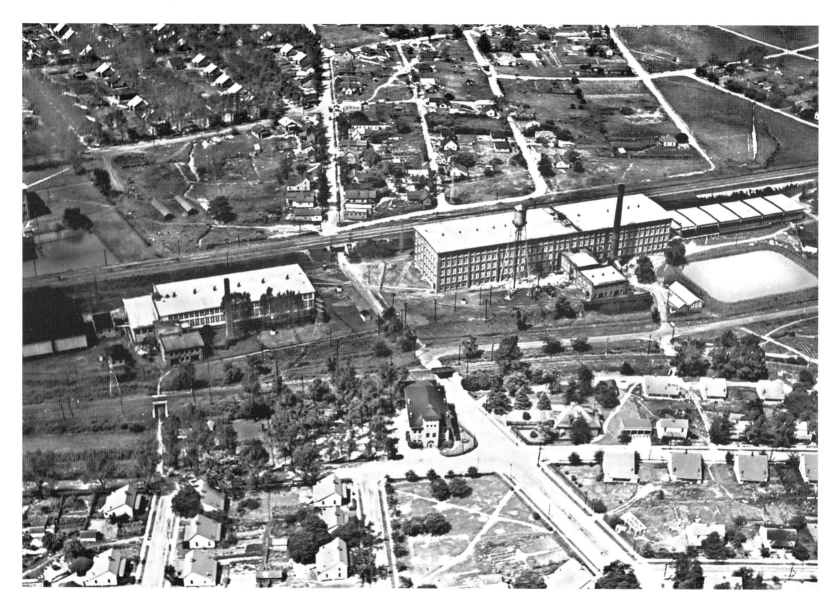

POE MILL AND AMERICAN SPINNING COMPANY. Bill Coxe was fascinated by arial photography and even learned to fly a plane himself in order to take pictures. This arial view of Poe Mill and the American Spinning Company provides a classic view of a mill and the surrounding village. The large building on the left is F.W. Poe Manufacturing Company, which was organized in 1895 by Francis Winslow Poe and began operations in January 1897. Its main building, four stories in height, was an eighth-of-a mile long. In 1912 male workers at Poe Mill started at 10 cents an hour. For a 60-hour, 6-day week, the earnings were $6. Poe Mill had one of the largest villages. By 1930 its population was 2,050. Poe Mill was destroyed by fire in 2003.

The American Spinning Company is the smaller building on the left. In 1894 Oscar H. Sampson founded the Sampson Mill, which was later reorganized as the American Spinning Company.

GROCERS, PACKERS, AND BOTTLERS

Bill Coxe was hired to photograph most of the commercial establishments in Greenville. His photographs constitute a valuable documentation of the city's business community in the first half of the 20th century. Earlier chapters in this volume have shown the businesses in the central downtown area. Chapter Six offers a representative selection of more downtown establishments as well as others outside the central business area. In addition to recording Greenville's commercial architecture, some of the photographs also show the employees who staffed these businesses.

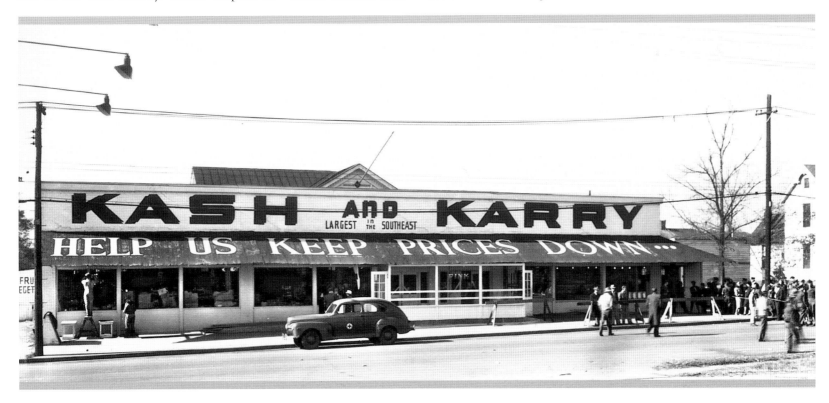

KASH AND KARRY. Before there were the giant discount chains and buying clubs, there was Kash and Karry. This Greenville institution began in 1930 as a small grocery store on Mulberry Street operated by J.S. Myers. Both Mr. and Mrs. Myers were active in the Greenville community. As the business prospered and expanded, it occupied part of the Ideal Laundry building and then moved to the 50,000 square-foot store that Bill Coxe photographed at 913 Buncombe Street. Volume sales, no-frill displays, and no advertising added up to discount prices. Goods were sold out of the original shipping boxes stacked on the floor of the store. Twenty-five check-out stations and 225 employees expedited the shopping expeditions of hundreds of customers.

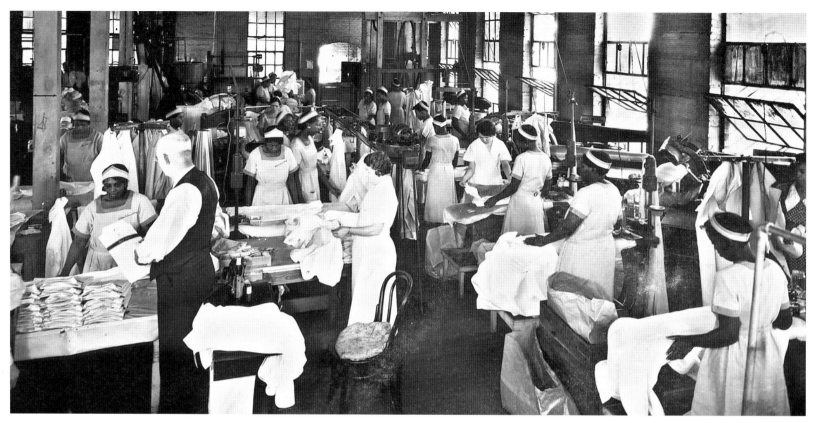

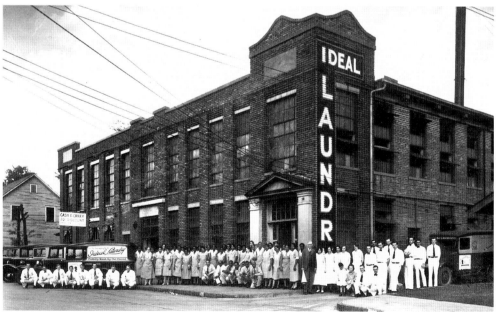

THE IDEAL LAUNDRY. Before the advent of home washers and dryers, commercial laundries eased the burden of home wash days. Although washing continued to take place in kitchen sinks, backyard tubs, and mountain streams, commercial laundries offered the urbanized Greenvillian a convenient service. The Ideal Laundry and Cleaner's main plant, pictured to the left, was located on Buncombe Street at the corner of Echols Street. At small pick-up and delivery branches throughout the city, curb service was available to the customer. Home pick-up and delivery was also available. The plant on Buncombe Street offered employment to African-American women. While on the job they wore uniforms, including caps, similar to those expected of housemaids. The delivery trucks were driven by white men dressed in white shirts and trousers and black ties. The main entrance to the plant, with heavy pilasters and pediment, is typical of the architectural adornment placed on otherwise austere exteriors in the early 20th century. The corner tower is possibly in imitation of textile mill architecture.

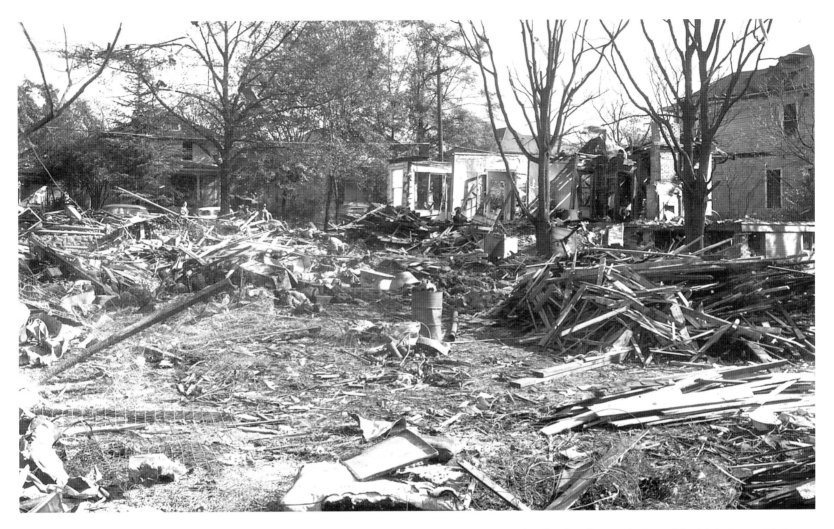

THE IDEAL LAUNDRY EXPLOSION. Shortly after the conclusion of the Main Street Christmas parade on November 19, 1946, an explosion rocked downtown Greenville that many thought was an earthquake. A propane gas explosion completely destroyed the Ideal Laundry and 10 surrounding houses. The Kash and Karry grocery store was damaged, as well as other nearby businesses. Some laundry employees were still in the building. Six were killed, and the injured numbered 120. Furman University historian A.V. Huff Jr. (writing in 1995) described the explosion as "the worst catastrophe in the history of the city of Greenville."

WFBC Radio station manager, Bevo Whitmire, lived on Buncombe Street. He ran to the station studio in the Poinsett Hotel to organize live coverage of the disaster. Whitmire, Norvin Duncan, and Jack Fulmer then raced to the scene. In the litter-strewn Kash and Karry store, Fulmer, the station engineer, found a telephone, hooked up an amplifier, and Duncan went on the air to give Greenvillians a live account. The result was the most extraordinary broadcast in the history of Greenville radio. Even when warned by the police of the possibility of a second propane tank explosion, the three remained at their job. In fact, when the warning came, Whitmire asked Duncan "if he could get in a little closer."

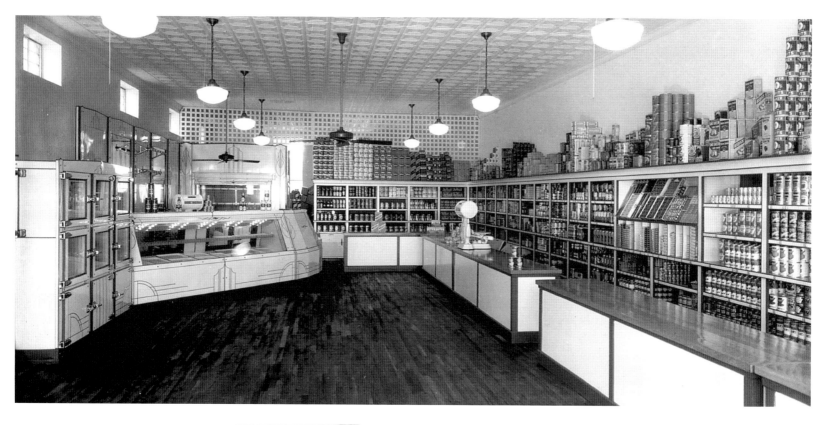

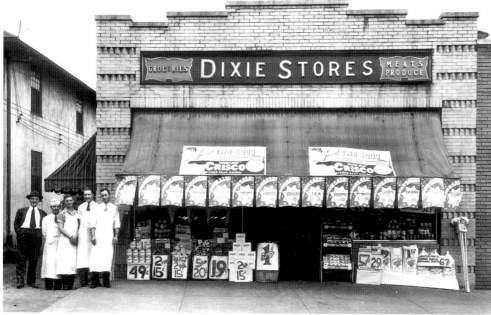

THE DIXIE STORES. Typical of the business mergers that were transforming Greenville from a small town into a commercial center was the evolution of two small grocery store chains into a regional chain of supermarkets. The Dixie Stores were organized by James P. Williamson, Marion Shafter Merritt, and Reece Parker. Their chain of 94 stores was based in Greenville. In 1937 the Dixie Stores merged with the 90 Home Stores, organized in Columbia by Robert E. Ebert. In 1955 the Dixie-Home chain merged with the Winn and Lovett chain of Florida. Soon the Winn-Dixie Stores grew into a regional chain with more than 600 stores in the Southeast.

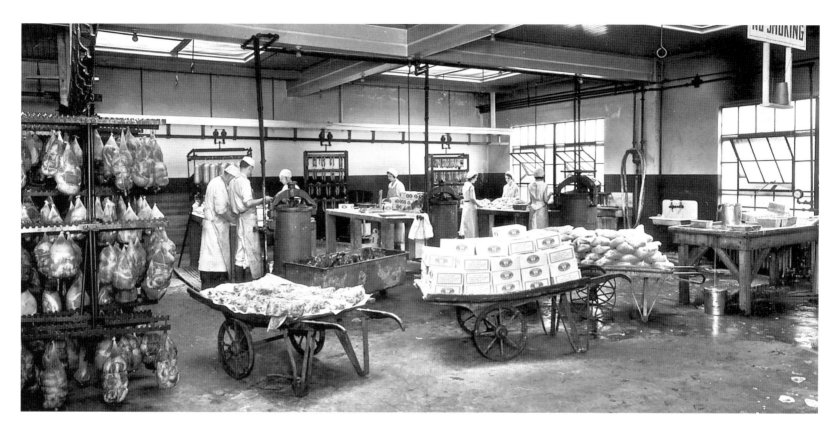

BALENTINE PACKING COMPANY. The dominance of the textile industry in the early years of the 20th century gave Greenville's leaders some cause for concern. A welcomed source of diversification came in 1917 with the founding of the Balentine Packing Company. William Hampton Balentine came to Greenville at the age of 20 from Laurens County and operated several meat markets. Since there was no meat-packing industry in the entire state, Balentine saw an opportunity. In the shadow of the Record Building on the south side of East Court Street, he began a packing company that became state-wide in the distribution of meat products. The plant expanded in time to cover an entire block. By 1930 Balentine Packing Company had the capacity to slaughter 125 hogs an hour. Although W.H. Balentine died at the age of 49, he left an able wife and 11 children to carry on the business he founded. The logo of the company became an "aristocratic pig," portrayed in an upright position sporting a monocle and top hat. Bill Coxe became the official photographer of the company and made a series of promotional photographs. In the bottom image the tower of the John Wesley Memorial Methodist Church is at the extreme right.

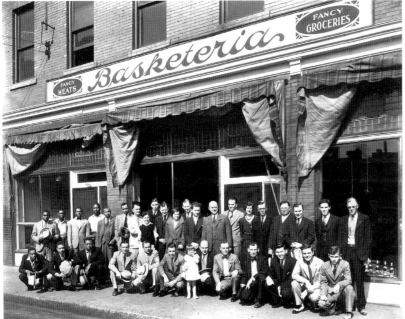

THE DELUXE DINER. In addition to cafes and restaurants, downtown Greenville also had several small diners, some of which actually were converted railroad dining cars. Located at 336 North Main Street and operated by James A. Tzouvelekas, the Deluxe Diner was between the Carolina Theater and Mackey's Mortuary. In this photograph, the Carolina parking lot is to the right of the diner, with the Ottaray Hotel in the background. Serving complete lunches and dinners, the Deluxe advertised itself as the "Home of the World's Best."

THE BASKETERIA. Advertising "Fancy Meats" and "Fancy Groceries," the Basketeria was one of the largest of Greenville's downtown grocery stores. First located on North Laurens Street, the store re-located in 1946 to the south side of the 200 block of East Washington Street. Later, this block became part of Wachovia Place.

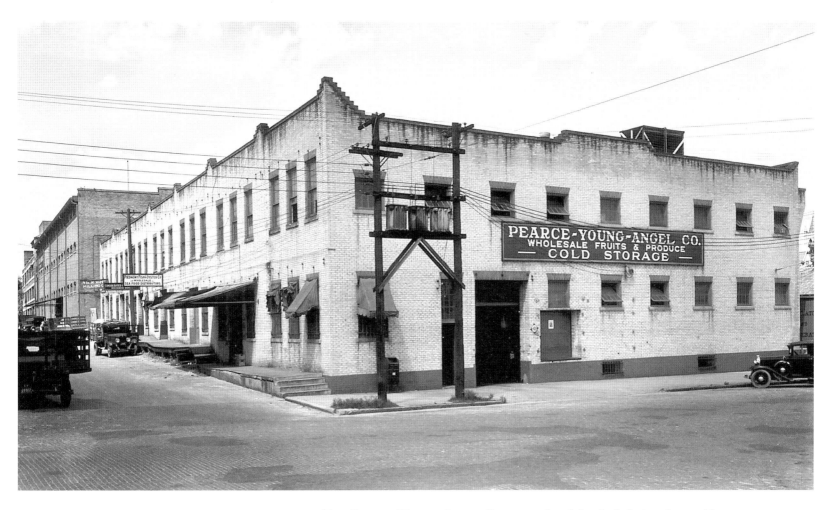

THE PEARCE-YOUNG-ANGEL COMPANY. Supplying fresh fruit and vegetables to grocery stores, Pearce-Young-Angel was founded in Columbia in 1903 by Christopher Columbus Pearce. In 1926 the business expanded its operations to Greenville under the guidance of C.C. Pearce Jr. At this point the firm ceased to be a mere purveyor of fresh produce and entered the food service industry as a supplier to restaurants and hotels. In 1937 Pearce-Young-Angel became the first in the area to handle the distribution of frozen foods. In 1967 Pearce-Young-Angel formed a merger with Consolidated Foods, distributor of the Monarch brand of foods. The name of the firm then became PYA/Monarch Inc.

When first coming to Greenville, the company was located at 490 McBee Avenue in a former warehouse of the Piedmont & Northern Railroad. In 1960 PYA/Monarch moved to the White Horse Road.

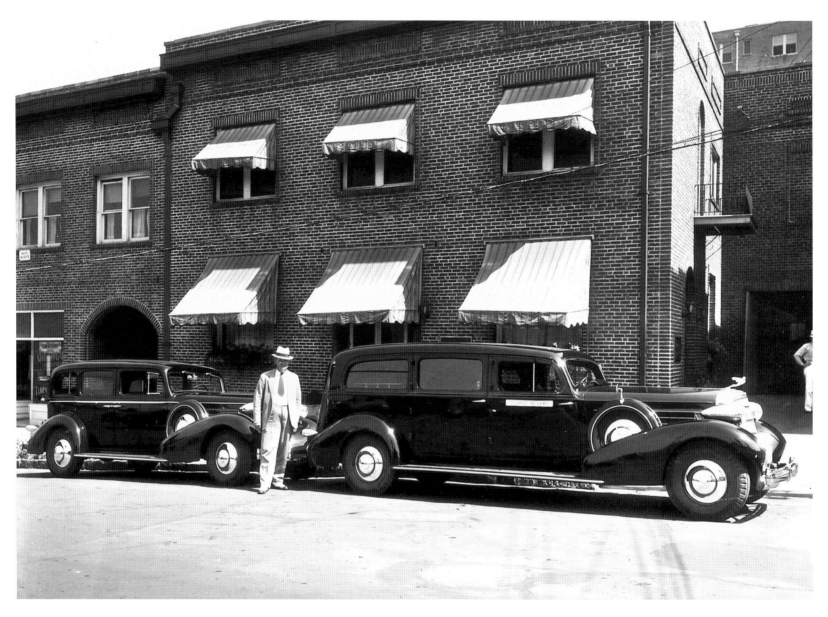

THOMAS MCAFEE FUNERAL HOME. Among the oldest of Greenville's family-owned businesses is the Thomas McAfee Funeral Home. In 1913 the founder came to Greenville from Georgia and became a partner in Ramseur-McAfee Company. Just a few years later the new funeral home was called upon to assist after the deaths of hundreds of soldiers at Camp Sevier in the flu epidemic of 1917–1918. In 1923 Thomas McAfee entered into a new partnership with R. David Jones to form the Jones-McAfee Company. The firm's new premises on West McBee Avenue was one of the most modern and elaborate in the Upstate. Later, Jones and McAfee separated to form their own individual companies. Thomas McAfee, whom Bill Coxe photographed with two of the company vehicles, remained at the West McBee Avenue location.

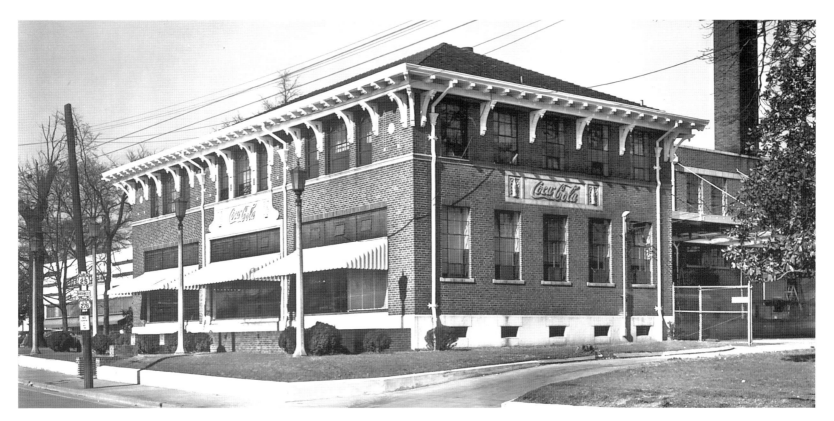

COCA COLA BOTTLING COMPANY. The Coca Cola Bottling company in Greenville was established by Charles W. Ellis. Following her husband's death in 1918, Stella Ellis capably assumed direction of the company. In 1930 a new bottling plant was built on four acres of wooded land on Buncombe Street. Although the brick building resembled Coca Cola plants in other towns, the Greenville building was distinctive. Defining the roof line was a heavy cornice supported by decorative brackets. In addition to being utilitarian, the ornamental down spouts and lampposts served a decorative purpose as well. The large plate-glass windows on the front allowed persons passing by to observe the bottling process, which included the use of water from Paris Mountain.

In 2002 the old bottling company site became the location of the new home of the Greenville County Public Library and of the Greenville Museum of Upcountry History. The front section of the Coca Cola building (shown above) survived.

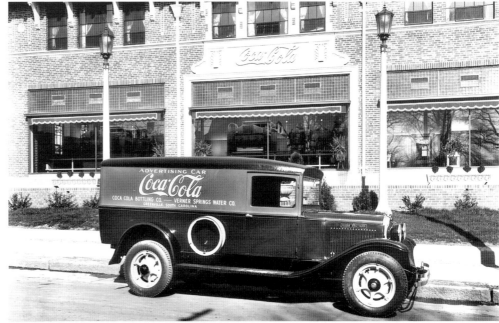

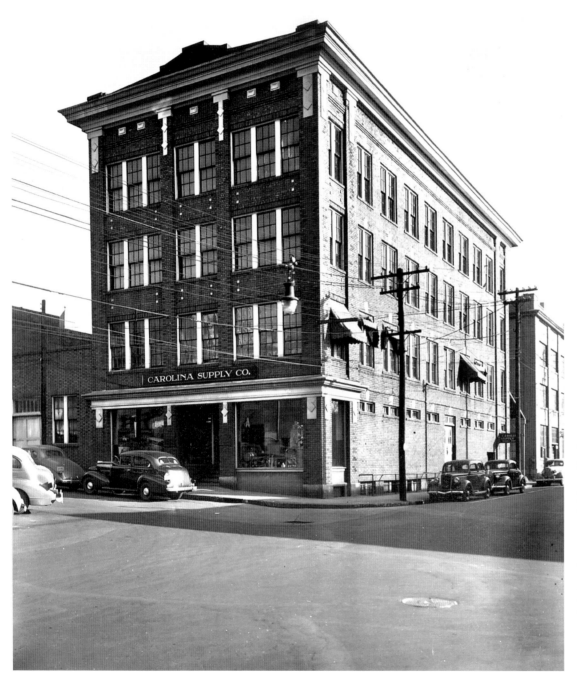

THE CAROLINA SUPPLY COMPANY. Large industries spawn smaller companies that supply the needs of the larger manufacturers. The phenomenal growth of Greenville's textile industry in the last decades of the 19th century created a need for mill supply companies. The Carolina Supply Company was organized in 1899 by a group of businessmen that included T.S. Inglesby, Francis Joseph Pelzer, and his namesake, Francis Joseph Pelzer Cogswell. Eventually Inglesby and Cogswell became sole owners. Carolina Supply grew to become one of the largest mill supply companies in the southeast. In 1914 the company constructed this large, four-story building on West Court Street.

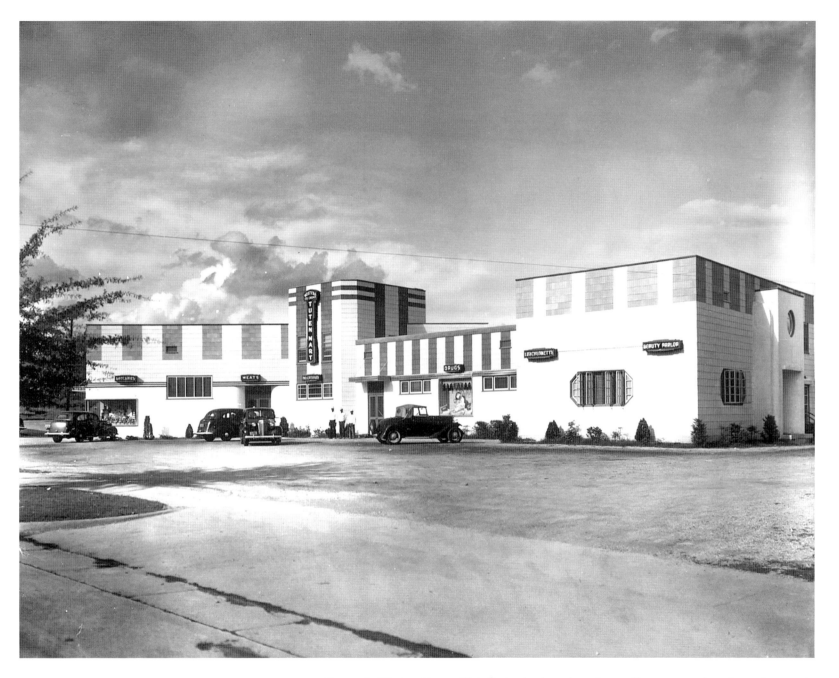

TUTEN'S MART. Greenville's first suburban shopping mall was opened on Jones Avenue in 1946 by Ralph O. Tuten Realty Company. The Piggly Wiggly grocery store anchors the left end. The middle portion is taken up by a drug store and luncheonette. In the unit at the right is the University Beauty Shop.

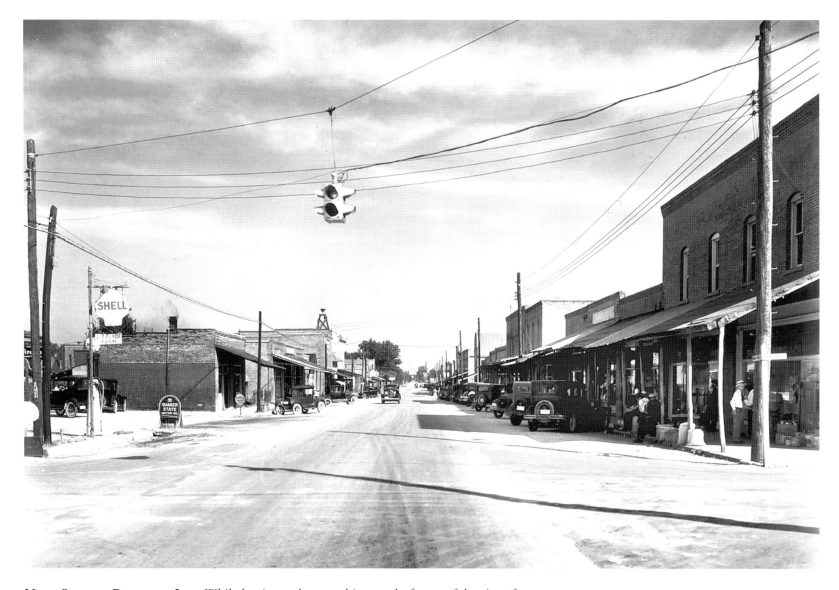

MAIN STREET, FOUNTAIN INN. While leaving a photographic record of most of the city of Greenville, Coxe also photographed many of the small towns in Greenville County. Fountain Inn was a stagecoach stop on the Old Stage Road from Greenville to Laurens. In 1832 a post office was established at the site of the future town. Following the Civil War, the site of the town was acquired by Noah Cannon. Later he transferred the land and his store to his son, James A. Cannon. James Cannon eventually sold half the property to James I. West. Like most small towns in the county, Fountain Inn owes its existence to the coming of the railroad. In 1884 the railroad line from Greenville to Laurens came through the area, and a railroad station was established. Cannon and West divided the land around the station into lots and acquired a charter for the new town of Fountain Inn. Economic growth followed the opening of the Fountain Inn Cotton Mill in 1898.

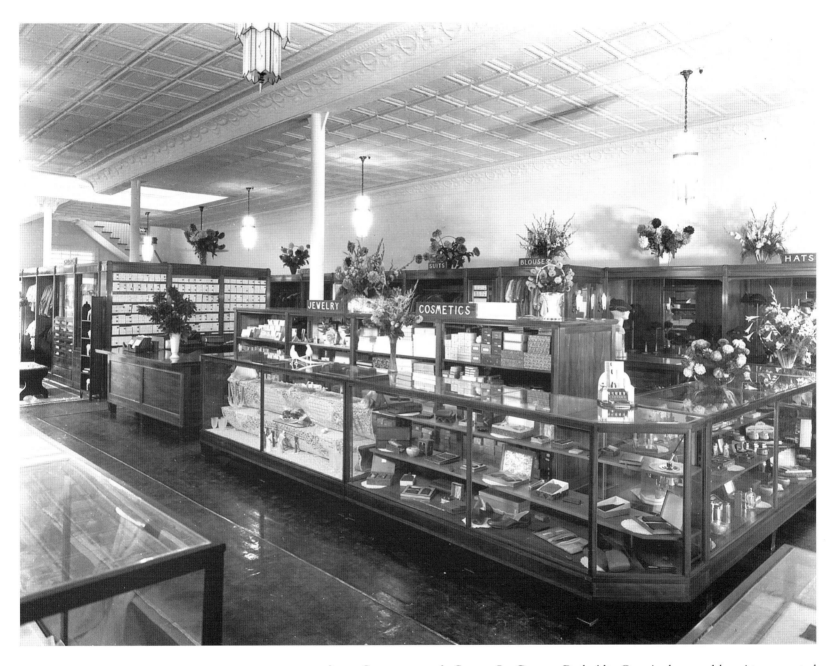

ALTA CUNNINGHAM'S STORE IN GREER. Both Alta Cunningham and her sister operated department stores for ladies. Lila Lee Cunningham's store was in Newberry. Alta's Greer store, located at 104–106 Trade Street, became an institution in Greenville County and beyond. Persons who could find nothing to wear in either Greenville or Spartanburg drove to Greer to seek the assistance of the imposing and elegant Miss. Cunningham. After her death in 1977, the store continued to operate under her name until it closed in 1993.

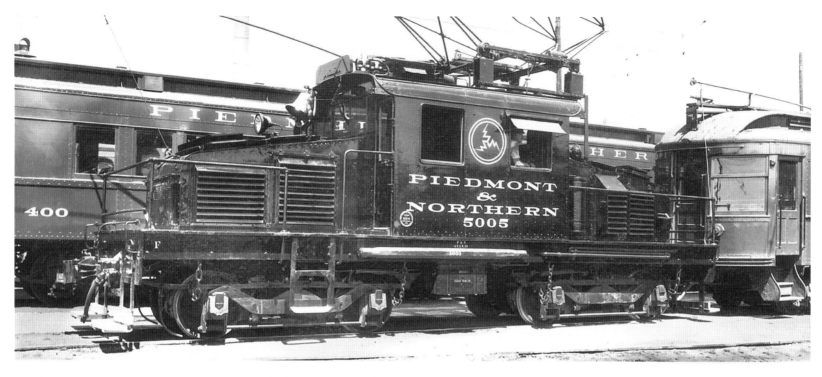

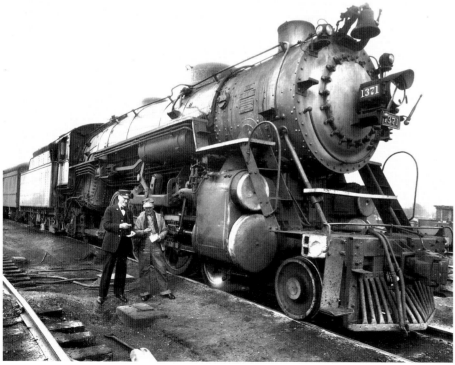

THE RAILROAD COMES TO GREENVILLE. The completion of a rail line from Columbia to Greenville in 1853 brought the railroad to Greenville for the first time. During the next half-century additional lines were built, until eventually Greenville was well served by both passenger and freight service. After defaulting on bonds in 1880, the Columbia & Greenville line was bought by the Richmond & Danville Railroad. In 1894 the Richmond & Danville Railroad merged with the Southern Railway, which became one of the largest railroads in the South. In 1905 Southern Railway completed a new depot at the end of West Washington Street, giving Greenville a proper station. Shown in the bottom photograph is the pride of the Southern Line, The Crescent Limited No. 37. In 1982 Southern Railway and Norfolk & Western merged to form the Norfolk Southern Railroad. The old depot was demolished in 1988.

In 1914 the Greenville, Spartanburg, and Anderson Railway was merged with the Piedmont Traction Company (Charlotte to Gastonia) to form the Piedmont & Northern Railway. The two lines operated independently and were never connected. The South Carolina segment extended for 89 miles from Spartanburg to Greenwood, with a branch line from Belton to Anderson. The inspiration behind this interurban electric railway was tobacco magnate, James B. Duke. The P&N merged with the Seaboard Cost Line Railway in 1969. Shown in the top photograph is a Baldwin steeplecab, No. 5005.

IN AND AROUND GREENVILLE

Bill Coxe was hired to photograph most of the commercial establishments in Greenville. His photographs constitute a valuable documentation of the city's business community in the first half of the 20th century. Earlier chapters in this volume have shown the businesses in the central downtown area. Chapter Six offers a representative selection of more downtown establishments as well as others outside the central business area. In addition to recording Greenville's commercial architecture, some of the photographs also show the employees who staffed these businesses.

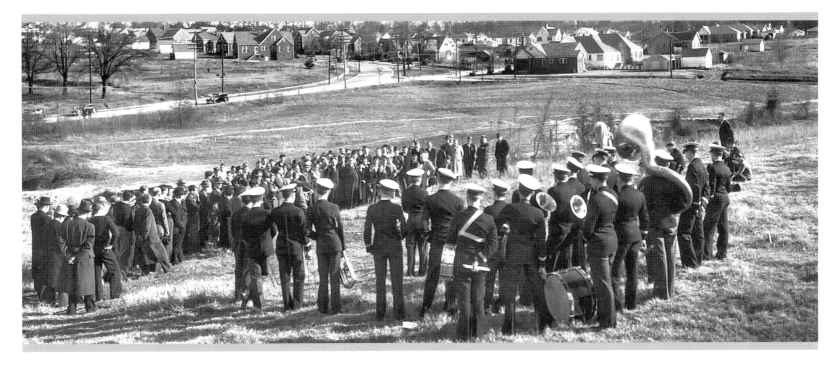

SIRRINE STADIUM GROUND BREAKING. The construction of Sirrine Stadium, which began in 1935, was a cooperative effort on the part of the city of Greenville and Furman University. A large sum was contributed by Furman alumni through the efforts of alumnus J.W. Sirrine. A large federal grant was also made through a WPA program. At first designated as a municipal stadium, the playing field and stands were on Furman University land. After all the construction bonds were retired in 1946, the stadium came into the full possession of the university.

After struggling with an underground stream and flooding, Morris-McKoy Building Company completed construction of the stadium in the fall of 1936. The first game played on the new field on October 31, 1936, saw Furman defeat Davidson College. Following the official dedication on November 14, 1936, Furman went on to beat the University of South Carolina. Bob (Robert B.) King captained the Furman team in 1936. In the photograph above, Jones Avenue and Cleveland Streets are in the background.

After Furman moved to its new campus in 1958, Sirrine Stadium gradually declined into disrepair. In 1981 Sam Francis spearheaded a campaign to raise $650,000 to buy the property from Furman and transfer ownership to the Greenville County School District. Almost 20 years later, a group calling itself Sirrine 2000 coordinated the raising of funds to completely renovate the historic sports facility.

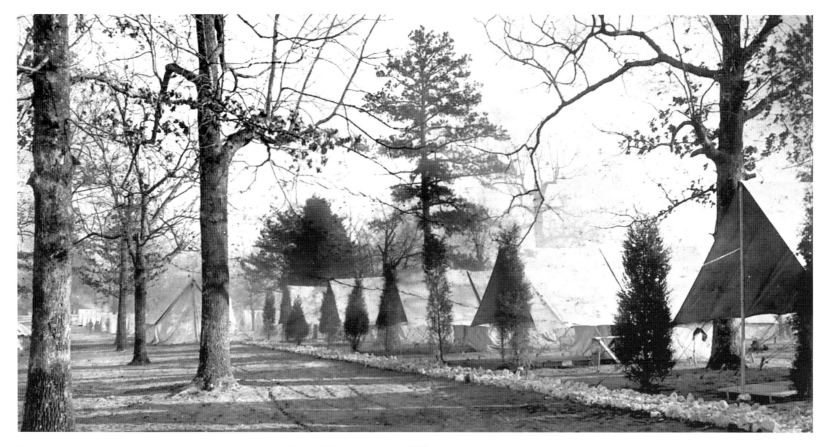

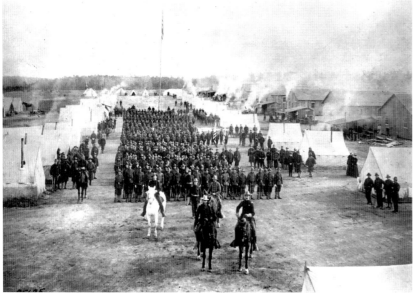

CAMP WETHERILL. When the United States declared war on Spain in April 1898, Greenville's only military unit was the Butler Guards. Soon the Greenville Guards and the Greenville Volunteers formed a second unit. Both Greenville companies were integrated into the First South Carolina Volunteer Infantry and sent for training in Florida. Greenville's business leaders now worked to have a training camp located in Greenville itself. Camp Wetherill was named for one of the first soldiers killed at the Battle of San Juan Hill, Alexander M. Wetherill. The camp consisted of two sections. One brigade of troops was located on a large tract north of Earle Street, stretching from Buncombe Road to the future Wade Hampton Boulevard. A second brigade was camped in an area south and east of Anderson Street that extended past Mills Mill. Although some wooden buildings were constructed, the troops weathered the severe winter of 1898–1899 in tents. Camp Wetherill ended its brief existence when it closed in March 1899. These photographs were probably purchased by Bill Coxe from an earlier photographer.

DAUGHTERS OF THE AMERICAN REVOLUTION.
The photographs in the Coxe collection form a record of diverse elements of Greenville's citizens. The top photograph was taken in 1923, when the Nathaniel Greene Chapter of the Daughters of the American Revolution dedicated the planting of 2,000 pine trees in memory of George Washington. The location is not identified.

CONFEDERATE VETERANS. The bottom photograph, possibly also dating from the 1920s, shows Greenville's remaining Confederate veterans gathered on the steps of Buncombe Street Methodist Church.

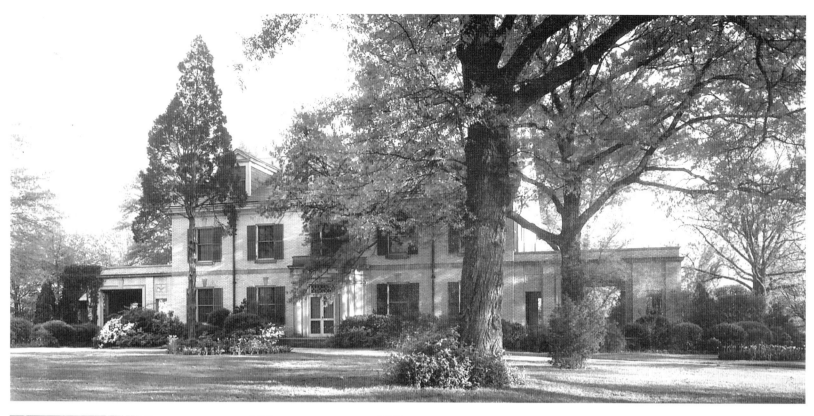

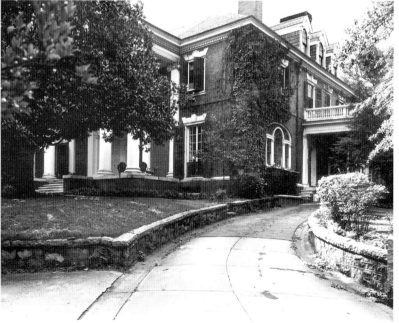

THE WOODSIDE HOME. As Greenville experienced a downtown construction boom in the 1920s, some of these involved in that boom were putting up substantial residences in new, fashionable neighborhoods. John T. and Lucile Woodside built their new home on Crescent Avenue. Designed by William Ward, the two-story residence was constructed of cream brick. When the Woodside financial empire collapsed during the Depression, the Woodsides moved to a more modest dwelling on Broadus Avenue. While under extensive renovation in 1947, the home burned and was then restored as a one-story residence. The home was rebuilt to the original design in 2002–2003.

THE POINSETT CLUB. The home of Lewis W. and Margaret Parker, built in 1904 on East Washington Street, shows the early 20th-century neo-classical reaction to Victorian architecture. Later the home passed into the possession of Allen and Mable Graham and then Marion and Zaidee Brawley. The Poinsett Club, which had previously been located on North Main Street, acquired the residence in 1935.

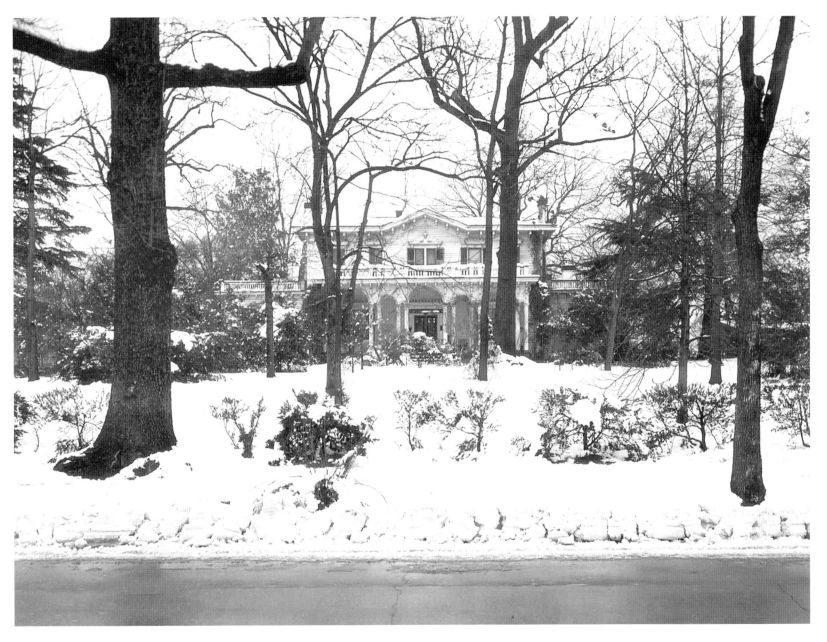

THE BEATTIE HOUSE. This stately home was built in 1834 by Fountain Fox Beattie for his bride, Emily Hamlin. It originally stood on East North Street (this photograph) at the corner of Church Street. The Greenville County Courthouse later occupied the site. Subsequent generations of the family added two wings, Italianate decorative features, and extensive landscaping. In 1948 the home became the Greenville Women's Club and was relocated to Beattie Place near the City Curb Market. During the redevelopment of Beattie Place, the house was moved again in 1983 to 8 Bennett Street. The Beattie house is on the National Register of Historic Places.

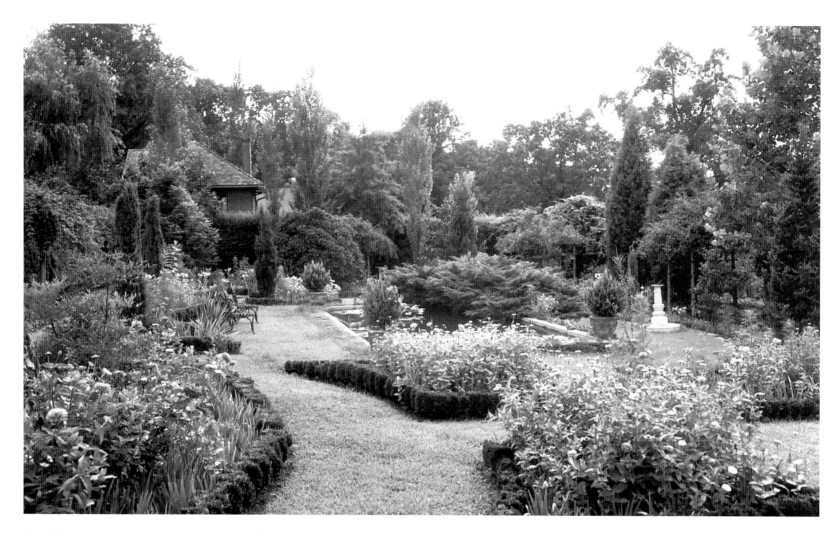

THE MARGARET MCKISSICK GARDEN. Bill Coxe was commissioned to take a series of photographs of the garden at Cohasset, the home of Margaret and Anthony Foster McKissick on Clarendon Avenue. The 17-acre garden had two lakes, a goldfish pond, and separate sections for flowers and vegetables. It was described as "a veritable arboretum of native and exotic plant life." There was also an area where cows, pigs, and chickens were kept.

Margaret Smyth McKissick was the daughter of textile pioneer Ellison Adger Smyth and Julia Gambrell Smyth. Her record of community service was extensive. She was the first woman to be presented the American Legion's Distinguished Service Plaque. She was president of the South Carolina Federation of Women's Clubs, the Greenville Red Cross, and director of the Community Chest of Greater Greenville.

Anthony Foster McKissick received a B.S. degree from the University of South Carolina in civil engineering with first-class honors and, at the same time, a master's in classical literature (Magna Cum Laude). After earning another master's degree in mechanical engineering from Cornell, he went on to found the department of electrical engineering at Alabama Polytechnic Institute (Auburn University). While publishing scholarly articles and distinguishing himself in the academic world, he was enticed into the textile business by his father-in-law.

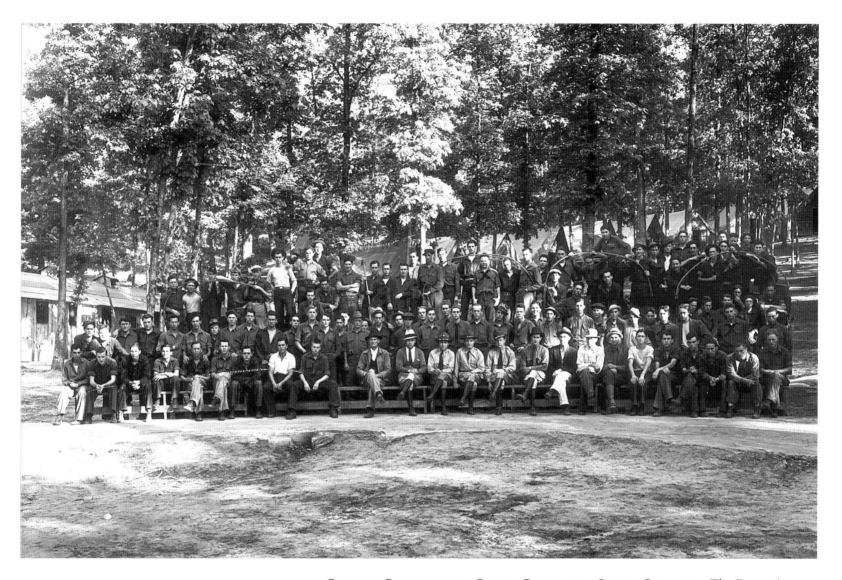

CIVILIAN CONSERVATION CORPS, CLEVELAND, SOUTH CAROLINA. The Depression saw millions of young men in cities unemployed and idle. In addition to the need to provide the urban unemployed with some form of relief, there was concern that idleness might turn into crime and violence. The Civilian Conservation Corps (CCC) not only contributed to the solution of this problem, but it also advanced the work of conservation and reforestation. Camps were created and organized in military-style where young men worked to create parks, plant trees, and build reservoirs. Cleveland Park was created in Greenville by the CCC on land donated by William Choice Cleveland.

The Coxe collection contains a valuable photographic record of CCC camps in South Carolina, North Carolina, and Georgia. Bill Coxe took the photograph on this page of a camp at Cleveland in the upper part of Greenville County. A study of the picture reveals that women were excluded from the program, and that the camps, throughout the country, were segregated by race.

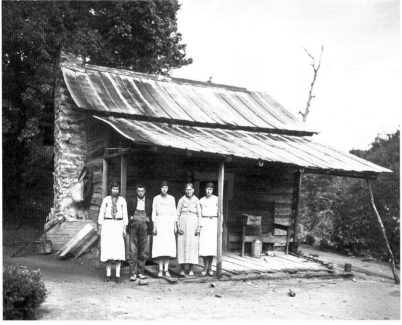

THE DARK CORNER. The Dark Corner is located in a projection of the northwestern corner of Greenville County, falling mostly in Glassy Mountain Township. In many ways, however, the section defies any geographical designation. For many who grew up within sight of its mountains, the Dark Corner is "a state of mind." During the late-colonial and Revolutionary periods, the area was known for a series of block-house-style forts, which provided protection for the sparse population from Native Americans, Tories, and British forces. Gowensville, the oldest community, takes its name from Maj. Buck Gowen and nearby Gowen's Fort.

Bridges constitute a notable part of the area's historical heritage. The oldest is the 1820 Poinsett Bridge, constructed of stone as part of the State Road connecting Charleston with Asheville. More recent, but more nostalgic, is Campbell's Covered Bridge. Constructed in 1909 over Beaverdam Creek, the 38-foot bridge was named for Alexander Lafayette Campbell whose grist mill was nearby. There are several theories as to why covered bridges were constructed. Perhaps the desire was to provide shelter from the weather, or to prevent the horses from shying when seeing the flowing water.

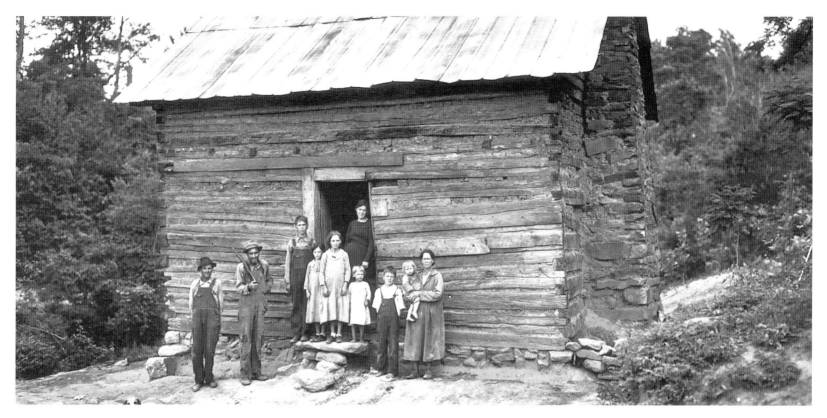

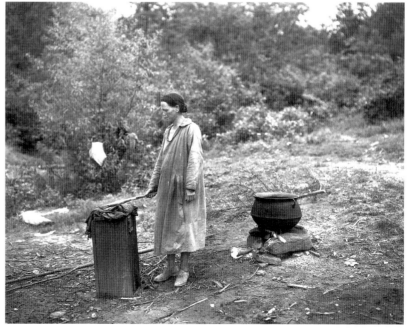

DARK CORNER MOONSHINE. In the 19th and early 20th centuries, the Dark Corner was known for the making of illegal whiskey. Accompanying this activity was a reputation for crime, violence, and a general disdain for the law and suspicion of outsiders. The Dark Corner was a poor agricultural region. At one time the Upcountry offered no opportunity for employment in industry. A farm family could subsist by growing corn. If the family converted the corn into whisky, a profit could be made. The mountainous and wooded terrain of the region made detection less likely. Thus, it was not a natural disposition toward lawlessness but economic necessity that led to the Dark Corner's best-known industry. A rifle became a standard feature of any family gathering (top photograph). The pictures that Bill Coxe took of life in the Dark Corner in the 1930s are among the most poignant in the entire collection.

In the latter part of the 20th century and early part of the 21st century, an entirely new type of settler migrated into the Dark Corner. The natural beauty of the area, and the proximity of interstate highways, led to the development of expensive residential areas and golf club communities. Glassy Mountain, which takes its name from the sun's reflection on ice-covered rocks, became dotted with expensive homes enjoying spectacular views.

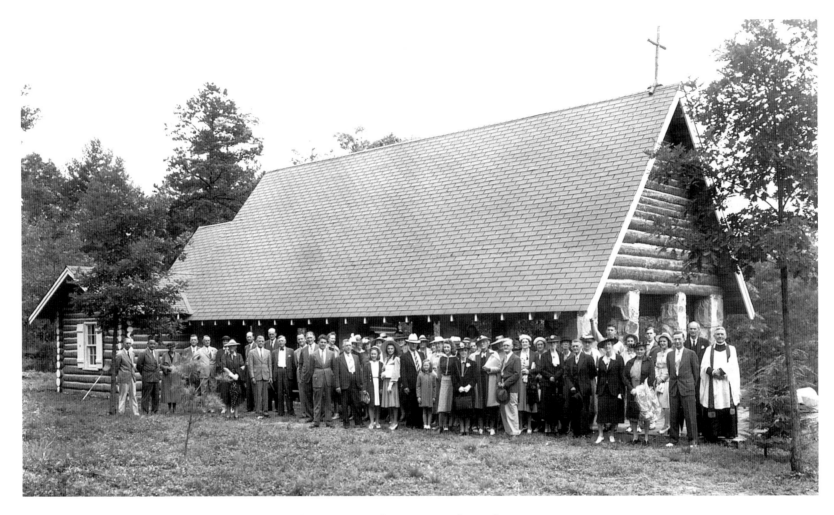

FAITH MEMORIAL CHAPEL, CEDAR MOUNTAIN. The mountains of Western North Carolina have long provided a summer haven for Greenvillians who sought to escape the summer heat. Among the 19th-century summer residents was Ellison Capers. Capers, a graduate of the Citadel, attained the rank of brigadier general in the army of the CSA at the age of 28. After the Civil War he studied for holy orders and was ordained a priest in the Episcopal Church. While serving for 20 years as rector of Greenville's Christ Church, Capers built a summer cottage at Cedar Mountain, North Carolina. In 1894 Capers, now the Bishop of South Carolina, spearheaded the building of Faith Chapel to serve the growing summer colony at Cedar Mountain and Caesar's Head.

After Bishop Caper's death, services ceased to be held and the little chapel fell into ruin. In 1936 Dr. Alexander R. Mitchell, rector of St. James Episcopal Church in Greenville, joined with others in an effort to re-establish a place of worship for the summer colony. On July 10, 1938, Dr. Mitchell conducted the first service in a new chapel located about half a mile from the original site. Following the service, Bill Coxe photographed the congregation. Dr. Mitchell stands on the far right. To his right, standing slightly behind him, is Dr. Mitchell's brother-in-law, Archibald Rutledge, future poet laureate of South Carolina. Some of the pews, salvaged from the first chapel, were re-installed in the new one. In 1952, Faith Chapel was extended 15 feet on both sides.

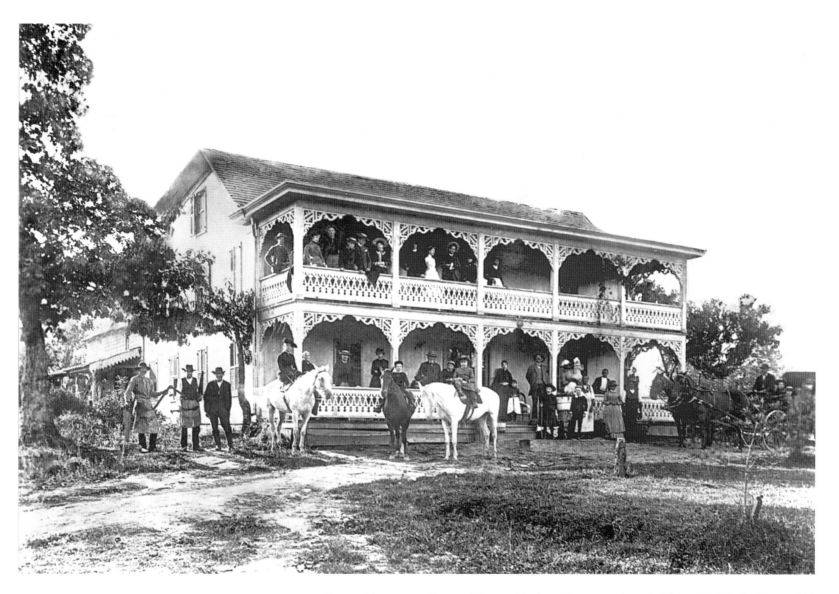

CEDAR MOUNTAIN HOTEL. Thomas Claghorn Gower was born in Maine in 1822. At the age of 19 he migrated south to Greenville in search of opportunities. In his new home, he became successfully involved in a number of businesses. A man of vision, he contributed to the transformation of Greenville from a village to a city. Gower was mayor from 1870 to 1871 and served as the chairman of the public school board. Seeking a healthful site for his son to recover from whooping cough, he is credited with the development of a summer colony at Cedar Mountain, North Carolina. Just across the state line, Cedar Mountain virtually became an extension of Greenville County. In the late 19th century many Greenvillians traveled to the area in search of a cooler summer climate. In response to the need, T.C. Gower built a hotel in 1884, which he called the Hotel de Gower. The 20 rooms each rented for $1.50 a day or $30 a month. There was a ballroom where dances were held. The wooden structure, with its ornate front galleries, burned in 1891.

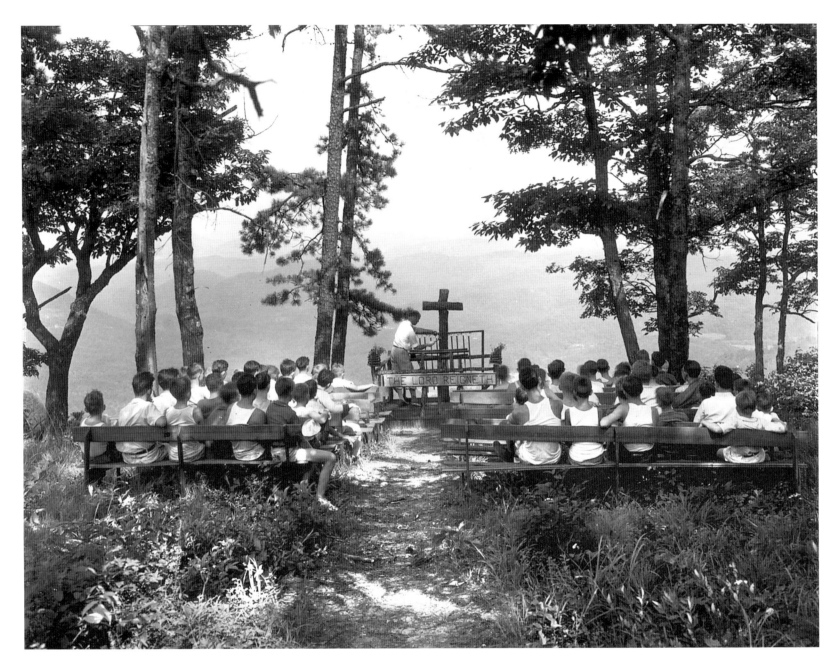

THE CHAPEL AT PRETTY PLACE. The first Greenville YMCA camp was held for two weeks in the summer of 1912 at Cedar Mountain. From 1914 to 1924 Camp Greenville operated at Blythe Shoals before finding a permanent home on a 28-acre mountain site donated by J. Harvey and Hazle Cleveland. A chapel was created overlooking a cliff with a spectacular mountain view that extended for miles. Hazle Cleveland had called the spot "Pretty Place." The chapel at Pretty Place has been described as "the closest place to Heaven in South Carolina."

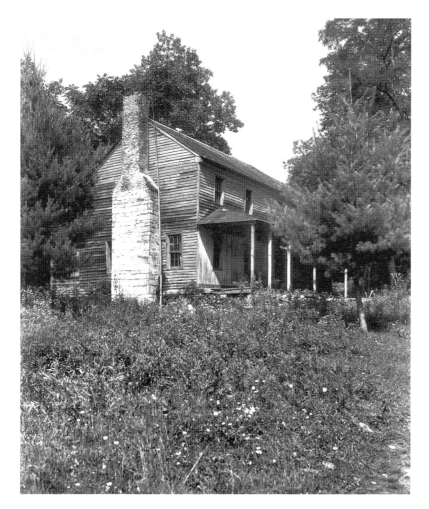

SUMMER RETREAT OF JOEL AND MARY POINSETT. Joel Poinsett was a Charleston native of Huguenot ancestry who set out as a young man to explore the world. After 10 years of travel, he settled down to a life of public service. After serving in the state legislature, Poinsett became the first director of the Board of Public Works for the state of South Carolina. On the national level, he served in the House of Representatives and as the first United States minister to Mexico. In the 1830s Poinsett purchased a farm, the Homestead, on the Pendleton Road west of Greenville. He became a leading member of Greenville's "summer colony," forming friendships with Vardry McBee and Benjamin F. Perry. After four years as Martin Van Buren's secretary of war, Poinsett and his wife, Mary Izard Pringle, divided their time between her Lowcountry plantation and their Greenville home. At the Homestead the Poinsetts could escape the Lowcountry summers but not a constant stream of visitors and social obligations. They further retreated to the northwestern section of Greenville County to a home (shown on this page) above Gap Creek. The home is no longer standing.

ROBERT QUILLEN. An internationally known columnist and humorist, Quillen was born in Syracuse, Kansas, in 1887 and grew up in his father's print shop. He left home at age 16 to travel and developed a dislike for large cities. Before turning 20 he arrived in Fountain Inn, South Carolina, to run a newspaper. The small town and the man were a perfect match. Quillen came to believe that the small town was the true reflection of humanity and the world at large. After acquiring ownership of the Fountain Inn Tribune, he made it the most widely read weekly in the country. His editorials and feature articles were syndicated in the Scripps-Howard newspapers and appeared daily in about 400 papers. The entire country came to know Fountain Inn and its people. One composite inhabitant created by Quillen, Aunt Het, appeared in a series of articles.

Bill Coxe traveled to Quillen's home to take a series of family pictures. Quillen's daughter, Louise, was the object of a series of articles entitled "Letters From a Dad to His Red-Headed Daughter." In the yard was a statue of Eve, whom Quillen described as "a distant relative of mine." Robert Quillen died in 1945.

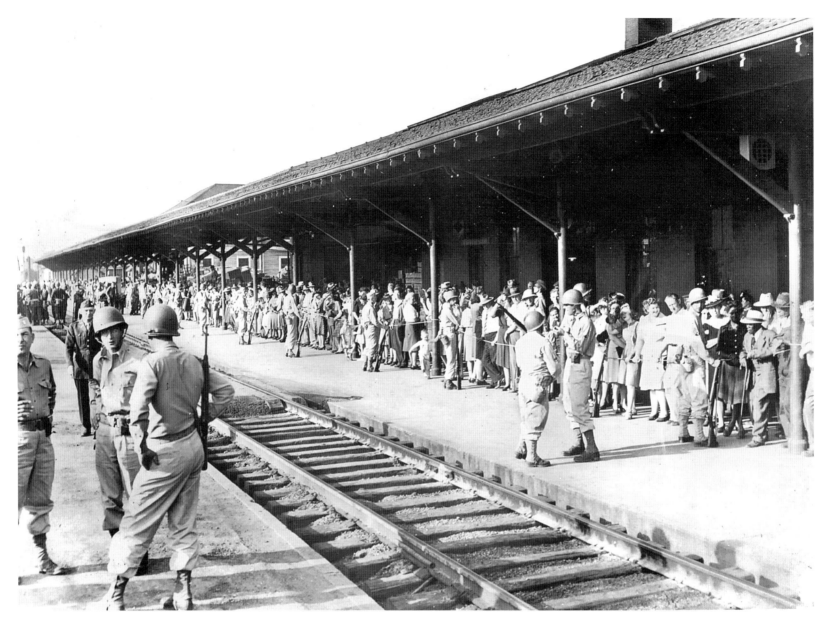

CROWD WAITS FOR ROOSEVELT FUNERAL TRAIN AT GREENVILLE DEPOT. On April 12, 1945, Franklin Roosevelt died at his Warm Springs, Georgia home. His body was carried along the Southern Railway back to Washington. At towns all along the route, grieving Americans gathered to see the train pass. At most towns the train merely slowed down as it passed the depot. In Greenville the train stopped for 37 minutes while the engines were switched. Mayor C. Fred McCullough presented wreaths to be placed in the funeral car.

Bill Coxe was one of those waiting at the Greenville Depot, along with 15 to 20 thousand others. The troops in his photograph were from Camp Croft, on the outskirts of Spartanburg.